STIEGLITZ
ON PHOTOGRAPHY

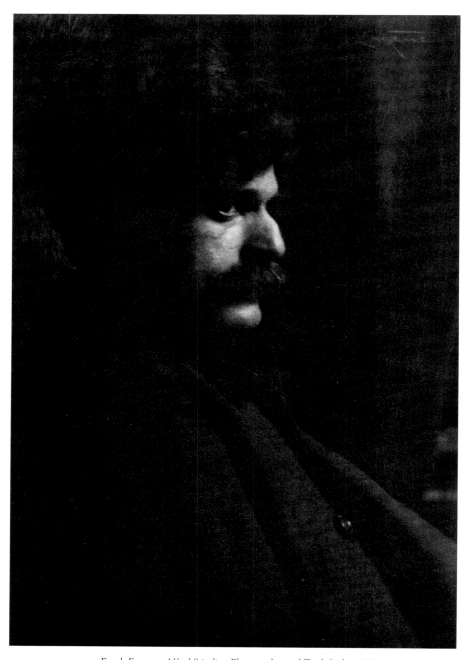

Frank Eugene, *Alfred Stieglitz, Photographer and Truth Seeker*, 1909

STIEGLITZ
ON PHOTOGRAPHY

his selected essays and notes

COMPILED AND ANNOTATED
BY RICHARD WHELAN

BIBLIOGRAPHY OF STIEGLITZ'S WRITINGS
COMPILED, WITH A PREFACE,
BY SARAH GREENOUGH

APERTURE

APERTURE GRATEFULLY ACKNOWLEDGES
THE GENEROUS SUPPORT OF
THE E. T. HARMAX FOUNDATION

TABLE OF CONTENTS

INTRODUCTION

Alfred Stieglitz (1864–1946) is perhaps the most important figure in the history of the visual arts in America. That is certainly *not* to say that he was the greatest artist America has ever produced. Rather, through his many roles—as a great photographer, as a discoverer and promoter of photographers and of artists in other media, and as a publisher, patron, and collector—he had a greater impact on American art than any other person has had.

Stieglitz edited three magazines, in succession: the *American Amateur Photographer* (1893–1896), *Camera Notes* (1897–1902), and *Camera Work* (1902/03–17). And he had three galleries: first (1905–17) the Little Galleries of the Photo-Secession (known as "291" from its street address, 291 Fifth Avenue), later followed by the Intimate Gallery (1925–29) and An American Place (1929–46). In those arenas—as well as in his articles for other publications and in the exhibitions he organized for various museums and organizations—he was the first (or, in some cases, among the first) to champion the work of such outstanding photographers as F. Holland Day, Frederick H. Evans, Alvin Langdon Coburn, Clarence H. White, Gertrude Käsebier, Frank Eugene, Edward Steichen, Charles Sheeler, Paul Strand, Ansel Adams, and Eliot Porter.

Stieglitz was by nature an evangelist who hoped to raise the ethical standards of the world—and especially of what he viewed as "philistine" America—through the aesthetic influence of art. In this he anticipated an epigrammatic formulation of the philosopher Ludwig Wittgenstein, who attended the Technische Hochschule in Berlin some years after Stieglitz had been a student there. In his *Tractatus Logico-Philosophicus* Wittgenstein wrote, "Ethics and aesthetics are one." In other words, a person who has a highly developed sense of the true beauty of the world—its spiritual beauty—cannot help but act ethically.

In 1908 Stieglitz told an interviewer that his ideal was a "perfect freedom," which can be attained only by people who are "taught to appreciate the

beautiful side of their daily existence, to be aware of all the beauty which constantly surrounds them." To that end, he continued, "The camera is one of the most effective means of teaching people to distinguish between what is beautiful and what is not." What he was advocating (though he was certainly unaware of the parallel) was essentially the Buddhist ideal of "no-mind" and "mindfulness"—a mind free from distracting preconceptions and therefore able to focus intensely on the deep reality and beauty of the present moment.

The main thing was learning to *see*—intelligently, spontaneously, and penetratingly. "In my opinion," he wrote in the *Photographic Journal of America* in October 1917, "the most difficult problem in photography is to learn to see. All else is comparatively simple, and one can only learn to see through comparison, through contrast. That is every artist's greatest secret."

His optimistic conviction only increased with the passage of time, as shown by a statement he made in that same magazine in July 1918: "Photography is a much more wonderful medium of expression than its staunchest adherents realize today. As I travel and study what art has accomplished in various countries and what nature really means and is, photography's possibilities assume gigantic proportions. It is to the men who understand nature and love it, and who love photography, that the future will bring about revelations little dreamed of today."

In 1901 the critic Charles Caffin wrote of Stieglitz that he united "the scientific and the artistic temperament. . . . [T]he foundation threads of his purposes are scientific, and into these he has woven the artistic."

When Stieglitz took up photography in the mid-1880s, he was interested more in technical matters than in artistic ones. Throughout the late 1880s and the 1890s he was constantly experimenting with photographic processes, and he contributed numerous reports of his findings to British, American, and German magazines. In them he expounded on such subjects as new developments in platinum printing, how to tone Aristotype prints with platinum, and how to save an overexposed plate by bathing it in potassium bromide before immersing it in a weak developing solution. In other articles he explained how to increase the photosensitivity of gelatin negatives with mercuric chloride and ammonia, and how to tone gelatin chloride printing-out paper with solutions of potassium oxalate, potassium phosphate, and sodium

chloroplatinate. During this period one might have predicted that Alfred—like his younger brother Julius, one of the foremost American chemists during the 1930s and forties—would become a scientist with a dilettante's passion for artistic photography.

Stieglitz's earliest published writings deal with two aspects of his new passion: amateurism and travel. By amateurism he meant serious dedication to photography for love, not for profit. Given his lifelong militant feelings about this issue (in 1942 he was still denying that he was, or ever had been, a professional photographer), it is fitting that his very first published article was "A Word or Two About Amateur Photography in Germany," which appeared in the *Amateur Photographer* (London) in 1887.

In two other articles—"A Day in Chioggia" (1889) and "Cortina and Sterzing" (1892)—we can see that at the beginning of his career Stieglitz believed that it was useful, perhaps even necessary, for him to travel in search of "picturesque" subjects for his camera. By 1893 he had begun to discover that he could, and should, do his most important work in his daily milieu, in New York City and at his family's house on Lake George, in upstate New York.

Stieglitz wrote his first review of a photographic exhibition at the request of Peter Henry Emerson, one of the greatest photographers of the nineteenth century. Their correspondence had begun in 1888, when Emerson was nearly finished writing his book *Naturalistic Photography* and Stieglitz was still studying in Berlin; Emerson wondered whether the young photographer could undertake a German translation. The following year Emerson, who was the British correspondent for the recently established *American Amateur Photographer*, asked Stieglitz to write a "short résumé of the Berlin Jubilee Exhibition" to include in his next piece for the magazine. Stieglitz's signed review, "The Berlin Exhibition," was published in the November 1889 issue.

By far the most prolific and significant period for Stieglitz as a writer was from 1892 to 1902, during which time he edited the *American Amateur Photographer* and then *Camera Notes*.

His articles from those years include exhibition reviews, annual overviews of the state of American photography, travel pieces, diatribes in which he campaigned for the establishment of an annual first-class photographic exhibition in America, and accounts of his untiring efforts to win recognition for

pictorial photographs as works of art worthy to be hung in museums alongside paintings, drawings, and etchings. He also wrote more technical articles—about such subjects as night photography, outdoor backgrounds for portraiture, and hand cameras—and an extremely detailed scientific exposition of platinum printing. This period culminated with general articles about pictorial photography for two of the most highly respected American magazines, *Scribner's* and the *Century*.

Much of Stieglitz's writing from the years 1892–1902 has a distinctly competitive tone, a holdover perhaps from his childhood athletic competitiveness, which found an outlet in running. In his reviews he frequently lamented that American photography was inferior to British. For instance, in "A Plea for Art Photography in America" (*Photographic Mosaics*, 1892) he wrote, "There is no reason why the American amateur should not turn out as beautiful pictures by photographic means as his English brother across the long pond, and still the fact remains that he does not do so."

Too, he constantly—often with harshly expressed disappointment—compared the work done by members of his own Society of Amateur Photographers of New York with that done by the clubs in Boston and Philadelphia. A typical judgment appeared in his review of an 1893 exhibition, in which he wrote of the New York group, "Taken as a whole, the work shown was photographically very good, artistically very poor." He soon honed that phrase, in letters to many *American Amateur Photographer* subscribers who sent him prints to critique, into the rather cruelly dismissive formula "Technically perfect, pictorially rotten."

In 1901, toward the end of Stieglitz's peak period as a writer, Charles Caffin wrote in his book *Photography as a Fine Art*:

> [A]llusion may be made to the propaganda [Stieglitz] has maintained by voice and pen. His correspondence with photographers throughout the world and contributions to periodicals apart from his editorial work, have been continuous and influential. His writings are terse and to the point; backed with so much knowledge and so disinterested that they command respect even from those who are disinclined to accept his views. There are heartburnings among photographers as among coworkers in other

lines, and Mr. Stieglitz has received a full share of knocks from opponents, but I doubt if there is a single one of the latter who does not heartily respect him even while he thumps him. He also is an accomplished thumper; delivering his blows with telling directness, the effect of which it is difficult to explain away. For it cannot be said that he has any private ends to serve, or that he is merely an artistic visionary or, on the other hand, that he is only a scientist with no feeling for art. So he is a troublesome antagonist, and even those who resent his *de facto* leadership among American photographers are bound to admit that he has not sought the honor, but that it has grown around his personality through his qualifications fitting so admirably the circumstances and needs of the time.

In that same book Caffin said of Stieglitz, "He is by conviction and instinct an exponent of the 'straight photograph'; working chiefly in the open air, with rapid exposure; leaving his models to pose themselves, and relying for results upon means strictly photographic." Because that is so obviously true of most of Stieglitz's work, some historians have been puzzled by his emphatic endorsement of the gum-bichromate process in the late 1890s. For example, in "The Progress of Pictorial Photography in America" (*The American Annual of Photography and Photographic Times Almanac for 1899*) Stieglitz wrote, "In Continental Europe . . . enormous strides in the right direction have been made within the last few years. . . . The gum bichromate printing process did much to arouse this dormant talent, for by means of this method the artist has at last found an unlimited means of expression. A new field of possibilities has been opened to him, and the prospects for the future of pictorial photography have become much brighter with its advent. Gum printing is bound to revolutionize pictorial photography." It seems, however, that Stieglitz championed gum printing mainly because he believed that the results, which often looked like drawings or watercolors, might finally convince the general public that photographs could be works of fine art. Once that was accomplished, the public could then be educated into acceptance of straight photography.

Although Stieglitz did himself briefly experiment with the technical aspects of gum printing in the late 1890s, his photographs from 1900 until the end of

his life were all "straight." In 1913 he wrote in his foreword to the catalogue of the Wanamaker photographic competition in Philadelphia, "The judges of the Competition were unanimous in condemning all such pictures in which imitation of painting was the keynote. Photographers must learn not to be ashamed to have their photographs look like photographs. A smudge in 'gum' has less value from an esthetic point of view than an ordinary tintype. . . . A photographer using photography to do a 'stunt,' or to imitate painting, may amuse those who understand neither the fundamental idea of photography nor the fundamental idea of painting."

Beginning in 1902, when he founded both the Photo-Secession and *Camera Work*, Stieglitz became less concerned with improving amateur photographic societies in America. Instead, he would devote himself to his élite group, which would set the standard by which all photography that aspired to the status of art would have to be measured. Although he continued to write an occasional exhibition review (e.g., "Some Impressions of Foreign Exhibitions" in 1904) or consideration of aesthetics ("Simplicity in Composition" in 1905), most of his published writing between 1902 and 1905 took the form either of editorials for *Camera Work* or explanations of the origin and policies of the Photo-Secession.

The year 1907 saw, in *Camera Work*, Stieglitz's first use of a literary form that suited him well: the reprinting of a group of his letters, or a sequence of postal exchanges, in order to "set the record straight." The piece in question is "The New Color Photography—A Bit of History," which would be followed in 1910 by a pamphlet entitled *Photo-Secessionism and Its Opponents: Five Letters*. Many years later he was tempted to resort to the same format, but wrote an article instead, when a dispute arose between him and collector Duncan Phillips (founder of the Phillips Collection in Washington, D.C.) regarding the price paid for a watercolor by John Marin.

Between 1905 and 1917 Stieglitz wrote very little for publication, though he kept up an enormous correspondence, sometimes writing as many as twenty letters in a single day. With the opening of the Little Galleries of the Photo-Secession ("291"), in 1905, much of Stieglitz's expressive energy was diverted from the printed page to the spoken word—in the form of endless monologues directed at, and conversations with, 291's regulars and its casual visitors.

"Stieglitz spoke almost incessantly—punctuated by long and pregnant silences—to all comers, whether in his gallery-demonstration centers, in restaurants, or in his living quarters," wrote his friend and amanuensis Herbert Seligmann. "Talks continued for hours and days, people came and went during volcanic outpourings to a silent and fascinated audience of from one to twenty or more. Here, in a sustained flow of narration, assimilating into its unbroken course whatever questions, discussions, or self-revelation might come from the participants, Stieglitz developed his main themes. . . . The foe was commercialism[,] . . . its accompanying indifference to quality[,] . . . and its disregard for the spirit."

Some people simply could not put up with Stieglitz's logorrhea. Not long after 291 first opened, Ashcan-School painter John Sloan complained that when he visited the gallery Stieglitz talked his ear off, and so he never went back. Another artist who turned hostile, though only after several years as a 291 regular, was Thomas Hart Benton, who remembered that Stieglitz "never talked directly to the point but wove a web of discourse over, under, and around a subject. One of Stieglitz's actual conversational sentences would, Faulkner-like, run to two or three pages of print." Even allowing for Benton's malicious exaggeration, we must conclude that Stieglitz's style as a monologist was very different from his style as a writer, the latter being generally quite clear, direct, and succinct.

In 1907 Stieglitz began exhibiting works by some non-photographic artists at 291: first the obscure Pamela Colman Smith, followed more importantly by Auguste Rodin, Pablo Picasso, and Henri Matisse. Stieglitz showed this work, and published some of it in *Camera Work*, because he was engaged in a redefinition of photography and a re-evaluation of its relationship to the other visual arts. His guiding principle was that painting should no longer imitate photography, and photography should no longer imitate painting. Paul Haviland, a photographer and *Camera Work* editor who often served as Stieglitz's spokesman, wrote in the April 1910 issue of the magazine, "The works shown at the Little Galleries in painting, drawing, and other graphic arts have all been non-photographic in their attitude . . . [T]he Photo-Secession can be said now to stand for those artists who secede from the photographic attitude toward representation of form." And, he should have added, for those photographers who had abjured pictorialism.

In 1912 Stieglitz stated in a letter, "[B]efore the people at large, and for that matter the artists themselves, understand what photography really means, as I understand that term, it is essential for them to be taught the real meaning of art. That is what I am attempting to do . . . in such a conclusive manner that it will have been done for all time."

After his return to New York from a European vacation in the summer of 1911, Stieglitz never again crossed the Atlantic. He became increasingly devoted to championing the work of living American artists—painters and photographers alike. Among them were Georgia O'Keeffe, John Marin, Marsden Hartley, Arthur Dove, Charles Demuth, Max Weber, Abraham Walkowitz, Paul Strand, Ansel Adams, and Eliot Porter.

Soon after Georgia O'Keeffe arrived in New York City in June 1918, she and Stieglitz began living together, and he began to photograph her obsessively—making not only portraits in the usual sense but also close-ups of parts of her body. From then until the opening of his Intimate Gallery in 1925, Stieglitz devoted himself to photography and wrote very little.

During the winter of 1926–27 a wealthy and artistically inclined twenty-one-year-old named Dorothy Norman began paying regular visits to the Intimate Gallery; when she got home she would write down Stieglitz's most trenchant remarks. In the spring of 1928 she began to visit the gallery almost every day and told Stieglitz that she would like to write an article about him. Soon she realized that she couldn't possibly say all that she felt about him in a single article. For the next eighteen years, until his death, she would collect material for her book, *Alfred Stieglitz: An American Seer*, which would not be published until 1973.

Stieglitz, who had married O'Keeffe in 1925, quickly became romantically involved with Norman and began to teach her the basics of photography. In the summer of 1929 O'Keeffe made the first of her thenceforth nearly annual summer trips to New Mexico—both to get away from her husband's infatuation and to escape from the claustrophobic role of nurse into which she had been forced by the heart attack he suffered late in the summer of 1928.

Thereafter the hypochondriacal Stieglitz constantly complained about a plethora of ailments. He became deeply pessimistic, even bitter, and the number of visitors to his gallery declined. He failed to recognize the genius of André Kertész, who showed him work. And when Berenice Abbott took him

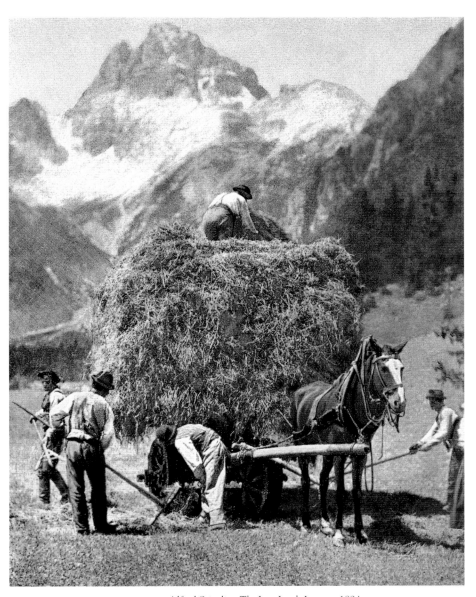

PLATE I. Alfred Stieglitz, *The Last Load*, January 1894

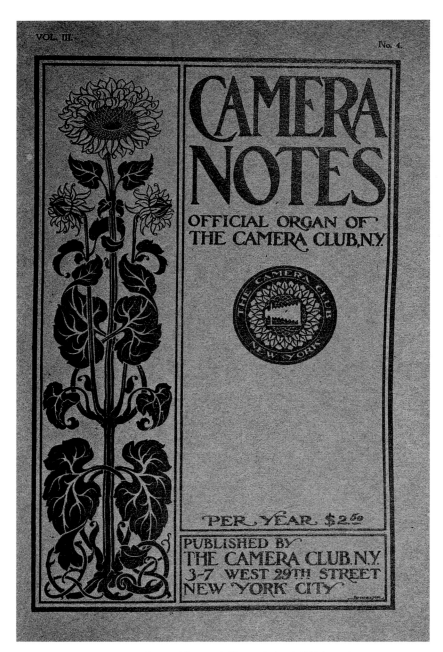

PLATE 2. *Camera Notes*, vol. III, no. 4, April 1900 (cover)

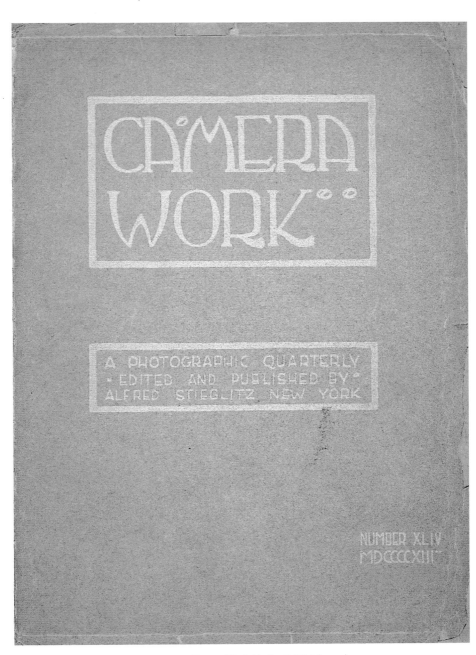

PLATE 3. *Camera Work* 44, April 1913 (cover)

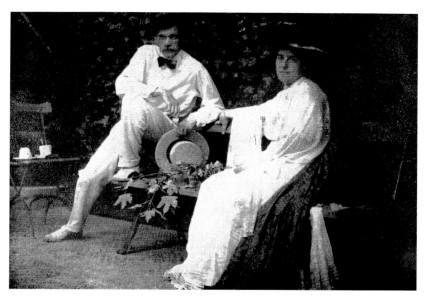

PLATE **4**. Frank Eugene, *Stieglitz and Emmy,* Tutzing, Bavaria, 1907 (Autochrome)

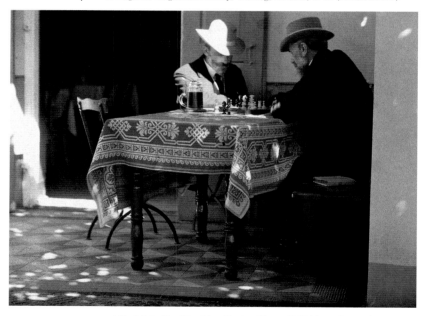

PLATE **5**. Alfred Stieglitz, *Two Men Playing Chess,* 1907 (Autochrome)

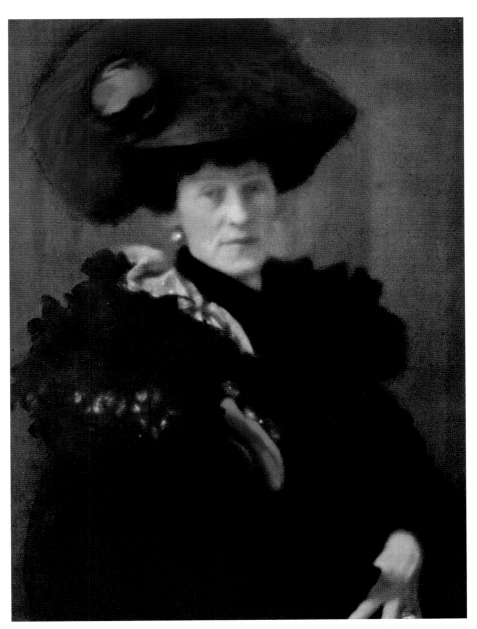

PLATE 6. Edward Steichen, *Portrait—Lady H.*, 1908 (Autochrome)

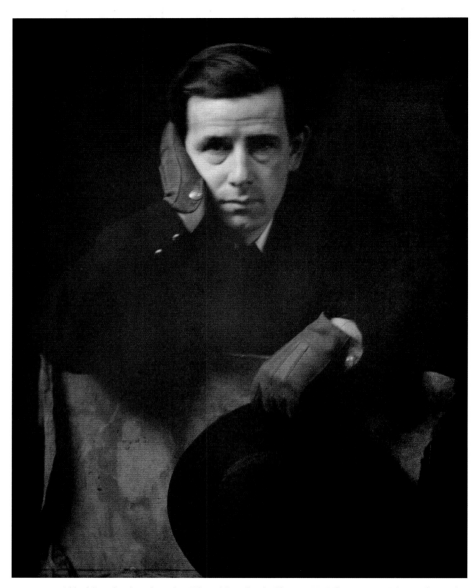

PLATE **7**. Alfred Stieglitz (attributed to Edward Steichen), *Clarence H. White*, ca. 1907 (Autochrome)

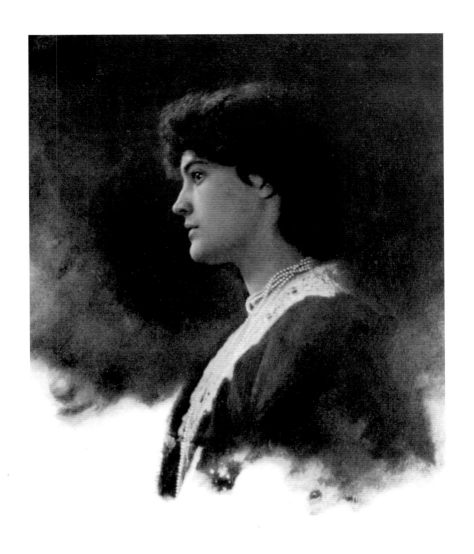

PLATE 8. Alfred Stieglitz, glycerine-platinum portrait of his wife, n.d.

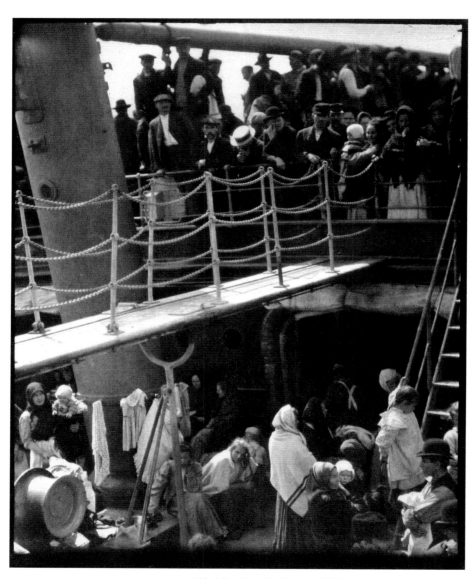

PLATE 9. Alfred Stieglitz, *The Steerage*, 1907

photographs by Eugène Atget, he declined to exhibit them, for Atget was a dead Frenchman, not a living American. Such photographers as Abbott and Walker Evans, who led the rising generation of Americans, found Stieglitz cold, cranky, and even irrelevant.

Stieglitz's photographs of skyscrapers, shot from the windows of his New York City "ivory towers" during the early 1930s, reflect his pessimism and his removal from everyday life. Harold Clurman, founder of the Group Theater, wrote perceptively that the city shown in these photographs had been "built up now to a pyramidal splendor, crowded, immutable, and terribly, terribly deathlike. . . . It is a city in which man has almost completely disappeared; despite all its metallic precision, it is like an enormous graven image of some very ancient civilization in which all signs of humanity have withered and everything is wrapped in silence."

In September 1938 seventy-four-year-old Stieglitz mentioned that his young friend Cary Ross was visiting him at Lake George and "is taking down stories out of my life. Not an autobiography. Just episodes, anecdotes or whatever the business should be called." Between 1925 and 1928 Herbert Seligmann had transcribed the stories he heard Stieglitz tell visitors to the Intimate Gallery, and for the past ten years Dorothy Norman had been making notes of Stieglitz's anecdotes, parables, and observations, which, Norman stated, "were not taken down literally in most cases, but represent an attempt to put into form in as direct a manner as possible, the essence of certain things that Stieglitz has said and stood for." Although Stieglitz complained of her occasional inaccuracy and incomprehension, he gave his blessing to the publication of some of her notes in the first issue of her new hardcover magazine, *Twice A Year: A Semi-Annual Journal of Literature, the Arts and Civil Liberties*, published in November 1938. Many additional reminiscences, transcribed by Ross and by Stieglitz's grandniece Peggy Davidson, would appear in four subsequent issues over the next eight years.

When it came to telling the story of his life, Stieglitz was not one to allow the specifics of mere circumstance to interfere with his vision of how things should have been. By the time he began dictating his reminiscences, they had undergone not only the inevitable unconscious distortions due to the passage of time but also many minor conscious and self-serving distortions. Stieglitz was constantly telling and retelling his stories, changing them and

elaborating them both to gratify himself and to illustrate moral lessons. His anecdotes became parables. Adherence to fact was far less important than making a point. Perhaps he told them in altered forms so many times that he came to believe the new versions as literal truth. It behooves us to approach them with circumspection.

In the present book, appropriate sections of Stieglitz's reminiscences from *Twice A Year* have been interspersed with his articles to create a chronological narrative. The reader should take care to distinguish between articles written close to the time of the events they describe and these later memories.

Stieglitz died in July 1946, at the age of eighty-two. The sadness of his last years should certainly not obscure the fact that for more than five decades Stieglitz's voice had been the most vigorous and effective in American photography. Perhaps the truest tribute he ever received was paid by the critic Austin Lidbury, who, in 1910, called him the "Napoleon of pictorial photography" and marveled that he had "put into the movement for internal progress and external recognition the fanaticism of a Mad Mullah, the wiles of a Machiavelli, the advertising skill of a P. T. Barnum, the literary barbs of a Whistler, and an untiring persistence and confidence all his own—a confidence that could move mountains, to say nothing of the mere prejudiced conservatism of artistic persons."

NOTE: In some of the articles collected in this book Stieglitz refers to specific photographs that accompanied his writing when it was first published. Whenever possible, the present publisher has reproduced those photographs here, but many of the images were not available for inclusion, and others have been added as illustration and reference. When a photograph title mentioned by Stieglitz differs from the title generally used today, the mention has been corrected. In cases where sufficient documentation was unavailable, dates provided for illustrations may be those of first publication or printing. The publisher has relied upon the information provided by the institutions which generously loaned the artwork for reproduction. A list of lending institutions can be found on page 275.

STIEGLITZ
ON PHOTOGRAPHY

from
WRITINGS AND CONVERSATIONS
OF ALFRED STIEGLITZ

My career in photography might be said to date from 1883, when I took up photography as a course in the Berlin Polytechnic with Professor Vogel, who can be looked upon as the father of scientific photography.

As a beginning in that course I was put to cleaning glass plates. They were to be chemically clean before they could be coated with collodion, which was then to be dipped into the silver bath. This plate when ready was exposed in a wet state in the camera in order to produce the negative.

There were about twenty of us in the class—or laboratory. For some weeks I was polishing glass and seemed unable to get what I considered a chemically clean plate. The job seemed hopeless but I stuck at it.

One day Professor Vogel walked over to me and said, "Are you still cleaning glass? What's the matter?" I told him what I had been trying to do.

He chuckled and said, "Man, what you have been trying to do is impossible. Let me see the glass you're cleaning." He looked at it and said: "Why, that's perfectly clean."

I looked at him amazed and said, "But I don't think it's clean in the sense I understood you to say it had to be clean."

Then he said, "Why, you'd have to live in a hermetically sealed room which would have to be chemically clean in order to accomplish what you're after. You have taken me too literally."

So I flowed the collodion on my piece of glass, and finally dipped it into the silver bath in order to sensitize it.

In due time I was taken into the studio by the professor and shown how to focus (this I learned very quickly). I was to photograph a plaster cast of the head of the Apollo of Belvedere, draped in part with a black velvet focusing cloth.

I had been shown how to experiment with pulling curtains—there had been curtains everywhere, so it seemed to me—so as to control the lighting of the object I was to photograph.

Hermann Wilhelm Vogel, *Plaster Cast of the Bust of Apollo Belvedere*, n.d.
Reproduced in Vogel's *Handbook of the Practice and Art of Photography* (Philadelphia, 1875).

I began a series of experiments lasting for weeks—I don't know how many weeks—trying to photograph what I called that "damned plaster cast," draped with black velvet, but never seeming to get a negative that I thought of any value, when the professor again appeared and said, "What are you doing now? Still cleaning glass?"

I told him of my troubles—that I didn't seem to be able to get a negative in which there was any relationship between the white plaster and the black velvet.

He said, "My God, man, don't you know that what you're trying to do can't be done—that photographing is a compromise."

I do not think I had heard the word compromise before in my whole life. I really didn't understand. He saw that I did not and then he explained what he meant—that is, that I could not get the modeling in the whites and at the same time any details in the black velvet. I'd have to choose what I wanted to do.

He went away and I wondered why I was fooling away my time with the wet process, as I had seen one of the students a week or so before using a camera with a newly introduced dry plate process. These plates could be bought in the open market.

So I went to the student, inquired where he had gotten his camera, and about the dry plates. Nothing was laid out for one at the Polytechnic. One could work as one wished. One was free. So I acquired a camera (and a more beautiful one never has been made) and got the necessary dry plates and instructions how to use them. The size of the negative used for the camera was thirteen by eighteen centimeters.

I began working along my own lines and was having a grand time. It was all tripod work. There were no shutters, no snap-shots. It was quite some years before Eastman existed.

I finally devoted most of my time to photographing. I gave up mechanical engineering in order to devote myself not only to the question of photographing but to finding out what photography meant in the social scheme of things.

In England amateur photography was flourishing. There was virtually no such thing in Germany. I might say that I was the first amateur photographer in Germany.

I sent my work to England and received recognition there at once. Artists in Germany, in Berlin and Munich, saw prints of mine and offered to give me paintings and etchings in exchange for prints. I didn't want etchings or paintings. I gave the prints away.

FROM *Twice A Year* I (FALL–WINTER 1938)

All we know for certain about the date at which Alfred Stieglitz began his photographic studies is that some time during the first half of the 1880s, while he was a student at the Technische Hochschule (technical high school, also known as the "Polytechnic") in Berlin, he received his first instruction in photography from Dr. Hermann Wilhelm Vogel of the school's department of chemistry and metallurgy. In 1899 Stieglitz's friend Theodore Dreiser wrote, "It was in Berlin that Mr. Stieglitz first studied photography. There, in 1885, he was studying mechanical engineering at the Polytechnic School, when Dr. Vogel, of the photo-chemical laboratory, persuaded the young man that a course of theoretical photography would be of great value in his profession." Stieglitz told Dreiser, "The camera always fascinated me; so did chemistry; I began to make mechanical drawings with it, and gradually switched over to the art side." In his *Who's Who* entry in the 1910s, Stieglitz stated that he studied "photo-chemistry and photography" at the Berlin Polytechnic from 1884 to 1888. In the account reprinted above, he dated the beginning of his career to 1883.

The photographic process that Stieglitz first learned from Dr. Vogel was the wet-collodion, a method of making negatives that had been perfected and published by the British sculptor and photographer Frederick Scott Archer in 1851. In the wet-collodion process, a glass plate was evenly coated with a viscous solution of collodion and potassium salts. The plate was then sensitized by immersion in a bath of silver nitrate solution. The exposure had to be made immediately, while the plate was still moist, and the exposed plate had to be developed before the collodion dried—in a maximum of about twenty minutes under normal temperature conditions.

In his course Vogel concentrated on copy photography, especially the making of undistorted copies of blueprints, charts, mechanical drawings, and works of art. In his *Handbook of the Art and Practice of Photography* Vogel lamented that generally in photographs of white sculptures against a dark background "the lights are too white and the shadows are too black." Delighting in technical tours de force, Stieglitz soon rose to the challenge and made several successful images of outdoor sculptures, such as an 1886 photograph of his friend Erdmann Encke's memorial to Queen Louise, in Berlin. The sculptor was the brother of painter Fedor Encke, one of Alfred's father's protégés. When Alfred first went to Berlin, he lived with Erdmann Encke, whom he considered "a very wise man."

Wanting to translate the colors of works of art accurately into tones of black, white, and gray, Vogel devoted himself to the chemistry of photography. In 1873 he invented the first successful orthochromatic plates. Until then, the silver bromide emulsion of the wet-collodion process had been overly sensitive to blue (which recorded as white in

prints) and had tended to darken green, yellow, orange, and red. Vogel, taking advantage of discoveries of the booming German aniline-dye industry, stumbled upon the phenomenon that adding certain dyes to the emulsion extended its sensitivity to colors, though not until panchromatic film became available in 1906 could a red object be photographed clearly against a black background.

Early in the 1880s Vogel was able to apply his method to dry plates, and the manufacture of orthochromatic dry plates began in 1884. Thereafter, Vogel continued his search for the formula that would allow silver bromide to render the entire visible spectrum in an accurate balance of light and dark. For two years Stieglitz spent much of his time assisting the professor in testing new batches of chemicals.

Stieglitz's first dry-plate camera was probably something like the Rochester Optical Company's "New Model" view camera with a collapsible bellows, which first appeared on the market in 1883. It came in two sizes, the smaller of which used dry plates measuring five-by-eight inches, the approximate size of Stieglitz's. Since the camera had no shutter, exposures were made by removing the lens cap. The photosensitivity of the emulsion on the plates was so low that exposures lasted several seconds. The camera's list price of sixteen dollars included a lens, a tripod, a wooden carrying-case, and a plate-holder. For a few dollars more one obtained a supply of dry plates, the necessary chemicals and developing trays, a candle lamp with a ruby canvas hood for use in the darkroom, and an instruction booklet.

A WORD OR TWO ABOUT AMATEUR PHOTOGRAPHY IN GERMANY

It is rather odd to write about amateur photography in Germany, when such a thing hardly exists; and still I venture to say a few words about its future, as it is most certain that Berlin, Germany's center for science, has given it an impetus, which promises to bring forth a host of well-trained workers. Thanks to the munificence of the city, which devoted upwards of £1,000,000 to the purpose, a new technical high school was erected and opened about two years ago. The building is a grand work of architectural art, unsurpassed by any educational institution on the face of the globe, both in exterior and interior beauty, and practicality. It is of enormous dimensions, and the 800 or 900 students who now occupy it are quite lost within its walls, as the building can accommodate 2,000 or more.

Particular attention has been paid to the building of a model photo-chemical laboratory, with the view towards giving the scientific student of every branch such insight into theoretical and practical photography as might prove of value and assistance in his future studies.

The laboratory is, without doubt, a model one in every respect, no expense having been saved in its appointment. It is so arranged that special rooms have been supplied for each process, and by this arrangement confusion is impossible. There is an elaborate studio, five dark rooms (one for the "wet," and three for the "dry" processes, and one for the preparing of gelatine plates); a "finishing" room for the negative process; a room to store away finished plates; three rooms for the printing; a glass shed to print under, in case of storm; *Lichtdruck* [collotype] room, lecture hall, chemical laboratory, etc., etc., all supplied with not only the necessities, but also all the luxuries that an inventive mind could suggest. These rooms are lighted electrically, the Swan system having been adopted.

Professor H. W. Vogel, whose name ranks amongst the first of photo-chemists, is the director and chief instructor. It is due to his untiring efforts

and the interest which he shows for the advancement of his pupils—an example of which is shown in the fact that they are the first to benefit by his many discoveries—that his students make such rapid progress, and turn out some really fine work.

It is needless to say that a great expense is attached to the acquiring of a practical knowledge of photography through unaided experiment. This obstacle has been removed by the providing of systematic courses of instruction by competent teachers, and an opening has been made for the student of limited means to that art to which his tastes directed but his purse opposed. For this reason, the German was forced to remain inactive and watch with envy the progress of his more favored English brothers, and thus the field is open to all who have the desire to enter it. Many have taken this advantage, and amateur photography is now fairly afloat.

One is safe in predicting that the influence of this school will be felt all over Germany, and that those students who come from other parts of the empire and derive the benefits offered in this seat of learning will return home, and, by example, will lead their townsmen to a standard commensurate with the hopes of the founders of this great institution. I hope soon to be able to report the formation of a society for the promotion of amateur photography, the sure sign of its firm hold and rapid advancement!

NOTES

FROM *Amateur Photographer* 5 [LONDON], (FEBRUARY 25, 1887)

In 1885 the Technische Hochschule (technical high school), which Stieglitz was then attending, had moved from downtown Berlin to a new building in the suburb of Charlottenburg. During the late 1880s, the British magazine *The Amateur Photographer*, in which Stieglitz's article originally appeared, was the finest photography magazine in the world—despite the fact that only its occasional "special numbers" reproduced any photographs. Its first issue, in 1884, referred to "the best pictures taken this year by amateurs—which is almost tantamount to saying the best photographs which have yet been produced." The magazine quickly took the lead in propagating the radical assertion that photography was the one art form in which the work of amateurs consistently surpassed that of professionals in artistic quality. That assertion would become the cornerstone of Stieglitz's crusade

for the acceptance of photography as a fine art—with the understanding, of course, that the term "amateur" referred not to a person deficient in skill or in seriousness but rather (acknowledging the derivation of the term from the Latin word for love) to a cultivated person who was dedicated to artistic photography because of a genuine love for the medium. It was no mere coincidence that amateurs tended to have independent incomes, which enabled them to devote much time to their art without having to give a thought to the saleability of their work. It was understood that a professional photographer would generally have to compromise his artistic freedom in order to please his customers.

Stieglitz passionately believed that only within the context of societies, which could provide darkroom facilities and organize exhibitions, could amateurs realize their full potential. In a letter published in the April 1887 issue of the magazine *Der Amateur-Photograph* (Berlin) he wrote of the importance of societies within which amateur photographers could "learn from one another and strive together for the goal of artistic and technical perfection."

The hope that Stieglitz mentioned in the last sentence of the present article was fulfilled later in 1887 with the formation of the Deutsche Gesellschaft von Freunden der Photographie (German Society of Friends of Photography) under Vogel's leadership.

A DAY IN CHIOGGIA

You may think it strange not having heard from me for some time, but since my last, urging you to join me in enjoying the beauties of Venice, I have had an adventure which makes me doubly sorry that you were not here with me to enjoy it.

As usual, an Englishman was at the bottom of it. But stop, I anticipate.

After having been in Venice over two weeks, and having photographed every style of man, woman, and child who would submit to the ordeal, Lou [Schubart] and I started out one bright morning looking for new worlds to conquer.

In the course of our vain search, we wandered up the Merceria (the chief commercial street of Venice), and just as we stepped through the Torre dell'Orologio (Clocktower) a picture struck our eyes. Here was a chance to impale a poor unsuspecting artist, with the Basilica as a background; for the artist, we saw, was busily at work copying the mosaics of the cathedral. Accidentally he turned, and, seeing our purpose, begged us to spare him. This naturally led to a conversation, during which we found, to our delight, that he was an Englishman and thoroughly acquainted with Venice and its surroundings. Being somewhat of an amateur himself, he became interested in our work, and asked us what style of pictures we were looking for. We told him that we were tired of landscape and architecture, and that we were hunting around for genre pictures and studies from life. "Haven't you been in Chioggia? That's the very paradise for such studies." We replied in the negative, and we thought that an involuntary smile crept into the corner of his mouth. It's never too late to mend, and, thanking him for his kind advice, we hurried off to the landing, which was close by, and found, to our delight, that a steamer would leave at daybreak the following morning. We went at once to our hotel to prepare for a good day's work. Who do you think was waiting for us at the hotel? F. S. H. [Frank Simon Herrmann], the Munich artist, and I need not tell you that he decided at once to join our party.

All three of us started off in the morning, [Herrmann] armed with his sketchbook and water colors, to be ready to make a few hasty sketches, and we with

our cameras. It was quite dark as we got on the boat, but soon it began to dawn, and we waited with anxiety to see whether Nature had a fine day in store for us. Luckily, it left nothing to be desired, and the day was such a one as could only be enjoyed in Italy. We proceeded on our course, passing through a rather tortuous channel, lined on both sides by mud banks, which, at low tide, were anything but picturesque; then into the broad lagoon, passing under the frowning guns of an immense war-ship which lay at anchor, we began picking our way through a fleet of little fishing smacks. At last the boat stopped at a rude dock, and we were greeted with the information that we were in Chioggia.

The first impression was not that we had struck paradise. We stood on the dock surrounded by our paraphernalia in a rather helpless condition, when a little chap, Leone by name, presented himself and offered to act as guide, which offer was gladly accepted. We started at once on our pilgrimage.

We were soon aware that we had after all struck a rich field, and so our cameras were immediately unpacked and shouldered, our little guide and porter carrying the slides.

But before I go any further let me give you an idea of Chioggia. It is hardly more than a village, a sort of miniature Venice, consisting, like the latter, of very narrow streets, canals, and numberless bridges. But there is a marked difference in the people of these two places, for Chioggia is inhabited only by fishermen and their families, a picturesque but rough and unsociable set of people. The architecture of the city offers no great attraction—the only charm of the place lies in the characteristic appearance of its people. Coming to a wide open place, we determined to photograph our guide, which operation caused not a little excitement in the crowd which followed us, and which was constantly on the increase, and, oddly enough, at every turn we found models awaiting our arrival and posed according to their own ideas in a most picturesque attitude. We came across a little fellow sitting outside a shoemaker's shop, mending a shoe quite as big as himself. This was a picture, and we didn't hesitate to take it.

During the rest of the day we were struck with the number of small boys mending shoes in Chioggia, where most people run about barefooted!

Following our little guide, we passed through many very narrow streets, on both sides of which unusually tall houses built in the peculiar style of nearly approaching one another at the top, and thus shutting out the light, and making it impossible for us to take any of the charming and original groupings and

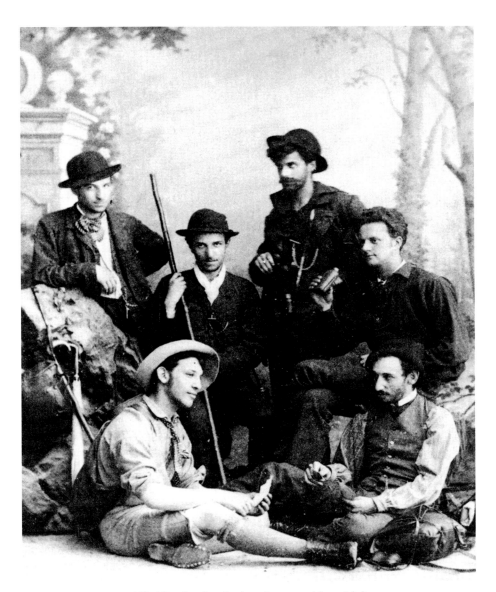

Alfred Stieglitz, Stieglitz (standing, second from right),
his brothers and his friends about to set off for Italy, Bavaria, 1887

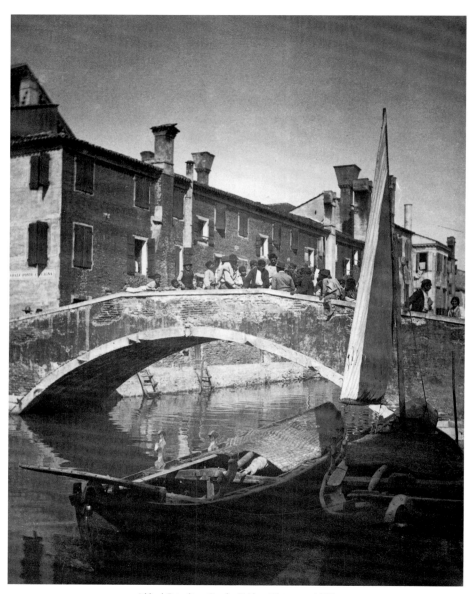

Alfred Stieglitz, *On the Bridge*, Chioggia, 1887

studies which gladdened our eyes and hearts. Oh for a flash-light, that we might photograph some of the scenes, of which we could, alas! make but mind pictures. It was in one of these alleys that we met Fiametta, a pretty Chioggian market girl. You will notice that she wears a characteristic dress, that is, an apron worn at the back instead of in the front, as our ladies wear them, and which can be drawn up over the head, thus protecting the wearer from the burning sun, when she has occasion to pass through the open marketplace.

Passing out of these dark alleys, we came to the chief canal of the place, and as we approached a bridge to cross it, we noticed a crowd of people who seemed unusually excited. Imagine our surprise to see our Munich friend in the midst of the crowd, vociferously gesticulating, and showing unmistakable signs of anxiety. We thought that he had gotten into trouble with the people, and hastened to his assistance, but we were happy to find our fears ground-less, and amused at the spectacle of his trying to speak the Chioggian dialect, when his whole knowledge of the Italian language lay in the expression "Niente." He tried to cover his embarrassment by assuring us that his object was simply to offer us an opportunity to photograph the bridge after the style of Passini. We had a good hearty laugh at him, but took the picture, the idea having been an excellent one.

We instructed our guide to take us to the best trattoria in the place, upon which his eyes grew very large, and he started off with alacrity. In order to avoid the heat, he led us through shady streets and fine archways, under one of which sat a man selling fruit. We patronized him at once, and found to our sur-prise that he was the father of our little guide. We photographed him, and I send you a copy, in order to show you how very quickly a man grows old in this place, as he assured us that he was but thirty years of age, and that Leone was his eldest child. At length we reach our haven of rest, and the host, who seemed to have been warned of our approach, stood at the door to receive us. He spoke French, and became most confidential, telling us all his trouble, and introducing us to his eldest daughter, whose features, though not as beautiful as they were interesting, showed distinctly that other than Chioggian blood flowed through her veins. After having very much enjoyed our macaroni and chianti, we took a short walk on the sea wall, where we saw some fishermen mending their nets and a great many of those little fishing smacks with their quaintly colored and decorated sails. These sailors showed a decided dislike to

being photographed, for as soon as they saw that our cameras were directed at them, they drew in their sails; however, with a little persuasion and some lires to back it, we at last succeeded in catching several of them. At the sight of the money all the sailors who had before hastily taken in their sails immediately hoisted them again, and only now it became clear to us why we had seen so many boys apparently mending shoes during our morning's round!

It was now approaching the hour for our departure, so we started to return to our host and settle up accounts. As we approached the house, a very striking picture met our eyes. Upon inquiry, the landlord told us that the girl whose picture we had just taken was his youngest daughter, who had been enticed away from home, and had but shortly returned, filled with remorse, yet still carrying in her heart the picture of her lover, and dreaming over again the only romance of her life.

NOTE—I used a Steinheil Aplanat [lens], 19 ins., for all the pictures, and isochromatic plates, about 18 Warnerke.

The work, from focusing to the burnishing of the finished prints, is all my own.

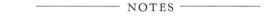

—————— NOTES ——————

FROM *Amateur Photographer* [LONDON], PRIZE TOUR NUMBER (JUNE 1889)

Before leaving Germany for New York in July 1888 to attend the wedding of his sister Flora, Stieglitz spent more than two weeks in Venice with his friend Lou Schubart (who would later marry Alfred's sister Selma). They were joined there by Frank Simon Herrmann, nicknamed Sime, who had been a classmate of Stieglitz's in New York. During vacations from the Technische Hochschule, Stieglitz often visited Herrmann in Munich, where he was studying painting. During the summer of 1887 Alfred, his brothers Leopold and Julius, and his friends Lou Schubart and Joseph Obermeyer had rendezvoused with Herrmann in Munich for a walking tour of northern Italy that took them as far as Venice.

Stieglitz's 1888 photographs of Chioggia, which covers several small islands at the southern end of the Venetian lagoon, garnered the third prize that year in *The Amateur Photographer*'s annual holiday tour competition. Among the surviving images is a fine one (*The Stones of Venice*, a title borrowed from John Ruskin) showing a woman on the steps of the harborside Ponte Vigo. The proto-cubistic composition of another, a study of fishing boats moored beside the Ponte del Cucagna, strikingly anticipates—by nineteen years —that of one of his most famous photographs, *The Steerage* (1907).

Alfred Stieglitz, *The Stones of Venice*, Chioggia, 1887

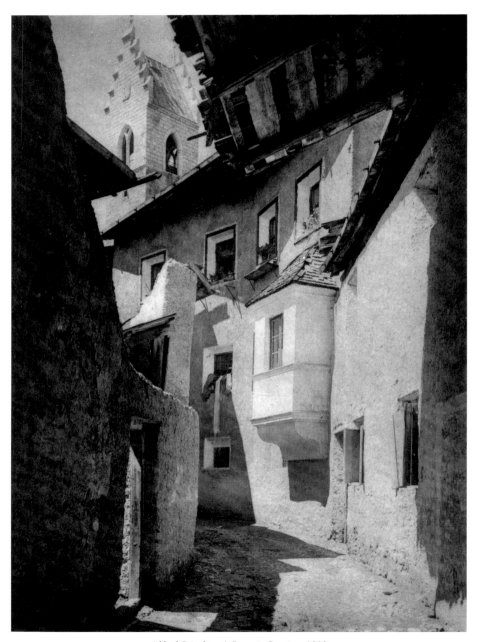

Alfred Stieglitz, *A Street in Sterzing*, 1890

CORTINA AND STERZING

After a severe and long term of experimental laboratory work, I managed to get a few days of vacation in order to take a run down to that picturesque and at the same time grandly-situated village, Cortina, the headquarters of mountain tourists in the Ampezzo Valley.

It was in the month of August that I left Vienna for the trip, and the chances of fine weather were in my favor. But, alas! I had hardly reached the mountain district when overtaken by a cyclone, which lasted two days. The trip to Cortina was therefore a long and unpleasant one, and my heart was heavy with the prospect of having to return to Vienna without having exposed a single plate, and, worse than that, without having seen anything but a thick mist, which hid even objects but ten or fifteen feet off. Half dead and disconsolate, I arrived in Cortina late at night, stopping at the Albergo Tre Croce, a first-class inn, especially frequented by mountaineers. After a good night's rest I hurriedly arose, and took a peep through the blinds to know whether the weather had changed for the better. Alas! it still rained in torrents, and the prospects were as grey as the weather. The host tried to cheer me up with the certainty of fine weather within a week! Fine irony on his part probably, but not appreciated by his humble servant, who felt more like knocking him down than smiling at his gracious consolation. The morning was spent in reading up the latest numbers of the *Amateur Photographer*, which had followed me from Vienna, and getting my camera and slides ready in case of—No, that would be too much good fortune, and I did not dare think of it! And still, after dinner, there was a glimpse of hope; the rain had ceased, and the clouds began breaking. Away I rushed with my camera, inasmuch as I wanted one picture at least. What a delightful spot of earth! Picturesque and grand at the same time. The sun having come out in full force, I was enabled to get a fine view of the village of Cortina. A few steps beyond that point a second view struck me, which seemed particularly beautiful.

Toward evening a third picture was procured in a private garden, charmingly situated, and especially beautiful on account of its extreme quietude. In

the evening the three plates were developed, and as all of them turned out to be first-class, the photographer was a happy man. At 5 A.M. the following day the camera and myself took a run over to Lago di Misurina, about two hours distant, a magnificently situated lake, surrounded by gigantic mountains, grand in their outline. The light was somewhat too glaring to get a view of the lake, but I managed to get a fine view of some of the mountains, which were about three miles distant from where I stood. Returning to Cortina, I met a crowd of peasants working in the fields, the result, which gives one an idea of the beauty of the surrounding country.

Another characteristic of the place is the number of pumps in the streets—pumps with immense basins, in which the women wash their linen, dishes, etc., etc. No washing is ever done in a house there. The pumps are surrounded by sketchers and painters, who find a gold mine in them for their sketch-books and canvases. That same afternoon the sky became overcast once more, and rain looked like a certainty. I managed to get a bit of the place, which is certainly a picture, and the print enclosed gives exactly the effect seen in nature.

At 9 P.M. the stage-coach was off for the railway station (six hours' drive), and the writer of these lines was comfortably and snugly placed in one of the four corners, ready to go off to sleep at a moment's notice and dream of the gold medals which would be awarded those treasures stored away in the boxes labeled *Open only in red light*.

The following morning was bright, and no trace of rain was to be seen when I arrived in Sterzing, a small quaint village situated near Franzensfeste. Having heard of the queer streets in that place, I determined upon "skipping" a train, and taking a look around. The streets are exceedingly picturesque, and the houses are the queerest bits of architecture my eye ever struck. The interiors would be a real "strike" for painters like Defregger and Grützner.

Unfortunately I had no flash light with me, and it was much too dark to try to photograph the interiors without; hence that pleasure was postponed for some future date. Upon my way to the train I passed through a street (!) remarkable for its width.

All my photos were taken with a Steinheil Aplanat, 19, on orthochromatic plates, without a yellow screen.

N.B.—It is my firm intention to go over the ground mentioned above again as soon as an opportunity offers itself, and I can but recommend my photographic friends to try the same, and they will surely be obliged to

ALFRED STIEGLITZ, New York

NOTE—*The paper used for prints 2, 5, 6, 7, 8, is a new one, and not in the market yet. The red tone may not please everyone, but my artist friends consider it "fine," especially for certain effects.*

——————— NOTES ———————

FROM *Sun Pictures from Many Lands.*
LONDON: AMATEUR PHOTOGRAPHER, 1892

In the spring of 1890 Stieglitz went to Vienna to undertake what he calls in the first sentence of this article "a severe and long term of experimental laboratory work" at the recently founded (1888) Graphische Lehr- und Versuchsanstalt (Graphic Arts School and Research Institute). This national printing and photography school was headed by Josef Maria Eder (1855–1944), at that time one of the world's foremost photographic chemists. In 1884, simultaneously with Vogel, he perfected an orthochromatic emulsion. That same year he published his *Comprehensive Handbook of Photography*, updated editions of which would remain in print for fifty years. In 1889 he discovered that by adding sodium bisulfite to a fixing bath, he could prevent the swelling of the gelatin emulsion that caused reticulation on the surface of dried prints.

In August 1890, seeking a change of pace and picturesque scenery, Stieglitz traveled by train to the northern Italian village of Cortina d'Ampezzo, now a fashionable ski resort, in the Ampezzo Valley of the Dolomite Mountains.

When Stieglitz states his regret that he had no "flash light" with which to photograph inside houses in Sterzing, he was referring to the technique, developed in Germany in 1887, of placing a quantity of magnesium powder in a hand-held apparatus and igniting it to produce a blinding flash and a cloud of acrid smoke. The names of the painters Defregger and Grützner, whom Stieglitz mentions as specializing in canvases of quaint interiors, have long since disappeared into probably well-deserved obscurity.

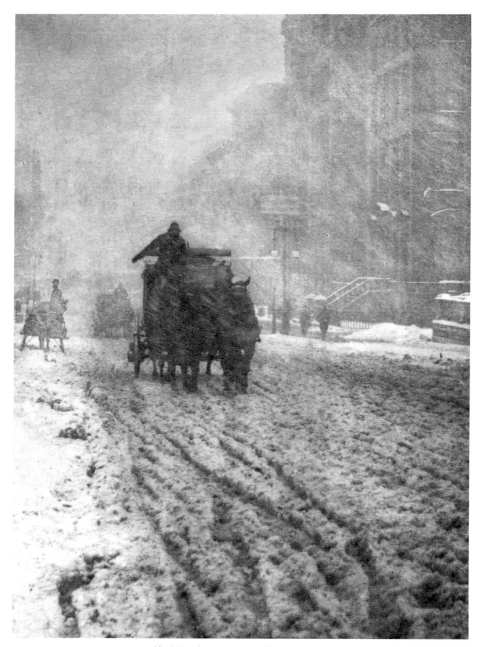

Alfred Stieglitz, *Winter—Fifth Avenue*, 1893

from
NOTES MADE BY STIEGLITZ

In 1890 when I returned to America I found that photography as I understood it hardly existed; that an instrument had been put on the market shortly before called the "Kodak" and that the slogan sent out to advertisers read, "You press the button and we do the rest." The idea sickened me.

There was the shooting away at random, taking the chance of getting something. To me it seemed rotten sportsmanship. I had been brought up with the idea of the tripod and awaiting one's moment to do what one willed to do.

I had walked day in and day out for months through the Tyrol and Switzerland and upper Italy with thirty pounds of camera and 18-by-24-centimeter plates on my back. Before I had ventured to expose a plate I had to feel sure that I'd get a result. There was nothing haphazard about it.

So the "Kodak" and all it represented did not tempt me. As a matter of fact, I was very unhappy in my own country. My yearning for Europe was constant.

Finally one day I met a middle-aged stock broker by the name of W. B. Post who had just returned from Nassau. He showed me some four-by-five prints he had made. I was amazed. They were beautiful.

Post showed me his camera, a box affair with camera inside—that is: a ground glass, a bellows, a lens—and a shutter that cost about fifty cents. There was a finder in the lid of the box and an opening in the box for the lens—to look through—and an opening in the back of the box for one to be able to look at the ground-glass—and there were as many plate holders as one cared to have. Plates were used.

He asked me if I did not want to try out his camera. The temptation was too great to resist. I had certain things in mind that I knew could not be done with the large camera and tripod.

So in 1892 [1893, ed.], in February, there was a great blizzard. I loved snow, I loved rain. I loved deserted streets. All these seemed attuned to my own feeling.

During the blizzard I stood at the corner of Thirty-fifth Street and Fifth

Avenue with Post's hand camera. I had been watching the lumbering stage-coaches appearing through the snow: the horses, the drivers, the driving snow—the whole feeling—and I wondered could what I felt be photographed.

The light was dim—at that time plates were "slow," and lenses were also "slow," but somehow I felt I must make a try. Wherever there was light, pho-tographing was possible. (That is what I had discovered in 1884 in the cellar of the Polytechnic when I made a photograph of a still dynamo lighted by a sixteen-power electric bulb, exposing over twenty-four hours and getting a perfect negative. That was an event that took my professor's breath away when he heard what I had done.)

Yes, where there was light there was the possibility of making a photo-graph. Finally I ventured to make a photograph of the blinding snow and the stagecoach with its horses and its driver coming towards me.

I went to the Society of Amateur Photographers, of which I was a mem-ber, and developed the negative. I was terribly excited. I showed the still wet negative to the men. They all laughed and said, "For God's sake, Stieglitz, throw that damned thing away. It's all blurred and not sharp."

And I replied, "This is the beginning of a new era. That negative is exactly what I want." And when twenty-four hours later I showed them the lantern slide made from this negative there was great applause and none would believe that it was made from the negative which they had told me to throw away.

The next day I walked the streets, and found myself before the Old Post Office. The Third Avenue street railway system and the Madison Avenue car system had their terminals down there.

Naturally there was snow on the ground. A driver in a rubber coat was watering his steaming horses. There seemed to be something related to my deepest feeling in what I saw, and I decided to photograph what was within me.

These two pictures, *Winter—Fifth Avenue* and *The Terminal (The Car Horses)*, became internationally famous. They still hold their own and now they are regarded as classics.

I bought myself a camera similar to the one of Post's and then began my series of New York pictures. I had in mind doing one hundred photographs—that is to do one hundred different phases of New York—to do them as supremely well as they could be done and to record a feeling of life as I felt it

and maybe in that way to establish photography in its true position in the realm of plastic expression.

But somehow this series that was clearly in my mind never was fully realized. The struggle for true liberation of self and so of others had become more and more conscious within me and before I realized it I was editing magazines, arranging exhibitions (demonstrations), discovering photographers and fighting for them, etc., etc. In short, trying to establish for myself an America in which I could breathe as a free man.

—————— NOTES ——————

FROM *Twice A Year* I (FALL–WINTER 1938)

Early in 1891 Stieglitz joined the Society of Amateur Photographers of New York (SAP), which had been founded in 1884. The headquarters of the SAP occupied an entire floor of the new Telephone Building at 113 West Thirty-eighth Street. William B. Post, who introduced Stieglitz to the four-by-five camera, was a fellow member of the SAP. He would become a member of the New York Stock Exchange in 1898, but in the early 1890s traveling was his principal occupation. During 1893 he photographed in Maine, the White Mountains of New Hampshire, Nassau in the Bahamas, Texas, California, and Japan.

Because he found it awkward to travel with a large camera and a tripod, Post had bought a medium-sized, hand-held camera. It was probably a Kodak No. 4 Folding Camera, a leather-covered box whose front folded down to provide support for the sliding bellows that connected the lens panel and the plate holder. A version of that model, modified for plates instead of the standard roll film, had been introduced in 1892.

Until he saw Post's work, Stieglitz had always regarded the hand-camera "as a mere toy, good for the purposes of the globe-trotter who wished to jot down photographic notes as he passed along his journey, but in no way adapted to the wants of him whose aim it is to do serious work." Part of his prejudice against the small cameras was due to the misleading advice, universally given, that they could be used successfully only in bright sunlight.

Having been assured that Post's camera was waterproof, Stieglitz stood for three hours (he claimed) in the blizzard that hit New York on Washington's Birthday, 1893. He was waiting for an opportunity to get the shot he wanted of a horse-drawn omnibus. His aim was to capture the feeling—the inward experience rather than merely the outward appearance—of the scene that resonated so powerfully in his own emotions. He considered his picture a symbolic self-portrait, for he felt that the driver struggling up Fifth

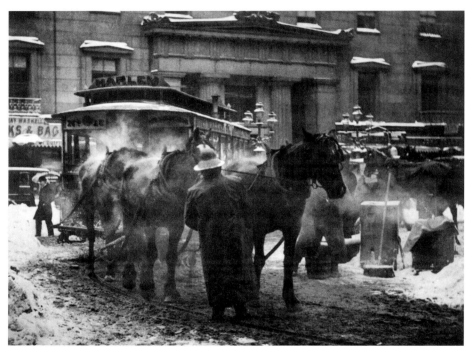

Alfred Stieglitz, *The Terminal (The Car Horses)*, 1893

Avenue against the blasts of a great storm represented his own plight as an artist in a philistine city.

The vertical lantern-slide that Stieglitz first made reduced the overall contrast and cropped off much distracting detail from the left and right sides of the original horizontal negative. But that was only the beginning of his work on this image. Our source is no less than Stieglitz's friend Theodore Dreiser, who was so impressed by Stieglitz's photograph that in his novel *The "Genius,"* published in 1915, he describes a painting by the protagonist that is obviously based on it. Dreiser wrote of *Winter—Fifth Avenue* in an 1899 article about Stieglitz, "Often months of work are devoted to such a picture: not constant, of course, but six or eight hours a week. In this case, the photograph was taken four or five years ago, and only completed a few months since. It had grown to an eleven-by-fourteen print, a gem of art."

On the day after Washington's Birthday, 1893, Stieglitz took Post's hand camera downtown to City Hall Park, the southern half of which was then occupied by a huge post office. Across Broadway was the famous Doric-columned, Greek-Revival-porticoed Astor House Hotel (visible in his photograph), in front of which streetcars turned around to head back uptown to Harlem. Stieglitz's eye was drawn to one of the drivers, wearing a rubber coat and hat, giving water to his horses, from whose bodies steam was rising. Stieglitz, whose love of racehorses extended to their poor cousins, admired the kind tenderness with which this man was doing his job. Feeling sorry for himself, Stieglitz envied the horses for having such a person to care for them. He regretted that the horse-drawn streetcars were already being rendered obsolete, for the first cable cars would appear on the Broadway line later that year. Stieglitz crystallized his emotions in his great photograph *The Terminal*, also known as *The Car Horses*, an extraordinary juxtaposition of the eternal and the ephemeral.

Vol. VII. June, 1890. No. 3.

JOURNAL

OF THE

Society of Amateur Photographers,

OF

NEW YORK.

THE OFFICIAL ORGAN OF THE SOCIETY.

PUBLISHED MONTHLY BY THE SOCIETY.
113 West Thirty-eighth Street,
NEW YORK.

The Journal of the Society of Amateur Photographers of New York, vol. VII, no. 3, June 1890 (cover)

A PLEA FOR
ART PHOTOGRAPHY
IN AMERICA

There is no reason why the American amateur should not turn out as beautiful pictures by photographic means as his English brother across the long pond, and still the fact remains that he does not do so.

Every exhibition in which the two meet proves this statement. "We cannot compete with those English fellows," I heard remarked over and over again at the Joint Exhibition held in New York City last May. And why not? I should like to ask. Have we Americans not the same innate sense for the beautiful? Have we not the same skill to reproduce what we see? Have we not the same material to work with? We have all this, and still look at the difference existing between our work and that of our English cousins. Every impartial observer and unbiased critic will grant that we are still many lengths in the rear, apparently content to remain there, inasmuch as we seem to lack the energy to strive forward—to push ahead with that American will-power which is so greatly admired by the whole civilized world, and most of all, by the Americans themselves.

In what respects are our photographs deficient, more especially when compared with those of our English colleagues? Granting that we are, in our technique, fully equal to the English; what we lack is that taste and sense for composition and for tone, which is essential in producing a photograph of artistic value—in other words, a picture.

When we go through an exhibition of American photographs, we are struck by the conventionality of the subjects chosen; we see the same types of country roads, of wood interiors, the everlasting waterfall, village scenes; we see the same groups at doorsteps and on piazzas; the same unfortunate attempts at illustrating popular poetry; the same etc., etc., ad infinitum.

Such attempts at original composition as we come across are, with some few meritorious exceptions, crude—that is to say, far-fetched and unnatural. In some cases, where the idea is undoubtedly good, the resulting picture

shows an entire lack of serious study of the subject, and suffers from want of that artistic sense which loves simplicity and hates all superficial make-up. Simplicity, I might say, is the key to all art—a conviction that anybody who has studied the masters must arrive at. Originality, hand-in-hand with simplicity, are the first two qualities which we Americans need in order to produce artistic pictures. These qualities can only be attained through cultivation and conscientious study of art in all its forms.

Another quality our photographs are sadly deficient in is the entire lack of tone. Those exquisite atmospheric effects which we admire in the English pictures are rarely, if ever, seen in the pictures of an American. This is a very serious deficiency, inasmuch as here is the dividing line between a photograph and a picture.

Atmosphere is the medium through which we see all things. In order, therefore, to see them in their true value on a photograph, as we do in Nature, atmosphere must be there. Atmosphere softens all lines; it graduates the transition from light to shade; it is essential to the reproduction of the sense of distance. That dimness of outline which is characteristic for distant objects is due to atmosphere. Now, what atmosphere is to Nature, tone is to a picture.

The sharp outlines which we Americans are so proud of as being proof of great perfection in our art are untrue to Nature, and hence an abomination to the artist. It must be borne in mind, however, that blurred outline and tone are quite different things.

The subjects touched upon in these lines would well bear a more detailed treatment, and, in consequence, more space than is customary to claim in an annual like the *Photographic Mosaics*.

I sincerely hope, however, that these few remarks, such as they are, will give rise to further thought by my American colleagues.

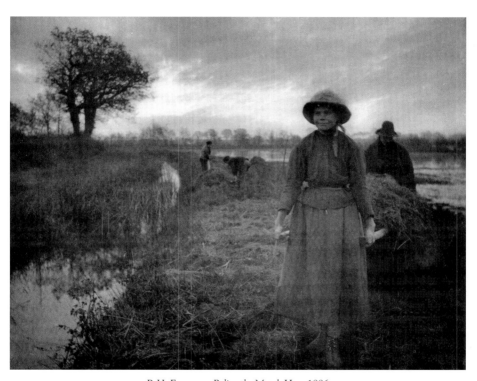

P. H. Emerson, *Poling the Marsh Hay,* 1886

FROM *Photographic Mosaics* 28 (1892)

Since 1887 the Society of Amateur Photographers of New York (SAP) had collaborated with the Photographic Society of Philadelphia and the Boston Camera Club to mount a Joint Exhibition every spring (except 1890), rotating among the three cities. The aim of these exhibitions, the only ones in the United States of more than local interest, was to promote the "artistic, scientific, and technical excellence of Photography." Participation was not limited to the membership of the three societies; photographers from all over America and from abroad submitted work. All of the hundreds of entries were hung, and a jury awarded silver medals to outstanding work in dozens of categories.

At the Fourth Joint Exhibition, held at New York's Fifth Avenue Art Galleries in the spring of 1891, Stieglitz was one of only three members of the SAP to receive a medal. Discouraged and embarrassed by the state of American photography, he penned "A Plea for Art Photography in America."

Stieglitz strongly felt that the British, who were developing the principles laid down by Peter Henry Emerson in his book *Naturalistic Photography* (1889), despite that eccentric's recantation (in 1891) of his theory of photography as art, were the greatest photographers in the world. The finest of the British works were, in Stieglitz's view, not simply photographs but pictures, a distinction he emphasizes in the present essay.

Early in his career, until about 1907, Stieglitz generally used the word "photograph" to mean any image that had been made by means of a camera. In his vocabulary that word was often pejorative, referring to an image with no artistic value. On the other hand, when he spoke of a particular photograph as a "picture" he meant that it succeeded as a work of art. This is a British usage of "picture," and the *Concise Oxford Dictionary of Current English,* for example, still gives as the first definition of the word: "a painting, drawing, photograph, etc., esp. as a work of art." That usage gave rise to the term "pictorialist," referring to photographers as artists and to photographs as works of art.

When, in this article, Stieglitz denigrated "sharp outlines" as "untrue to Nature," he was upholding P. H. Emerson's technique of "differential focusing," according to which "the principal object in the picture must be fairly sharp, just as sharp as the eye sees it and no sharper, but everything else, and all other planes of the picture, must be subdued ... slightly out of focus."

THE PLATINOTYPE PROCESS
AND THE NEW YORK AMATEUR

It is really remarkable how very few of my colleagues ever attempt to use the platinotype printing process for their work. Probably not one in five hundred uses it in this city, while in Philadelphia it is in general use for all fine work. For exhibition work it is indispensable, and the sooner the New York amateur makes up his mind that, in order to compete successfully with the Englishman, or even with the Philadelphian, in the large exhibitions, he will have to discard all albumen-paper, glazed aristotype (that bête noir for every fine-feeling eye), etc., and turn to either kallitype paper, or still better, to that prince of all processes, the platinotype. The latter being beyond a doubt a permanent process, it is preferable to the kallitype, inasmuch as the permanency of the latter is questionable. Personally I do not believe it permanent, although more so than bromide paper.

I willingly grant that 99 percent of the negatives produced by the "camera artists" ought to be printed on a most non-permanent process for the sake of coming generations; but such pictures have no business at a large public exhibition—hence we need not consider them.

The majority of New York amateurs seem to be under the erroneous impression that the platinotype process is one of extreme difficulty, and hence, with his usual "go-ahead" spirit, he prefers not to tackle it.

In my humble opinion, it is not only one of the two (platinotype and carbon) finest printing processes we have, but undoubtedly the simplest and quickest.

My method of working is as follows: I always print in the sun, exposing the paper until the whole image, with the exception of the highlights, is faintly visible. For an ordinary negative that means from two to five minutes, between the hours of ten and two, at this time of the year [i.e., springtime]. The print is then developed by drawing it, face down, slowly over the surface of a boiling solution of—

$$\text{Oxalate of potassium} \ldots \ldots \ldots 100 \text{ parts}$$
$$\text{Water} \ldots \ldots \ldots \ldots \ldots \ldots 300 \text{ parts}$$

avoiding air-bubbles, or even immersing it entirely in the same for about ten seconds, the picture by that time having been fully developed. It is then plunged, without intermediate washing, successively into three baths of acidified water—

$$\text{Water} \ldots \ldots \ldots \ldots \ldots \ldots 100 \text{ parts}$$
$$\text{Hydrochloric acid.} \ldots \ldots \ldots \ldots 1 \text{ part}$$

for about four minutes each time, in order to eliminate any traces of iron left in the paper.

After the print has passed through the last acid bath, it is washed for few minutes in running water, and then dried.

Now this does sound as if the process were not very simple and quick after all; and yet let me assure you that many of my prize photos, all of which are still in as perfect condition as on the day they were made, were turned out inside of fifteen minutes, including printing, developing, fixing, washing and mounting!

Try the process. It will be a revelation to every careful and earnest student of the photographic art who has not given it a fair chance.

In order to secure good results, fresh paper from Willis & Clements, Philadelphia, is necessary.

In the near future I hope to be able and let the readers of the *American Amateur Photographer* have the formulas, so that they may be enabled to sensitize their own paper, if desirable.

NOTES

FROM *American Amateur Photographer* 4 (APRIL 1892)

P. H. Emerson had maintained that platinotype and photogravure were the only two processes suitable for serious artistic photography. Stieglitz followed his lead, though adding carbon printing to the élite processes. Glossy silver-gelatin paper was especially stigmatized as the choice of crass professionals and of snapshooting hobbyists.

Platinum prints (platinotypes) are often made on the handmade, textured rag paper

American Amateur Photographer, vol. V, no. 9, September 1893

that artists use for watercolors. Because there is no shiny gelatin emulsion, the resulting matte image seems to be imbedded in the surface fibers of the paper. Although the prints generally lack intense whites, they are prized for their rich, velvety blacks and for their sensitivity to subtle gradations throughout the entire range of grays.

Depending on the formula and temperature of the developing solution, the grays and blacks in a platinum print will be cool and purplish, warm and brownish, or something in between. The warmer the developer, the warmer the tones. Uranium toning can yield reddish, greenish, or bluish prints.

An Englishman, William Willis, Jr., invented the platinum process in 1873. He came to America in 1877 and, two years later, joined with his compatriot Alfred Clements to establish the Platinotype Company, in Philadelphia, to manufacture ready-to-use platinum paper. Today, printers must make their own platinum paper from scratch, mixing and applying the chemicals themselves, as Stieglitz and his most serious contemporaries did by choice.

Unlike silver salts, platinum compounds are not affected by light; the process depends upon the fact that the composition of certain iron salts is altered by the action of ultraviolet light in proportion to the length and intensity of exposure. The photographer sensitizes the paper by brushing it evenly with a solution of ferric oxalate and a potassium compound that contains platinum. Stieglitz and his contemporaries printed in sunlight, whose ultraviolet rays change the ferric oxalate to ferrous oxalate.

It is nearly impossible to make platinum enlargements, since a normal enlarging lens filters out ultraviolet light. Platinum paper is usually printed in contact with the negative, which must, therefore, be the size of the desired image.

When the exposed paper is placed in a developing solution of potassium oxalate, the chemical reaction causes the precipitation of pure platinum powder, which is black, though platinum used in jewelry is silvery. The paper is then washed with dilute hydrochloric acid to remove iron and potassium salts, thus leaving on the paper deposits of platinum, the varying densities of which create the image. Since platinum is one of the most stable of all metals, a platinum print is as permanent as the paper on which it is made.

Carbon printing, one of the other techniques mentioned by Stieglitz in his article, used pigment and a hardened bichromate emulsion to yield sharply defined images. The process was patented in 1864 by an Englishman, Joseph Wilson Swan, who manufactured paper that was coated with an emulsion of gelatin, bichromate, and carbon black— though any other pigment could be used to make the print whatever color the photographer wished.

The kallitype process was quite similar in principle to the platinotype, except that the former produced an image composed of metallic silver rather than platinum. A newly-made kallitype print can be difficult to distinguish from a platinum print, though with the passage of time the metallic silver of a poorly washed kallitype may react with chemical

residue and darken. The process was perfected and named in 1889 by Dr. W. W. J. Nichol, a chemistry professor in Birmingham, England. In ancient Greek "kallos" means beautiful.

Aristotype paper, which became available commercially during the 1890s, was coated with an emulsion of gelatin (or, less commonly, collodion) and silver chloride. Aristotypes "printed out" during exposure to light, producing a visible image without any need for development in chemical solutions. Aristotypes, which were often toned in a bath of potassium chloroplatinate and/or gold chloride, tended to look like slightly glossy platinotypes.

Albumen printing paper, invented by Louis-Désiré Blanquart-Evrard in 1850 and generally used to make prints from wet-collodion negatives, was the predominant printing medium from the 1850s through the 1880s. The paper was coated on one side with a mixture of beaten egg white (albumen) and ammonium chloride or common salt (sodium chloride), sensitized with a solution of silver nitrate.

Albumen paper, which was not sensitive enough to use for making enlargements, was placed in contact with the negative in a printing frame and exposed (in those days before electricity) for at least ten minutes—and sometimes for as long as an hour, depending on the available sunlight. Like Aristotype, albumen paper "printed out."

Albumen prints are smooth and slightly glossy, with superb clarity of detail and extraordinarily subtle gradations of tones.

In 1879 J. W. Swan, the inventor of carbon printing, perfected a paper coated with an emulsion of gelatin and silver bromide, which had to be developed after exposure in order to reveal the latent image. During the 1880s, when Stieglitz began his studies in photography, bromide paper became available commercially and was soon established as the standard for commercial black-and-white prints. With the invention of powerful electric light bulbs, bromide paper was sufficiently photosensitive to permit enlargements of virtually any size. Swan himself contributed to this progress, for in 1880 both he and Thomas Edison, independently, developed vacuum light bulbs.

THE JOINT EXHIBITION
AT PHILADELPHIA

According to the agreement between the Boston Camera Club, the Photographic Society of Philadelphia and the Society of Amateur Photographers of New York, these societies alternate every year in holding an international exhibition of photographs. These exhibitions have become a most important event in photography every spring, and all interested in the progress of art by means of photography always look forward with the keenest interest to them.

The sixth of these annual joint exhibitions has just come to a successful conclusion at the Pennsylvania Academy of the Fine Arts in Philadelphia. It was, without doubt, the finest exhibition of photographs ever held in the United States, and probably was but once excelled in any country. I refer to the memorable exhibition of photographs held at Vienna several years ago, when no picture was accepted unless passed on by a board of judges, who judged the pictures as such only—that is, as works of art. Everyone remembers how but fifteen percent of all pictures submitted were accepted and hung, and that every one of the six hundred pictures on the walls had been passed upon as works of art by a board of artists, including many celebrated names.

This year's exhibition undoubtedly was a revelation to the American public, and the English work shown clearly proves that works of art can be produced by means of a camera. But of this later on.

In all there were nearly two hundred exhibitors, showing about eighteen hundred pictures. That the exhibition was of an international character is shown by the fact that Great Britain was represented by fifty men; Japan, five; Australia, one; India, one; Germany, two; Switzerland, one; Society of Philadelphia, thirty-five; New York Society of Amateur Photographers, thirty-seven; Boston Camera Club, nineteen; etc., etc.

The management of the exhibition, the lion's share of which fell upon Mr. [Robert S.] Redfield's shoulders, was well-nigh perfection. It is without doubt

that the great success in collecting the choicest foreign work is entirely due to his untiring energy and zeal in working for the cause of the improvement of art photography. The hanging was admirable, every picture having an equally good place, which was due to the superabundance of space at the committee's disposal.

Of course Philadelphia is especially favored in having such a beautiful and spacious place as the Pennsylvania Academy of the Fine Arts to hold its exhibitions. As for the judging, this was done by a competent Board of Judges: Messrs. John C. Browne, Robert W. Vonnoh, Thomas Hovenden, James B. Sword, George W. Hewitt, who, after a week of conscientious hard work made their awards. We are told that the result was not easily arrived at, inasmuch as the standard of work exhibited was so exceptionally high, and inasmuch as the judges were limited to a certain extent in the number of medals to be awarded.

As usual, there will be some dissatisfaction expressed in certain quarters, but unjustly so. The judges did remarkably well, and with but few exceptions all connoisseurs will agree with the result.

As heretofore, Great Britain walked away with a majority of the awards, thirteen medals of the twenty-six awarded going to its representatives. Six went to the Philadelphia Society, two to the Boston Camera Club, and one to the Society of Amateur Photographers of New York, one to Germany, one to Rochester, one to Albany, and one to Yonkers.

Three exhibitors were hors concours: Messrs. George Davison, of England; Paul Lange, of England; and John C. Browne, one of the judges. The work shown by Englishmen is proof positive that we Americans are "not in it" with them when art photography is in question. Where are our Davisons, [Karl] Gregers, [F. de Paula] Cembranos, [Henry Peach] Robinsons, [Frank] Sutcliffes, [J. P.] Gibsons, [Lyddell] Sawyers, [Joseph] Gales? They stand out by themselves in bold relief in the photographic art world; they constitute a class by themselves. We do not approach them, and though once in a while some of us may carry off a prize in an English competition, that does not put us in the same class with them. Our best men would about be at the top of the second class in England. Still, the present exhibition goes to show that we are progressing rapidly, that we are becoming more serious in our work, striving in the right direction, and that many of us display a striking individ-

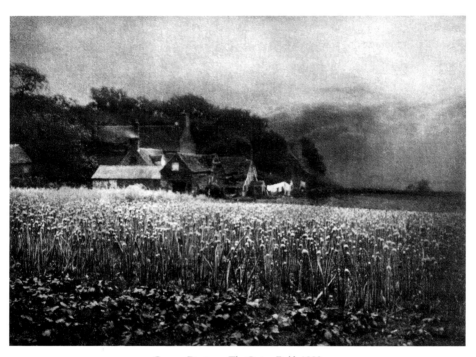

George Davison, *The Onion Field*, 1890

uality, which in time, with the aid of experience and arduous study, will undoubtedly develop into something considerably above second class.

Second class sounds harsh, but the truth is rarely agreeable to those who are trying to fool themselves. The sooner we wake up and acknowledge our inferiority, the sooner we'll get on the right road—the road leading us to the highest standard of work.

This exhibition has also proven beyond a doubt that real works of art can be turned out by means of the camera and plates, and that the days of sneering at our attempts are about over. Of course there were but few pictures shown which were of real art value; still there were some, and that is one tremendous step forward. It proves the possibility of such a thing, notwithstanding Emerson. How many appreciate the enormous benefit that P. H. Emerson has bestowed upon photographic art? Call him by whatever name you may, criticize him from any point of view, and still the fact remains: his teachings formed the basis of what we saw in this exhibition.

EXHIBITS NOT FOR COMPETITION. Of all the work shown, George Davison's, secretary of the London Camera Club, stands in a class by itself. Here we are dealing with a genuine artist. Every one of his pictures is a delight to the eye, a gem in its way. His work is full of individuality, full of power and effect; and the camera, which is used either with or without lens, suiting the purpose, is but a tool in his hands, just as the painter uses his brush, palette, colors, etc. Artists as well as photographers must admire this work. There is only one class of men who criticize it: the "absolutely sharp" imbeciles, who strut about examining pictures with a magnifying glass stuck in their eye, and holding up their hands in dismay when not satisfied with the sharpness of every little line. This class of men is fortunately disappearing very fast. It is the same class that prefers a chromo to a Millet or a Bastien Lepage. They call forth a sort of misplaced pity in us, we being, as a rule, more good-natured than they.

Perhaps the most striking of all Davison's pictures is his *Onion Field*. This picture is world-renowned, and has been medaled wherever shown. If the writer is not mistaken, the picture was taken with a pin-hole instead of a lens, the result being a delightful delicacy of atmosphere. The new school, for Mr. Davison's work is called so, goes in for suggestiveness. Of course these

pictures can only be criticized as such, and not upon the principles hitherto used in criticizing photographs. This point is generally overlooked by the majority: a photograph and a picture have but one thing in common, and that is, as already once mentioned, the tools used. Mr. Davison uses the roughest platinum paper (unfortunately not to be had from Willis & Clements, in Philadelphia), in order to increase the luminosity of the whole picture. The effect undoubtedly is marvelous. Although every one of his pictures is a gem in its way, two of the most striking are undoubtedly *Oyster Boats* (broad masses of light and shade, beautifully balanced) and *Wind-blown*, which is very suggestive and a delight to the eye. Of course it would be folly to advise everyone to try to imitate Mr. Davison. There are many schools of painting; why should there not be many schools of photographic art? There is hardly a right and a wrong in these matters, but there is truth, and that should form the basis of all works of art. The means are but secondary, and whatever the school, whether impressionist, realist, naturalist or call it whatever you may, stick to truth in nature. . . .

AMERICAN MEDALLISTS. Robert S. Redfield (Philadelphia) is without doubt one of the most talented of American photographers. He has an eye for the picturesque and a perfect knowledge of photographic manipulation. *Study of Sheep* is extremely well handled and very delicate, while *Landscape with Cattle* is very striking and quite first class, comparing favorably with much of the English work shown.

Clarence B. Moore (Philadelphia) is represented by a set of pictures, most of which have gained recognition the world over. His work shows a decided improvement over that shown in New York in 1891. His subjects are exceedingly droll, and hence please the general public. He is strongest in depicting negro characters. Some of the attempts outside of this field are rather commonplace, and not worthy of Mr. Moore. Notwithstanding that *The Coming Race* is one of the pictures chosen by the judges, it is a poor piece of work, lacking even in technique. It is sooty in the shadows, and is much too black and white. Mr. Moore himself probably cannot understand the judges' choice. A very good attempt is *A Veteran's Tale: The Assault*. It is too theatrical, though, to be natural. Still it is full of good points and promises well for the future.

Charles R. Pancoast (Philadelphia) is an artist. His work is without doubt

among the very best shown by Americans, the pictures being full of atmosphere, a thing lacking in 99 percent of American work. Atmosphere is absolutely necessary in a picture which claims to have any artistic merit. This is one of the distinctive differences between a picture and a photograph. Mr. Pancoast is equally strong in genre and landscape. A *Letter from Her Boy* is exceedingly natural and sunny, and is full of sentiment. . . .

Miss Emma Justine Farnsworth (Albany) is the only lady who carried off a prize. Every one of her pictures is full of life and artistic quality, bold in conception and execution. Miss Farnsworth is one of the strongest lady amateurs in the United States; taking all qualities into consideration, probably the strongest. Her work is unaffected and full of individuality.

John E. Dumont (Rochester) is easily recognized, inasmuch as there is a sameness about his choice of subjects which is not altogether pleasing. *The Solo* is very beautiful, probably the best thing Mr. Dumont ever did. Mr. Dumont at one time promised great things; he has hardly kept his promise. Still, his work is undoubtedly amongst the very best done here, and holds its own abroad too. There are but few really first-class genre artists anywhere, even in England; that class of work is much more difficult than landscape. No one will dispute that. Most attempts are theatrical and forced.

R. Eickemeyer, Jr. (Yonkers), is a well-known exhibitor. *Gathering Lilies* and *Mistress Dorothy*, the two prize pictures, are clever little pictures. The posing of the figures is good, the composition harmonious. . . .

THE SOCIETY OF AMATEUR PHOTOGRAPHERS OF NEW YORK.
This society was out in full force, thirty-seven of its members being represented. The photographs in the main showed a decided lack of seriousness, and gave an impression as if photographs had been treated as a sport and pastime and not as an art and science. This is to be deplored, for without a doubt the society contains many very talented men, who have been misled and misguided by a non-progressive majority who claim that Americans will never be able to compete with the English, inasmuch as they lack the time and money. Is anything more idiotic? Certainly time and money are of great advantage, still how is it that on an outing hundreds of plates are wasted upon trash, and the exposing, developing and printing of the same is equivalent to time and money.

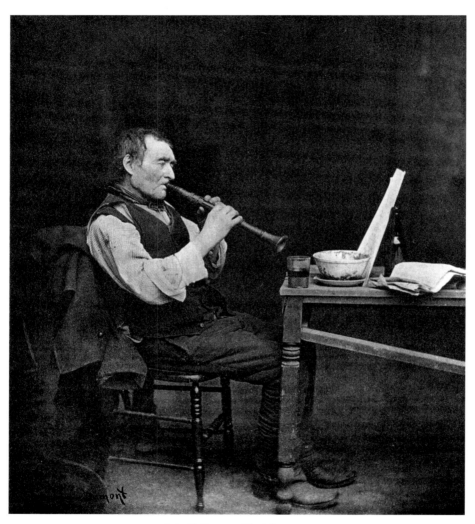

John E. Dumont, *The Solo*, 1899

Rudolf Eickemeyer, Jr., *Gathering Lilies*, n.d.

One piece of serious work a year is worth a hundred thousand random shots. A word to the wise is sufficient. In hand-camera work the society showed up very strongly, and also in slides, Miss [Emilie] Clarkson and Mr. [William B.] Post running the medallists a very close race. Taken as a whole, the work shown was photographically very good, artistically very poor. Of course there were notable exceptions.

W. B. Post is without doubt one of the most talented men in the society. He is an ardent and serious worker, knowing exactly what he wants and bent upon "getting there." He has already gained distinction abroad and at home for his hand-camera work and slides, in both of which branches he excels. His hand-camera work is of high artistic merit, some of the little bits are real gems. Unfortunately the trash hung around the frames of Mr. Post's best work somewhat killed his pictures. The same are extremely delicate and atmospheric.

THE PHOTOGRAPHIC SOCIETY OF PHILADELPHIA. This society is without doubt the foremost in the United States. The standard of their work is high, and they are always initiative in everything progressive in the line of photography. The judges appreciated this fact, and although they may have been a little more lenient with Philadelphians than with others, the society undoubtedly deserves to be congratulated upon its first-class exhibit. The average of the work shown was very fair, not a single member exhibiting really poor work, as many of the New Yorkers had done. Amongst the non-prize winners who showed up boldly were:

Alfred Clements, whose work is always very acceptable technically as well as artistically.

John G. Bullock, a mainstay of the Philadelphia Society, has shown to better advantage in previous exhibitions. Some of his pictures have the same fault as some of Mr. Moore's—they are too heavy in the shadows.

As a closing remark let the writer say that though this review may seem, at times, unnecessarily harsh and severe, he does not believe in praising where praise would be out of place, and that everything written is done in the interest of the advancement of art in photography. Let us look to next year's exhibition in New York with further revelations in store for us from the other side of the water, and a decided step forward in our home productions.

---------- NOTES ----------

FROM *American Amateur Photographer* 5
(MAY 1893)

The July 1893 issue of the *American Amateur Photographer*—that following those in which this two-part review appeared—carried an editorial announcement stating, "[W]e are happy to say that we have induced Mr. Alfred Stieglitz, so well-known both here and abroad for his artistic work, to become an active editor on our staff; with his co-operation we have no doubt but what important improvements in the magazine will be undertaken, which will include, perhaps, a greater number and variety of illustrations. His judgment of the value of photographic work is always good, while his technical knowledge . . . is unsurpassed."

For publication in the present volume, the editor has deleted from Stieglitz's article his discussions of work by many photographers whose names mean little today.

Of the photographers mentioned by Stieglitz, Peter Henry Emerson and George Davison were most important to his own career.

Emerson, one of the greatest photographers of the nineteenth century, possessed an independent fortune and an insatiable appetite for scientific knowledge. He studied physics, chemistry, and botany at Cambridge and went on to earn several medical degrees, though he never practiced medicine. Instead, he devoted himself to making photographs influenced by the paintings of such artists as John Constable and Jean François Millet.

Emerson staunchly believed that if a photographer of intelligence, sensitivity, and character made very direct, spontaneous, and intuitive photographs of nature and of people living and working in nature, the result would be art—as he stated in his book *Naturalistic Photography for Students of the Art,* published in 1889.

In 1890 Emerson had a crisis of aesthetic faith, and in January 1891—much to the chagrin of Stieglitz and his colleagues—he sent to the editors of all the major British and American photographic magazines an announcement that he no longer believed that photography could be considered an art form. Nevertheless, his book remained extremely influential, and Stieglitz remained grateful to Emerson for that beneficent influence.

In an editorial note in the November 1893 issue of *The American Amateur Photographer,* Stieglitz called British photographer George Davison "probably the foremost of living photographers."

Stieglitz admired Davison not only as an innovative artist but also as a founder of the British photographic society that called itself the Brotherhood of the Linked Ring. Organized in 1892, it was devoted to "bringing together those who are interested in the devel-

The Joint Exhibition at Philadelphia 47

opment of the highest form of Art of which Photography is capable." In October 1894 Stieglitz and Rudolf Eickemeyer became the first two Americans to be offered membership in the Linked Ring.

The most important function of the Linked Ring was to sponsor an annual exhibition, the Photographic Salon, in London. At these exhibitions only what the jury selected as artistically outstanding was hung, and prizes and medals were eschewed. Weeding out all the inferior work meant that what remained could be hung tastefully in two or three rows at eye level. In 1902 Stieglitz wrote of the Photographic Salons that their advent in 1893 had "mark[ed] the beginning of modern pictorial photography."

Stieglitz became quite obsessed by his desire for a grand American version of the Photographic Salon, to be held annually in New York. Hanging only work "of artistic value" would, he assumed, force American photographers to do more progressive, pictorial work. Since everyone with any talent would want to be included in the show, they would have no choice but to rise to its standards.

A PLEA FOR A
PHOTOGRAPHIC ART
EXHIBITION

After having patiently watched and closely looked into the various photographic exhibitions of the past few years which were held in the United States, and not having noticed any decided step forward in the management of said exhibitions, it is the writer's opinion that the time has arrived for us Americans to hold an exhibition worthy of the name Art Exhibition. In England, in Austria, in Paris, and everywhere where picture photography has been recognized as an art, exhibitions have been held with remarkable success. These exhibitions have been run upon the strictest lines, pictures were hung upon their merits only, and these merits had to be of no mean order at that.

The writer distinctly remembers how Messrs. Srna, Scolik, Mallmann and others, of the Viennese Camera Club, talked about a Photographic Salon as early as 1889, and how they were laughed at first. But these gentlemen were not to be discouraged by petty sneerers, and, going ahead with the courage of their convictions, they soon had the whole Club interested in the work, and, as we all remember, the Viennese Photographic Salon was a huge success and a triumph for picture photography.

In England this example was soon followed with equal success, and then Paris followed suit.

And we here in the United States! What have we done? We continue upon the same old lines, shrug our shoulders with a self-satisfied air and remark: "That may be all right abroad, but we can never have an exhibition run upon such lines here." Let me tell you that I do not agree with you—that I saw the same shrugging of shoulders abroad—the same dubious smiles—the same self-satisfied air—and still triumphant results! We Americans cannot afford to stand still; we have the best of material among us, hidden in many cases; let us bring it out. Let us make up our minds that we are equal to the occasion, and prove to the photographic world at large that we are awake

and interested in the progress of picture photography. Abolish the joint exhibitions, which have done their work and served their purpose, and let us start afresh with an Annual Photographic Salon, to be run upon the strictest lines. Abolish medals and all prizes; the acceptance and hanging of a picture should be the honor. There is no better instructor than public exhibitions.

Let all of those interested in this matter combine and go to work at once. The editors of the *Photographic Times Annual* will certainly lend a helping hand in this serious matter, and the writer will, with much pleasure, sacrifice time and money in order to bring about a revolution in photographic exhibitions in the United States.

<div align="center">—— NOTES ——</div>

FROM *American Annual of Photography and Photographic Times Almanac for 1895*

When Stieglitz felt that a particular exhibition would advance the cause of artistic photography, he did everything possible to promote it. In the case of the Seventh Joint Exhibition, however, held in New York in April 1894, Stieglitz was annoyed that the names of the appointed judges had been kept secret until the last minute. He decided to boycott the exhibition, and he encouraged others to do likewise. "First class men are rather chary in submitting their pictures to judgment to unknown quantities," he wrote in the *American Amateur Photographer* in the spring of 1894.

Stieglitz's wish for the abolition of the Joint Exhibitions was granted; the seventh was the last. Many photographers were angered by Stieglitz's role in ending what had been a very enjoyable and satisfying annual event. Most members of the three participating clubs did not share anything like Stieglitz's single-minded dedication to photography, nor did they aspire to more than modest artistic distinction. The majority were hobbyists who were pleased to get an occasional good shot, and they wanted an opportunity to show off the pictures of which they were proud. They valued the assurance that their work would be hung, and they liked to have a chance at winning a medal to impress their families and friends. Therefore, they could muster no enthusiasm for Stieglitz's dream of a Photographic Salon, from which they would in all likelihood be excluded, and at which no medals were to be awarded even to those lucky enough to have their work hung.

TWO ARTISTS' HAUNTS
by *Alfred Stieglitz and Louis H. Schubart*

It were an Herculean task for the artist or photographer to find two other places on this vast planet so alike in the great amount of material yet so absolutely different in the nature of what they offer than the lovely southern mountain village Gutach and the cold Dutch sand dunes of Katwyk.

The Black Forest and Holland, Gutach and Katwyk. Two names for the camera-artist to conjure with. The illustrations in this article should give the reader a good idea of the relative values of these two towns as a field for work, yet a short description of the places themselves, the inhabitants, the difficulties which beset an artist; and a few words about the nature of the people one has to employ as models will not be amiss and will be of value to those who wish in future to visit these Golcondas of genre and landscape. Unlike our cosmopolitan America—where the people of every section possess almost the same general characteristics, wear the same dress and resemble each other so closely that one is often in doubt whether a person is from the East or has his home three thousand miles to the West—the inhabitants of each kingdom, each little principality in Europe are characteristic of their birthplace, so much so that it requires but little experience for the traveler to correctly connect a man and his country. The inhabitants of each section have their own dialect, their own idioms, and, what is more important to the photographer, their own costume and physique. The people of the Schwarzwald are small from long years of ploughing and harvesting. Their faces reflect the sunshine of spring and summer and the protection their pleasant homes grant them in the winter; while our tall Katwyk fisherman tells at a glance of his battles with wave and wind. In Gutach, Nature smiles; in Katwyk, she is forbidding and pessimistic.

The stories of the Black Forest are told in fairy tales; those of the North in epic poems and stern dramas.

Gutach lies in the very heart of the famous Schwarzwald or Black Forest,

the lovely woods which make the Duchy of Baden famous, and the inhabitants have taken something of the sunshine and the odor of the pines into their souls, making them cheerful simple natures, ever willing to assist, entering into the spirit of the artist, and the smallest gratuity prompts the willing spirits to long hours of posing. The many artists who frequent this famous town and the fact that it lies far off the beaten track of globe trotters and summer excursionists explains the simplicity and readiness to oblige of these simple people. The town itself offers every possible variety of subject. Mountains, even the snow-clad ones of the Alps in the distance, beautiful vistas in the pine woods, farming scenes—for these people are distinctly agricultural—everything that the artist could desire, and no tall factory buildings with their modern rectangular lines of bricks and windows to disturb, no railroads with smoky locomotives to dim the pure atmosphere, and all these ever changing, presenting a new and varying view at every turn, changing with each season of the year, with every change from lowering storm to noble inspiring sunshine. Trees, flowers, wheat-fields, mountains and valleys, rushing streams and babbling brooks, a waterfall here and there to add variety, willing models in their quaint caps and mediaeval costumes, what more can the artist or photographer desire than unlimited time and an inexhaustible supply of plates and lenses.

The frontispiece, *Happy New Year*, in this number, showing the little girls putting a letter in the box, shows fully the interesting character of the townsfolk, and "From Acorns Grow Mighty Oaks." The old folks on the wheat field were once just such rosy-cheeked children. The thatch-roofed cottage nestling in the woods is not a too romantic casket for these photographic jewels. Katwyk presents an entirely different side of nature, not a whit less interesting, not a whit less beautiful, but differing as the night from the day, as the north from the south. All that I have said of the simplicity of the inhabitants of Gutach and their willingness to act as models, remains true here, and for the same reasons. An hour distant from Amsterdam, the spires of the Casino at Scheveningen within sight, yet as far off as if hundreds of miles separated Katwyk from the capital city of Holland and its most famous watering place. As Gutach lives off its land, Katwyk lives off the ocean. Fishermen and their boats, and the houses built to resist the rude storms, are the themes here on which artists frame their poems, and the people are like the

phase of nature that surrounds them. Immense in stature, hardy, brave beyond belief, stoical from long habit, seeing brother, father, son and husband leave on their perilous fishing trips far out in the North Sea, not knowing when or whether at all they will return, welcoming them with a simple handshake, no embrace, no tender kiss for the returning hero, for hero he is. The homecoming is saddened by the shadow of the next departure with all its risks and all its uncertainties. The boats which these hardy fishermen use look as if they could weather any storm and outlive any of their masters, yet ten years is considered a long life for them and the beach is strewn with what were but a few years ago staunch vessels, built of hardest oak, and ribbed with knots and sinews of steel.

The way these boats are landed on their return is not the least interesting of the many novelties which Katwyk presents to the observer. The strand is constantly patrolled and watchful eyes scan the sea. We observed one man for two long days with spyglass to his eye, standing motionless, trying to pick out on the horizon one particular sail. Who knows what that weary vigil meant to him, but no change of expression told the tale. A sail came in sight, the watcher withdrew to his home—no smile, no expression of relief—that watch was to him, no doubt, one of many. The boats approach; it is high tide; brave men on horseback rush through the surf, far out till only the head of the horse remains out of water. The rider returns with the anchor-rope; he plants the anchor deep in the sand; then strong arms warp the boat as high up on the beach as they can, the tide recedes, and our vessel, with its load of men and fish, lies high and dry. The next tide floats her and she leaves again. So day after day, one unending monotony. The whole village is out of doors to greet the coming fleet, but the men in one group, the women in another—always separate, always serious and silent.

The dunes lie quite high at Katwyk, and from the land side the ocean is not visible. It is on these dunes that the nets are spread to dry, and it is a remarkable sight to see the women outlined against the horizon bending over their work mending the rents. There is one peculiarity about these people which made our work somewhat difficult at first. A superstition exists among them that to have their portraits taken is to sell their souls to the Evil One. A group of women and children seated on the sands gave promise of some fine pictures, but at the first click of the shutter they started to their feet, and

Alfred Stieglitz, *Gutach Peasant Girl*, 1894

with pale and frightened faces left the spot. After that every time they saw us with our cameras they eyed us with suspicion. They willingly, in fact they seem to enjoy posing for the painters who visit Katwyk; and it was only after a friendly artist explained to them that we were not there to make portraits, but to make pictures (even though we used no canvas or colors), that they would allow us to use them in our work. There were, of course, the difficulties which a stranger unacquainted with the language must expect, but these were soon overcome and are not sufficiently important to be dwelt upon.

One of the unpleasant features the photographer has to contend with is the sand storm; and to find one's plate-holders filled with fine sand, the varnish gone from the camera, and the lens barrel polished to an undesirable degree, is not uncommon.

The houses in Katwyk are built to resist the onslaught of the elements, and are small, low and dark, having often but one window, making "interiors" next to impossible; and as running water is not a common luxury, developing is fraught with dangers and difficulties.

When the photographer has made all the pictures he can and has left his work still uncommenced, for Katwyk is inexhaustible, he has but to travel for fifteen minutes to find the green fields, romantic windmills, and shepherds with their flocks, which serve as inspiration for the grand pastoral pictures of Israëls and his followers.

PHOTOGRAPHIC NOTES. The pictures taken during my trip were made with Lumière ortho and Schleussner ortho plates. The latter are probably the more reliable, and are certainly as near perfection as one can wish for. The plates are extremely rapid, and do not necessitate the use of a color screen. Although having various lenses with me, I invariably used the Zeiss anastigmat, 1:7½, with a Thornton-Pickard time and instantaneous shutter. Most of the plates were developed during the tour at night. All my pictures were taken on plates; my experience with films never having been very fortunate.

Alfred Stieglitz, *Scurrying Home*, Katwyk, 1894

Alfred Stieglitz, *Early Morn*, Gutach, 1894

FROM *Photographic Times* 26 (1895)

While he was a student in Berlin during the 1880s, Stieglitz spent an occasional vacation with Wilhelm Gustav Friedrich Hasemann, a close friend of Edward Stieglitz's protégé Fedor Encke, in the picturesque and pristinely non-industrialized Black Forest farming village of Gutach. Hasemann, who specialized in sentimental portraits of peasants, first visited Gutach in 1880 and soon established an artists' colony there. His genre scenes, landscapes, and idealized character studies of farmers became very popular, even in America, and his work was widely known through reproductions.

Stieglitz had such fond memories of Gutach that he included a visit there on his honeymoon trip in 1894. He married Emmeline Obermeyer in December 1893, but they delayed their honeymoon until the following summer and were then accompanied by Lou and Selma Stieglitz Schubart, whose wedding had taken place in 1892. After visiting Hasemann in Gutach, they went to Katwijk aan Zee (which Stieglitz always called Katwyk), a Dutch fishing village that was favored by painters. Alfred's and Lou's old friend and European touring companion Sime Hermann—who was active in Munich throughout the 1890s, painting in an Impressionistic style—was in Katwijk while the honeymooners were there; he may even have been responsible for their visit.

Katwijk was closely associated with the so-called Hague School of painters, whose sentimental realism was very popular in New York and all over Europe. The photographs that Stieglitz made of the people at Katwijk are among the most straightforwardly naturalistic of his early works, owing a great deal to the work of P. H. Emerson. They are, however, tinged with the sentimentality associated with Emerson's bête noire, Henry Peach Robinson, the English photographer known for composing his preconceived tableaux from numerous negatives pieced together.

TWO ARTISTS' HAUNTS.

BY ALFRED STIEGLITZ AND LOUIS H. SCHUBART.

[*Illustrations by Alfred Stieglitz.*]

A GUTACH MEETING.

IT were an herculean task for the artist or photographer to find two other places on this vast planet so alike in the great amount of material yet so absolutely different in the nature of what they offer than the lovely southern mountain village, *Gutach* and the cold Dutch sand-dunes of *Katwyk*.

The Black Forest and Holland, Gutach and Katwyk. Two names for the camera-artist to conjure with. The illustrations in this article should give the reader a good idea of the relative values of these two towns as a field for work, yet a short description of the places themselves, the inhabitants, the difficulties which beset an artist, and a few words about the nature of the people one has to employ as models will not be amiss and will be of value to those who wish in future to visit these golcondas of genre and landscape. Unlike our cosmopolitan America, where the people of every section possess almost the same general characteristics, wear the same dress and resemble each other so closely that one is often in doubt whether a person is from the East or has his home three thousand miles to the West. The inhabitants of each kingdom, each little principality in Europe are characteristic of their birthplace, so much so that it requires but little experience for the traveler to correctly connect a man and his country. The inhabitants of each section have their own dialect, their own idioms, and, what is more im-

AT ANCHOR, KATWYK.

portant to the photographer, their own costume and physique. The people of the Schwarzwald are small from long years of ploughing and

STREET IN GUTACH.

harvesting. Their faces reflect the sunshine of spring and summer and the protection their pleasant homes grant them in the winter; while

"Two Artists' Haunts," original layout in *Photographic Times*, vol. 26, 1895

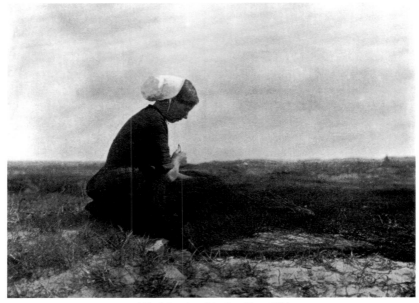

Alfred Stieglitz, *Mending Nets*, 1894

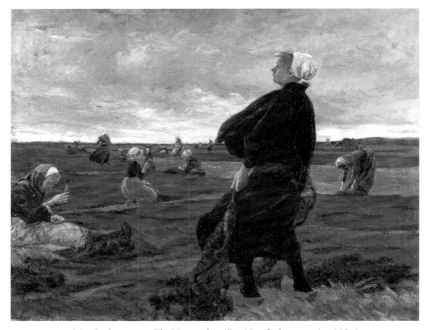

Max Liebermann, *The Netmenders* (Die Netzflickerinnen), 1887–9

MY FAVORITE PICTURE

It is a most difficult and unsatisfactory task to single out one of my pictures as a favorite. But you insist, and so it must be done. Possibly, if I have any preference, it may be for *Mending Nets*, as it appeals to me more and more, and time is the true test of merit. Then, too, the picture brings before my mind's eye the endless poetry of a most picturesque and fascinating lot of people, the Dutch fisher folk. What artistic temperament does not delight in studying them and portraying them either in art or literature! *Mending Nets* was the result of much study. It expresses the life of a young Dutch woman: every stitch in the mending of the fishing net, the very rudiment of her existence, brings forth a torrent of poetic thoughts in those who watch her sit there on the vast and seemingly endless dunes, toiling with that seriousness and peacefulness which is so characteristic of these sturdy people. All her hopes are concentrated in this occupation—it is her life.

The picture was taken in 1894 at Katwyk. Taken on an 18-by-24 centimeter plate, with a Zeiss lens. The exhibition prints used are enlarged carbons, as the subject needs size to fully express it.

NOTES

FROM *Photographic Life* 1 (1899)

The solitude of the figure makes Stieglitz's photograph much more powerful than the canvas showing dozens of such women that the leading German impressionist Max Liebermann had painted at Katwijk in 1887–89. Stieglitz told critic Sadakichi Hartmann that when he made his photograph "Liebermann's representation of Dutch fishing folk had never entered my mind."

PICTORIAL PHOTOGRAPHY IN THE UNITED STATES, 1895

U ntil this year, the three recognized representative American photographic societies—those of New York, Philadelphia, and Boston—alternated in holding an annual international photographic exhibition, known to the world as the Joint Exhibition. These latter were always looked forward to with much interest, especially by those interested in the progress of pictorial photography, for they were the means of bringing together the best American work of the year, besides providing an opportunity for the American to compare his work with that of his foreign colleagues, inasmuch as the European countries were always well represented in these exhibitions. Although the joint exhibitions were not supposed to be run only in the interests of pictorial photography, they rarely contained scientific exhibits. The general public is always interested in pictures, good or bad; unfortunately, as a rule, more so in the latter.

After the last joint exhibition, which was held in New York [in 1894], and which, in many respects, was a decided success, Boston, whose turn came next, announced its withdrawal from the series. No one was willing to shoulder the responsibilities, and face the inevitable criticisms of every move to be made. This announcement meant that the year 1895 would be without a first-class photographic exhibition. This was an unfortunate blow to the interests of pictorial photography, for exhibitions are the only means of learning, especially so in an immense country like ours, in which the earnest workers are scattered over a great area of territory. From another point of view, the natural death of these joint exhibitions has its decided advantage. We need an exhibition run on the salon basis, and it is probably only a question of a short time [before] we shall have one. We are certainly approaching a new era on this side of the water. We have learnt much from our European brethren, and especially from our English friends, who are ever unselfish in their desires to advance the beautiful art.

Nevertheless, the year has not passed by without many local exhibitions, all run more or less in the interests of manufacturers and stockdealers. Such was the exhibition held in Washington under the auspices of a bicycle club! The affair savored of junk shop and county fair methods. An exhibition like this is very apt to disgust the serious worker, with the natural result that he sickens of exhibiting his work. This feeling is spreading daily; it was probably this same sort of sentiment which led to the formation of salons in other countries.

Another annual farce in the way of photographic exhibitions is our so-called "Convention." It is run in the interests of our large professional houses and dry-plate manufacturers. Diamond pins, statuary, solid silver tea services, and gold medals are awarded in great quantities to such fortunates as have a decided "pull." The American professional has done absolutely nothing to advance pictorial photography; he is generally a person who has failed in some other means of livelihood. We have no Robinsons, Sutcliffes, Annans, Sawyers, etc. Why?

These few remarks will show the unsatisfactory state of the interests of pictorial photography in the United States at the close of '95. Fortunately there are some enthusiasts and hard-workers left who keep the flame a-burning; their endeavors will be rewarded in due time.

NOTES

FROM *Photograms of the Year* 1895

At the end of every year from 1895 to 1897 Stieglitz wrote an article for the British yearbook *Photograms of the Year*, reviewing the state of American photography and photographic exhibitions during that year.

It is ironic that in the above article Stieglitz comments that the 1894 Joint Exhibition, the boycott of which he had led, turned out to be "in many respects . . . a decided success." Having, in 1894, loudly called for the abolition of the joint exhibitions (which he here calls, by implication, "first class"), Stieglitz ended 1895 by lamenting their demise and laying the blame upon the Boston Camera Club. Then, despite his being well aware of how resistant most Americans photographers were to his wish for an annual exhibition modeled on the London Salon, he blithely goes on to predict that America will soon have such a show.

The exhibition in Washington, D.C., of which Stieglitz wrote so contemptuously in

his article was the so-called Washington Photographic Salon, sponsored by the Capital Bicycle Club. The following year he wrote, again in *Photograms of the Year*, that the 1896 Washington Salon represented an improvement; it was "held in the interests of pictorial photography" and, though it was certainly not a Salon in the British sense, "the promoters were sincere in their purpose and endeavors, and their efforts were crowned with enough success to prompt them to undertake the organization of a 'Washington Salon' for 1897, to be run on broader lines." However, as we shall read in Stieglitz's annual review for 1897 (below), that exhibition was cancelled.

By the end of 1895 Stieglitz had made himself quite unpopular, not only because of his role in ending the Joint Exhibitions but also because of his scathing criticism of photographs by SAP members and by readers of the *American Amateur Photographer*. When the latter led to an epidemic of cancelled subscriptions, Stieglitz was presumably asked to resign from the magazine. In a letter published in the British *Amateur Photographer* in February 1896 he announced that he had "severed his connection" with the *American Amateur Photographer* and declared, "I shall henceforth devote all my spare time to pictorial photography."

THE HAND CAMERA—
ITS PRESENT IMPORTANCE

Photography as a fad is well-nigh on its last legs, thanks principally to the bicycle craze. Those seriously interested in its advancement do not look upon this state of affairs as a misfortune, but as a disguised blessing, inasmuch as photography had been classed as a sport by nearly all of those who deserted its ranks and fled to the present idol, the bicycle. The only persons who seem to look upon this turn of affairs as entirely unwelcome are those engaged in manufacturing and selling photographic goods. It was, undoubtedly, due to the hand camera that photography became so generally popular a few years ago. Every Tom, Dick and Harry could, without trouble, learn how to get something or other on a sensitive plate, and this is what the public wanted— no work and lots of fun. Thanks to the efforts of these persons hand camera and bad work became synonymous. The climax was reached when an enterprising firm flooded the market with a very ingenious hand camera and the announcement, "You press the button, and we do the rest." This was the beginning of the "photographing-by-the-yard" era, and the ranks of enthusiastic Button Pressers were enlarged to enormous dimensions. The hand camera ruled supreme.

Originally known under the odious name of "Detective," necessarily insinuating the owner to be somewhat of a sneak, the hand camera was in very bad repute with all the champions of the tripod. They looked upon the small instrument, innocent enough in itself but terrible in the hands of the unknowing, as a mere toy, good for the purposes of the globe-trotter, who wished to jot down photographic notes as he passed along his journey, but in no way adapted to the wants of him whose aim it is to do serious work.

But in the past year or two all this has been changed. There are many who claim that for just the most serious work the hand camera is not only excellently adapted, but that without it the pictorial photographer is sadly handicapped.

The writer is amongst the advocates who cannot too strongly recommend

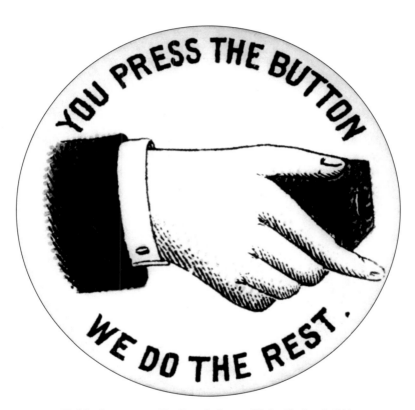

Kodak advertisement *"You Press the Button, We Do The Rest,"* 1888

the trial of the hand camera for this class of photography. He frankly confesses that for many years he belonged to that class which opposed its use for picture making. This was due to a prejudice which found its cause in the fact that the impression had been given him that for hand camera exposures strong sunlight was sine qua non. The manufacturer is chiefly to be blamed for this false impression, as it was he who put up the uniform rule that the camera should be held in such a position that the sunlight comes from over one of the shoulders, in order to insure such lighting as to fully expose the plate. In short, the manufacturer himself did not realize the possibilities of his own ware and invention.

In preparing for hand camera work, the choice of the instrument is of vital importance. Upon this subject that able artist, J. Craig Annan, of Glasgow, who does much of his work with the hand camera, says: "Having secured a light-tight camera and suitable lens, there is no more important quality than ease in mechanical working. The adjustments ought to be so simple that the operator may be able to bring it from his satchel and get it in order for making an exposure without a conscious thought. Each worker will have his own idea as to which style of camera comes nearest to perfection in this respect, and having made his choice he should study to become so intimate with it that it will become a second nature with his hands to prepare the camera while his mind and eyes are fully occupied with the subject before him."

To this let me add, that whatever camera may be chosen let it be waterproof, so as to permit photographing in rain or shine without damage to the box. The writer does not approve of complicated mechanisms, as they are sure to get out of order at important moments, thus causing considerable unnecessary swearing, and often the loss of a precious opportunity. My own camera is of the simplest pattern and has never left me in the lurch, although it has had some very tough handling in wind and storm. The reliability of the shutter is of greater importance than its speed. As racehorse scenes, express trains, etc., are rarely wanted in pictures, a shutter working at a speed of one-fourth to one-twenty-fifth of a second will answer all purposes. Microscopic sharpness is of no pictorial value. A little blur in a moving subject will often aid in giving the impression of action and motion.

As for plates, use the fastest you can get. They cannot be too fast. Do not stop down your lens except at the seashore, and set your shutter at as a slow

speed as the subject will permit. This will ensure a fully exposed plate. Under-exposures are best relegated to the ash-barrel, as they are useless for pictorial work.

The one quality absolutely necessary for success in hand camera work is Patience.

This is really the keynote to the whole matter. It is amusing to watch the majority of hand camera workers shooting off a ton of plates helter-skelter, taking their chances as to the ultimate result. Once in a while these people make a hit, and it is due to this cause that many pictures produced by means of the hand camera have been considered flukes. At the same time it is interesting to note with what regularity certain men seem to be the favorites of chance—so that it would lead us to conclude that, perhaps, chance is not everything, after all.

In order to obtain pictures by means of the hand camera it is well to choose your subject, regardless of figures, and carefully study the lines and lighting. After having determined upon these watch the passing figures and await the moment in which everything is in balance; that is, satisfies your eye. This often means hours of patient waiting. My picture *Winter—Fifth Avenue* is the result of a three hours' stand during a fierce snowstorm on February 22nd, 1893, awaiting the proper moment. My patience was duly rewarded. Of course, the result contained an element of chance, as I might have stood there for hours without succeeding in getting the desired picture. I remember how upon having developed the negative of the picture I showed it to some of my colleagues. They smiled and advised me to throw away such rot. "Why, it isn't even sharp, and he wants to use it for an enlargement!" Such were the remarks made about what I knew was a piece of work quite out of the ordinary, in that it was the first attempt at picture making with the hand camera in such adverse and trying circumstances from a photographic point of view. Some time later the laugh was on the other side, for when the finished picture was shown to these same gentlemen it proved to them conclusively that there was other photographic work open to them during the "bad season" than that so fully set forth in the photographic journals under the heading, "Work for the Winter Months." This incident also goes to prove that the making of the negative alone is not the making of the picture. My hand camera negatives are all made with the express purpose of enlargement,

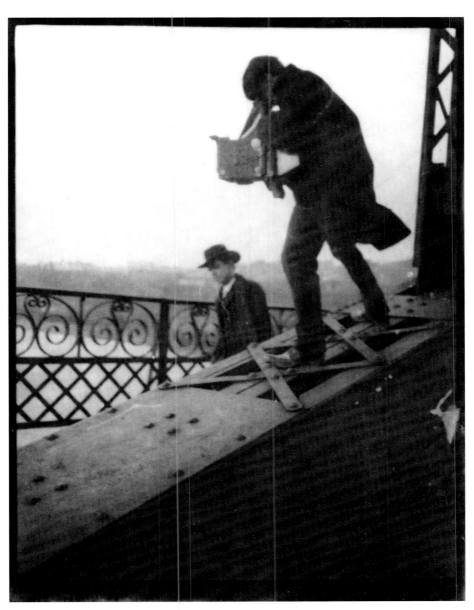

Anonymous, *Alfred Stieglitz Photographing on a Bridge*, ca. 1905

Graflex advertisment, *Camera Work* 16, October 1906

and it is but rarely that I use more than part of the original shot.

Most of my successful work of late has been produced by this method. My experience has taught me that the prints from the direct negatives have but little value as such.

The hand camera has come to stay—its importance is acknowledged.

A word to the wise is sufficient.

—————— NOTES ——————

FROM *American Annual of Photography and Photographic Times Almanac for 1897*

The "bicycle craze" to which Stieglitz referred in the first sentence of his article was nothing less than a revolution in American transportation and in the use of leisure time. Three inventions had sparked this revolution: the development of the modern bicycle, with a diamond-shaped frame and equally sized wheels (1885); the pneumatic tire (1889); and the drop frame for women (mid-1890s). Suddenly city dwellers who couldn't possibly afford a horse had a means of exploring the countryside on days off. Since many did so in search of picturesque subjects for their cameras, photography and bicycling became popularly linked, and many of the bicycle clubs that sprang up in every American city combined the two pastimes. Bicycling, however, generally took precedence, as it offered men and women, in that heavily chaperoned age, precious opportunities to meet and to socialize in an acceptably genteel manner away from parental eyes.

Bicycle mania reached its peak in 1896, the year before Stieglitz's article was published, but it lingered on until bikes were replaced by, or at least took second place to, automobiles.

Stieglitz was, of course, referring to the Eastman Company when he sneered at an "enterprising firm" that "flooded the market with a very ingenious hand camera," namely, the Kodak, which appeared on the market early in 1889. Eastman's famous slogan was "You press the button, we do the rest." That was literally true, for the Kodak came already loaded with a roll of nitrocellulose film that could yield up to one hundred pictures. After the film had been exposed, the photographer would send the entire camera back to the firm's headquarters in Rochester, New York, where the film would be processed and the camera reloaded.

As Stieglitz states, hand cameras were "originally known under the odious name of 'Detective.' " The reason was that some of the first dry-plate cameras to appear, during the 1880s, were miniature devices concealed in the handles of walking sticks, or disguised

as cigarette cases, or designed to be worn under a vest, with the tiny lens protruding between the buttons and a shutter-release cord down one's sleeve. A few of these novelty gimmicks, which were naturally dubbed "detective cameras," may actually have been used by detectives, but they appealed most to practical-joking clubmen eager to get amusing shots of their fellow members. Unfortunately, the term came to be applied, for some years, to all hand-held cameras, no matter how conspicuous they might be.

Stieglitz greatly admired the work of J. Craig Annan, whom he quoted at length in his article. Annan lived in Glasgow, Scotand, and worked for his family's firm, T. and R. Annan and Sons, widely known for its magnificent photogravure printing. For his own photography Annan used cameras of several sizes, one of them a hand-camera for plates that measured approximately four-by-five inches.

Annan, a leading member of the Linked Ring, had been born two months after Stieglitz and would die one month before him. There were remarkable parallels, too, in their work. In 1892 Annan had made a number of photographs in the Dutch fishing village of Zandvoort very similar to Stieglitz's Katwyk pictures, and both men worked in Venice during the summer of 1894. Their careers—both as photographers and as eminent statesmen in the world of photography—would repeatedly intersect. Stieglitz would eventually acquire some sixty prints by Annan, more than he owned by anyone else except Edward Steichen, and he would reproduce photographs by Annan in five issues of *Camera Work*.

Shortly after the turn of the century Stieglitz gave his allegiance to one particular make of hand-held camera: the Graflex, a single-lens-reflex apparatus manufactured in a range of sizes for plates measuring from four-by-five to eight-by-ten inches. With his Graflexes of various sizes, Stieglitz used Goerz Double Anastigmat lenses, of which he wrote in a letter to Mr. Goerz that "for all around hand camera work they are certainly without equal." Stieglitz stated that "the covering power and speed of the lenses with full opening are not approached by any other lens that may have passed through my hands."

THE PHOTOGRAPHIC YEAR
IN THE UNITED STATES

When last we had the pleasure of penning a short résumé of the American work for the year, prospects for a brilliant photographic 1897 were certainly more than promising. Once again we have been doomed to disappointment, and all our expectations have fallen flat. Not a single photographic exhibition of importance can be recorded for the year. We were promised a Washington Salon, to be run on broad, liberal lines, with no awards or ribbons; and although the prospectuses had been issued and success insured, petty jealousies in the club under whose management the Salon was to be held caused the whole matter to be abandoned.

The Camera Club of New York meditates holding a Salon, which, when held, is to be thoroughly representative. Foreign work is to be sent in upon invitation without jury restriction, while Americans will have the opportunity of submitting as much of their work as they please for selection. This will be left to a jury composed of accepted authorities. For the present, the whole matter is in an embryonic state, and nothing definite has been done. The writer has been appointed a Committee of One to draw up the general lines for the undertaking.

Before making a move, better times are eagerly looked forward to, as they are an important factor towards ensuring the financial success of such a huge undertaking. At present, notwithstanding [President William] McKinley, the outlook is none too promising.

The Camera Club, since its consolidation a year ago, has shown great signs of activity; and we have every reason to believe that the future of American pictorial photography is at last in good hands. The Clubs in Boston and Philadelphia, which were amongst the most active ones a few years ago, show but little sign of life.

Notwithstanding the lack of exhibitions, many Americans have been working diligently and seriously, the character of the results having decidedly improved. Nevertheless, there is still that tendency to "prettiness" in the pictures produced,

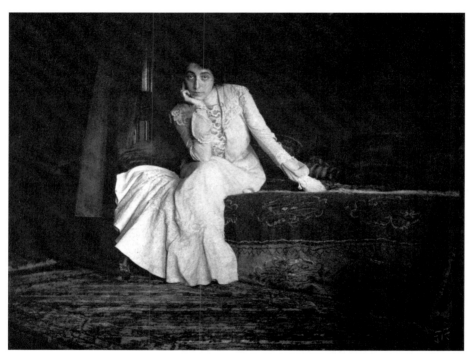

Joseph T. Keiley, *Portrait—Miss de C.* [Mercedes de Cordobal], 1902

and only a very limited number of men are working in the direction of real strength and breadth. [French photographer Robert] Demachy, in his recent criticism on the American exhibit at the Paris Salon, is of similar opinion.

During the year Americans have exhibited many of their pictures abroad, at Berlin, Hamburg, Vienna, Paris, Brussels, as well as in all important and unimportant exhibitions in Great Britain. In very many cases their efforts have been crowned with success, if one can judge by the class and quantity of medals which have passed through the American Custom House.

The desire of winning medals is not on the wane on this side of the water, even amongst our better class of workers. That is due to the fact that medals have not been given galore in the States as yet, and the winning of one abroad is considered an honor. Those thoroughly initiated in foreign exhibition matters are fully aware that most of the best Britons and Austrians, the two leading schools in pictorial photography, abstain from all photographic competition, and therefore discount the apparent value of such awards.

Amongst those who have won recognition abroad during the past year in the more important of the foreign exhibitions we may mention: Miss [Emilie V.] Clarkson, Miss [Emma J.] Farnsworth, Miss [Frances Benjamin] Johnston, Messrs [William A.] Fraser, [William B.] Post, [Charles] I. Berg, [Charles] Simpson, . . . Hinsdale Smith, E. Lee Ferguson, Clarence B. Moore, [Charles] Pancoast, Ashton Hand, [F. Holland] Day, etc., etc.

[Rudolf] Eickemeyer did not exhibit during the year, but has not been idle, having done some exquisite work, which he proposes to send to the two London exhibitions this autumn. It is not generally known that Mr. Eickemeyer joined the professional ranks a year ago, working conjointly with James T. Breese, formerly also a prominent amateur.

Professional photography is improving, and a few of the profession are at last worthy to be ranked as thorough artists. [George] Cox and Hollinger, both portrait photographers, are doing great work. Cox, who is an exceedingly eccentric genius, stands in a class by himself, his portraits comparing very favorably with those of [Frederick] Hollyer, [Henry Herschel Hay] Cameron, [William] Crooke, and other giants of yours [in Britain]. For years past, this artist has been turning out magnificent portraits full of character and individuality, and treated in a bold execution, but it is impossible to induce him to exhibit any of his

work, even in an exhibition like the Salon. Hollinger, though not quite as broad in his work as Cox, certainly has a strong individuality; his portraits are always interesting in their treatment and never conventional. The pictures of both these workers are doing much to cultivate the taste of the better element in the general public, and it is with great pleasure that we are able to record the fact that they are the first American professionals whose work will always live on account of its true value. We also fully expect to see the seed they have sown bear fruit and perhaps in the near future we shall have the pleasure of recording that American professional photography will contain amongst its rolls names equivalent to the Sutcliffes, Robinsons, Annans, Crookes, etc., of Great Britain. For the present let us be thankful.

———————————— NOTES ————————————

FROM *Photograms of the Year* 1897

In the spring of 1896, Stieglitz was one of the principals who negotiated the merger of the New York Camera Club and the Society of Amateur Photographers of New York, a project that he referred to as "an amalgamation of the dying and the dead." The result was the Camera Club, New York, which is still in existence today.

For many of the members of the old New York Camera Club photography had been largely a pretext for outings, smokers, and gentlemanly competitions. They felt that their desire for camaraderie could be satisfied just as well—or even better—by a bicycle club. But Stieglitz filled a voting majority of them with new enthusiasm for photography.

At first the new club occupied the quarters of the SAP on West Thirty-eighth Street, but in January 1898 a lease was signed for the top floor of the recently constructed eight-story building at 3-7 West Twenty-ninth Street. The new headquarters had a large room for exhibitions and lectures and a huge workroom, off which were numerous darkrooms.

When he was interviewed by Theodore Dreiser about the Camera Club, Stieglitz told him that one of his goals for the club was to establish in New York "an annual exhibition, of a much higher order than anything yet known, giving no awards, but only a certificate of acceptance, which shall be, in itself, a treasure." This exhibition was, of course, to be an international one modeled on that of the Linked Ring, which Stieglitz was determined to surpass.

When, in his article, Stieglitz made a pessimistic mention of the need for the nation's financial outlook to improve before a major international photographic salon would be feasible, he was referring to the economic depression that had begun in the spring of 1893. Its severity abated somewhat during 1897, at least partly in response to the conser-

vative fiscal policies of the newly inaugurated president, William McKinley, but not until 1898 did statistics indicate that general prosperity was finally returning.

In March 1897 the trustees of the Camera Club, New York, approved Stieglitz's proposal to edit and publish, under the club's auspices, an ambitious and largely independent quarterly magazine, which was to be called *Camera Notes*. The first issue appeared in July 1897, its green cover embellished with an art nouveau sunflower—which, because of its constant turning toward the sun, was the floral symbol of photography. In an average issue about half the articles dealt with individual photographers and aesthetic questions, the rest with scientific and technical matters. Reviews of books and of local, national, and international exhibitions were followed by a sizable section devoted to Camera Club news and a substantial number of advertisements.

Every issue was illustrated not only with numerous halftones but also with at least two, and usually three or four, meticulously hand-pulled photogravures "representing some important achievement in pictorial photography." In the first issue Stieglitz stated, "[T]he utmost care will be exercised to publish nothing but what is the development of an organic idea, the evolution of an inward principle; a picture rather than a photograph, though photography must be the method of graphic representation."

Stieglitz recruited a young photographer named Joseph T. Keiley to help him edit *Camera Notes*. Keiley, a Wall Street lawyer who never married and who lived with his mother and sister in Brooklyn, soon became Stieglitz's closest friend and most valuable ally. Although Keiley was not a brilliant photographer, Stieglitz called him "an artist of marked individuality," enthusiastically featured his landscapes and portraits in exhibitions and on the printed page, and, in December 1899, saw to it that he was elected a member of the Linked Ring.

After the founding of *Camera Notes*, Stieglitz wrote primarily for his own magazine, though many of his contributions were unsigned editorials. Several years saw little by Stieglitz, except an occasional letter to an editor, published elsewhere.

Stieglitz greatly admired the work of Frederick Hollyer, Henry Herschel Hay Cameron, and William Crooke, all of whom were British professional portrait photographers and members of the Linked Ring. In his review of the seventh Joint Exhibition (*American Amateur Photographer*, May 1894) Stieglitz wrote: "We were . . . struck by an exhibit of exceptional beauty and dignity, without a doubt the finest one in the exhibition. We refer to Mr. Hollyer's portraits; all exceptionally good and characteristic, each one bearing the stamp of individuality. . . . We have never seen such portrait work on this side of the Atlantic, and shall probably see none like it soon again." Given Stieglitz's usual contempt for professional photographers, such praise is all the more remarkable.

Henry Herschel Hay Cameron was the son of Julia Margaret Cameron, whose style of portraiture strongly influenced his own. He had a successful portrait business in London from the mid-1880s until 1905, when he gave up photography to fulfill his childhood ambition of being an actor.

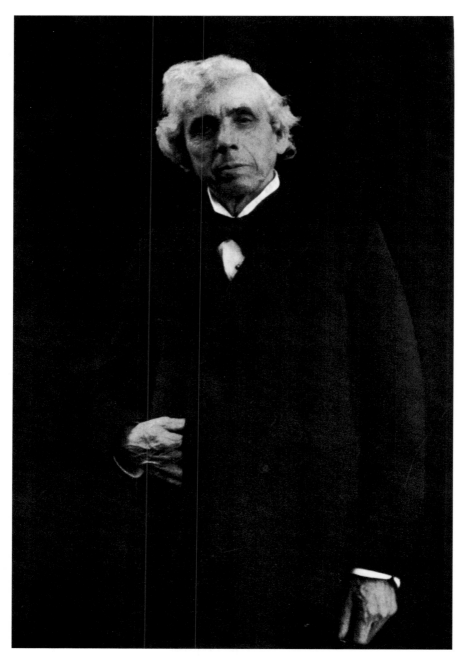

Alfred Stieglitz, *Portrait of Mr. R.* [Anson Davies Fitz Randolph], 1897

A NATURAL BACKGROUND
FOR OUT-OF-DOORS PORTRAITURE

Few amateurs succeed in making successful portraits. It is a common complaint that the lack of a suitable studio is the cause of this. If it be suggested that out-of-doors portraiture is at times successful, he is apt to complain of restless and disturbing backgrounds.

It is to help along such complainants that these few lines are written.

The two accompanying pictures, which are to serve as illustrations of successful out-of-door portraiture, have been exhibited extensively, and have been lauded as splendid specimens of studio work. It will therefore surprise not a few to be told that both portraits were taken out-of-doors without any accessories, and that the black background is simply an underexposed cluster of trees, thickly covered with green leaves.

Those who spend their summer months in the country, and who are desirous of making portraits of a similar character, will be able to do so, by following the few directions herewith given:

Late in the afternoon, about an hour or less before sunset, place the subject to be photographed about thirty to forty feet in front of the trees which are to serve as a natural background, in such a position that the light strikes the face at a suitable angle; that is, in such a manner as to bring out the characteristic qualities of the head. Many effects of lighting can be easily obtained by moving the figure back or forward a trifle. Experience in this direction is the best teacher. Focus on the eyes, and expose the plate without stopping down. In order to obtain the best results, your lens must be able to cover the plate at full opening. Using a very rapid ordinary plate, not orthochromatic, give only a sufficient time to fully expose the full figure or head, whichever it might be. The plate is developed with a full strength developer, and development stopped when the portrait has gained sufficient density. It is best to keep it on the thin side—most portrait negatives are much too dense. After having fixed the plate, it will be noticed that the detail in the trees is but faintly suggested.

This is the natural cause of their having been badly illuminated during the exposure, and that the ordinary plate is not oversensitive to the green of leaves. When ultimately printing from such a negative, the background will print out black, while the portrait proper assumes its proper gradations. No doctoring of negatives thus obtained, nor any dodging in printing them, is ever necessary, if the original conditions have been carefully attended to.

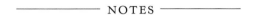

NOTES

FROM *American Annual of Photography and Photographic Times Almanac for* 1898

The two photographs that accompanied this article when it was originally published were Stieglitz's *Milkmaid, Gutach* and *Returning from the Pastures* by Otto Scharf. Oddly, Stieglitz's comments in the third paragraph do not seem to apply at all to either of these pictures.

We may guess that Stieglitz had intended his article to be accompanied by a reproduction of his outdoor *Portrait of Mr. R.,* to which his comments apply precisely. It was one of his most widely exhibited and published photographs from the 1890s—so much so that in 1901 critic Charles Caffin wrote, "No picture has secured its author more deserved reputation than the *Portrait of Mr. R.*"

The subject of this intense three-quarter-length portrait, dating from 1895, was Anson Davies Fitz Randolph (1820–1896), whose modest cottage was near Oaklawn, the Stieglitz summer estate, at Lake George, New York. The widely revered Randolph, a New York bookseller who specialized in religious and theological works, was best known for his devotional and patriotic verse.

Stieglitz had long admired Randolph's balance of sweetness and dignity, but whenever he persuaded Randolph to pose, the old man became hopelessly self-conscious. So Stieglitz decided to try a trick. One day he took Randolph on a stroll around the grounds of Oaklawn until they arrived at the spot, in front of some dense foliage, where the photographer had set up his camera and tripod. Stieglitz then said he wanted to check their placement for a figure-study he was planning, and he offhandedly asked Randolph to stand in front of the camera for a moment. As soon as the unsuspecting—and thus completely relaxed—Randolph complied, Stieglitz squeezed the shutter-release bulb he had hidden in his pocket. The result, in which the subject's face and hands are dramatically highlighted against the featureless dark background and against his black frock coat, in the style of the French painter Léon Bonnat, is the equal of any daguerreotype by the great American portrait partnership of Albert Sands Southworth and Josiah Johnson Hawes.

NIGHT PHOTOGRAPHY
WITH THE INTRODUCTION
OF LIFE

Night photography, so termed because pictures are taken out-of-doors at night by either gas or electric light, has been the novelty of the year. This method of photography is not really new, several successful attempts at such work having been exhibited at various times at the larger exhibitions in England during the past few years.

The writer exhibited a picture entitled *A Wet Night* at the London Salon last year. It was an attempt at reproducing the impression of a rain storm in an asphalted street, illuminated by electric lights. Everyone, no doubt, has been struck with the picturesqueness of the wet streets on such a night. The picture had been actually taken during a downpour of rain near midnight. The exposure lasted over half an hour.

It is due to the splendid efforts of Paul Martin, of London, which he exhibited in the shape of twelve lantern slides at the 1896 Royal Photographic Society Exhibition, and for which he was awarded the much coveted medal, and [it is also due to] his unselfishness in publishing his mode of procedure in several very interesting articles in the *Amateur Photographer* (London), that this branch of photography has become more popular, and has found many new adherents.

Mr. [William A.] Fraser, of the Camera Club of New York, was the first American to take up the work on similar lines to those laid down by Paul Martin, with the difference that while the latter exposed most of his plates a short time during the departing daylight and finished up at night, Mr. Fraser exposed most of his work actually at night. A full account of his working methods can be found in *The Photographic Times*, April, 1897.

The writer having begun his experiments last year, as before mentioned, continued them during the winter of this year, and has but little to add to the working instructions already given by these gentlemen.

Nevertheless, there are certain matters to which attention might be called.

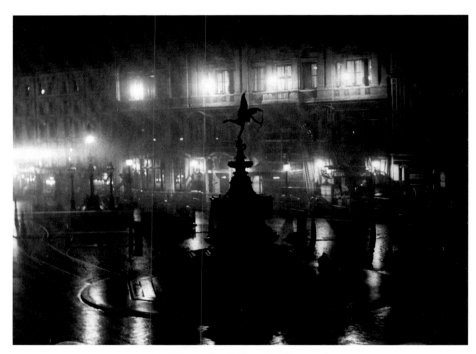

Paul Martin, *Eros in Piccadilly Circus*, n.d.

Most of the night scenes thus far exhibited are more or less topographical, with but little attempt at real picture-making. The novelty of these effects is oftentimes mistaken for true artistic merit, and although not denying the merits and many interesting qualities of such photographs, one cannot but realize, after having seen several of them together, that the impression conveyed is one of sameness, although the subjects presented may vary considerably. This is but natural, considering the conditions under which most of the photographs have been taken.

We question whether, after the novelty of such photographs has worn off, their merits as to pictorial value will stand the test of time. There may be certain exceptions.

Nevertheless, we believe that this branch of photography opens up certain possibilities which have not as yet been attempted. We refer to the introduction of life into these scenes. The illustrations to this article are the first experiments made by the author in this line, and he is fully convinced that they are but the first steps to a most interesting field of work.

The exposure of these negatives, which were made on double-coated non-halation plates, with no extra backing as Mr. Fraser is wont to use, was but 58 seconds!

The negatives are fully exposed, notwithstanding the exceedingly short exposure, which was made entirely at night at about 9 P.M. This shortening of the exposure makes it possible to include life in night photographs of this character, thus increasing the possibilities of picture-making.

Paul Martin's work shows an entire lack of halation around his lights, which, although speaking well for his technical skill in mastering the photographic bugbear halation, is a decided shortcoming from a pictorial point of view. We do not wish to say that halation galore improves night-work in which the illuminating source is included, but a certain amount of it certainly gives a more sincere and picturesque rendering of the object itself. Especially on rainy nights, and these are certainly the most thankful for the night photographer, all those who have studied the subject carefully will see a bright glow around the lights themselves. Why eliminate them in the picture?

Those interested in this branch of photography will find that subjects like these are best reproduced by means of lantern slides, for by this method only is it possible to preserve the luminosity of the original scene.

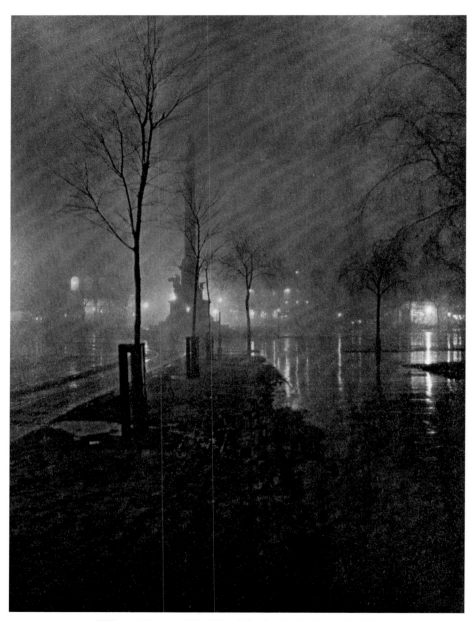

William A. Fraser, *A Wet Night, Columbus Circle, New York*, 1899

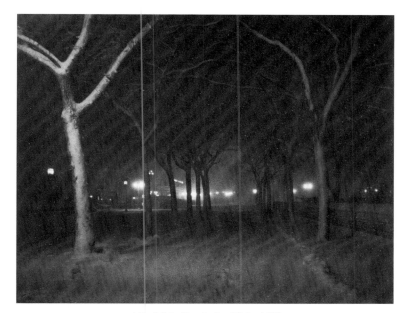

Alfred Stieglitz, *An Icy Night*, 1898

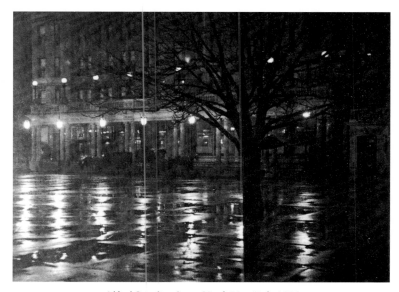

Alfred Stieglitz, *Savoy Hotel, New York*, 1896

Prints are always more or less disappointing, and process reproductions still more so.

NOTES

FROM *American Annual of Photography and Photographic Times Almanac for 1898*

In the fall of 1896 the *Amateur Photographer* published a two-part article by British photographer Paul Martin entitled "Around London by Gaslight." Reading of Martin's experiences and techniques led Stieglitz to become preoccupied with night photography, which posed the sort of technical challenges that he loved.

In the present article Stieglitz praised Martin for the unselfishness with which he had explained the details of his procedure; gave him credit for having pioneered the specialty that had been "the novelty of the year"; and stated that "Mr. Fraser, of the Camera Club of New York, was the first American to take up the work on similar lines." By 1910, however, Stieglitz was not prepared to be quite so generous. He then claimed that "simultaneously with Mr. Paul Martin, in London," he himself had been "the first to successfully experiment with night scenes."

In truth, Stieglitz's innovation was the reduction of exposure times to less than a minute, making practical the recording of people. When nighttime exposures could take half an hour, it was virtually impossible to capture an image of a person on a negative—unless a subject could be persuaded or bribed to stand as still as a statue for thirty minutes. One of Martin's long-exposure photographs from 1896 created something of a scandal when close scrutiny revealed the figure of a policeman; outraged taxpayers protested that no officer of the law had any business standing in one place for half an hour.

Several of Stieglitz's most beautiful night photographs were shot from Manhattan's Grand Army Plaza, at Fifth Avenue and Fifty-ninth Street, looking eastward across the wet pavement of the avenue to the Savoy Hotel, where he and his wife, Emmy, had been living since their marriage, in 1893. His first night photograph to include a person shows a driver sitting on the box of a carriage waiting outside the hotel.

Despite his disparagement of prints of nighttime photographs, as opposed to lantern slides of them, Stieglitz did sometimes make prints from his negatives. Tinted slightly yellow to approximate the effect of incandescent light, the prints of such pictures are rather melancholy romantic nocturnes.

PLATINUM PRINTING

Of all the modern printing processes at the command of the photographer, whether amateur or professional, none deserves to be more popular than the platinum. The simplicity of manipulation, combined with the beauty of the results obtained with it, is enough to recommend it to every photographer. And above all, the prints produced by this method are as permanent as the paper which supports the image.

Its range, yielding the strongest blacks with pure lights and a long scale of intermediate half-tones or grays, is only equaled by the carbon process. The platinum print has an indescribable charm, suggesting atmosphere, though the negative printed on another medium may be entirely devoid of this valuable pictorial quality.

Notwithstanding these decided beauties and charms, the great majority of photographers, and especially beginners, imagine that platinum printing belongs to the advanced stage of photography.

Excluding the process of producing blue-prints, none is so easy and simple, and none requires so few chemicals and so little time and trouble to produce a finished print.

In printing, the image is only partially visible and it takes a little experience in overcoming the difficulty in judging how far to go. This factor has undoubtedly been the great bugbear of this otherwise almost ideal photographic printing process, and has been the cause which frightens the beginner who has generally accustomed himself to some of the printing-out silver papers. But in consideration of the fact that the difficulty is often more imaginary than real, and that the manipulations of developing, cleaning and washing hardly take more than a few minutes, is it not worth while to at least try this mode of printing?

The paper is manufactured in sheets 20-by-26 inches, but can be bought from any dealer in any desired size, packed in dozens in a tin tube. The writer wishes to warn the beginner not to buy the paper in any way but in tins, for otherwise he will not receive the paper in proper condition. The advice of some dealers in this matter is ruinous. The paper is packed in tin tubes, as it is

extremely sensitive to damp, which spoils it. Each tin contains a bit of cotton wool, enclosing a small piece of asbestos, saturated with calcium chloride, which absorbs all traces of moisture apt to get into the tube, which would otherwise attack the paper.

In a fairly cool place it keeps for months. Excessive heat will deteriorate it rapidly, so that in a very hot climate it is best to keep it in a refrigerator.

Inasmuch as the paper is more sensitive to light than the gelatine and collodion silver papers in the market, it must be handled in subdued light, that is, not too near a window nor out-of-doors.

After opening a tube and taking out a sheet for printing purposes, pack away the balance exactly as originally packed, and the sheets can be kept until wanted.

The paper is exposed in the usual way to daylight (sunlight preferably, according to the writer's opinion) and is examined from time to time to note the process of the printing. This must be done with the back to the window. The image is only partially visible. A little practice will teach you how far to print; actinometers, as recommended by some, being entirely unnecessary. The developing is done by immersing the print in a solution of oxalate of potash, which brings out the image in its full strength nearly instantaneously. It is then put directly into a weak solution of hydrochloric acid to clear it, and then washed. This is the outline of the process. Full particulars and detailed instructions are enclosed in every tube of paper.*

The paper comes in various varieties, which are marked as follows:

AA (smooth, thin)
BB (smooth, stout)
CC (rough, very stout).

* NOTE—The development of "cold-bath" platinotypes recommended by the manufacturers provides for the use of their own developer.

As soon as print is removed from developing dish it must be immersed face down for five minutes in the following bath: Hydrochloric acid, 1 part; water, 60 parts. Remove to a second acid bath for ten minutes and to a third for fifteen minutes. Wash fifteen minutes in at least three changes of water.

The sepia papers are similarly handled except that to each ounce of developer is added one sepia tablet (put up by the manufacturers of the paper) and developer is used hot: 150° to 160° Fahr.—Ed.

These are the cold-bath papers which are in general use here in the United States, and which give pictures of a black image.

Besides this class, the Platinotype Company manufactures the "Sepia" papers, which are developed hot, and give a rich brown print. They also come in the various varieties of smooth and rough.

The most popular of all these grades is that known as CC; it is a tough heavy paper, with a decided tooth or grain like a rough drawing medium. It also has better keeping qualities than any of the others.

It cannot be impressed too greatly upon the beginner that moisture is the greatest enemy of the process, and that if is necessary for him to keep printing-frames, pads and negatives bone dry, if he is aiming at superior results. For certain effects it is sometimes desirable to allow the paper to absorb some moisture, but this will hardly be in the line of a beginner. It is therefore to be recommended before starting a day's printing to dry the printing-frames and pads in the kitchen or in some dry place, and even to dry the negatives if the air is laden with humidity. Gelatine is very hygroscopic, that is, readily absorbs moisture. It might also be pointed out that with paper which is old and perhaps slightly damp, printing need not be carried as far as with fresh and dry paper.

Most photographers have an idea that the platinotype process requires a so-called "plucky" and "brilliant" negative. This is not the case. Any negative which gives a good result with other papers will yield good prints with platinum.

As a beginning the tyro will do well to closely follow the instructions enclosed in every tube of paper. After having fully mastered all the operations, and feeling thoroughly at home in the manipulation of the paper, he may, if he so desires, sometimes alter the directions to suit special purposes.

In using the cold-bath paper, it is at times advantageous to develop it hot. This can be done in case one is printing from a rather harsh negative, which if developed in the ordinary way would yield a print devoid of all gradation or half-tone. If developed hot, the same print will come out with considerably more softness, that is, yielding more half-tones.

In other words the temperature of the developing bath has a decided influence on the tonality of the print, as also on the color of the image.

The colder the bath, the colder the image, may be set down as a rule. The warmer the bath, the warmer the image. Thus, one is enabled at will, to produce either a cold blue-black picture or one of a warm black, the resulting color

depending entirely upon the temperature of the oxalate solution.

Dampish paper yields prints of a brownish black color, with a tendency to mealiness.

At times, it is desirable to increase the vigor of a print, and in order to accomplish that result the print must be developed in the following developer, recommended by Horsley Hinton:

Oxalate of Potash. 1 lb.
Phosphate of Potash. 4 ozs.
Sulphate of Potash ½ oz.
Water . 6 pints

This solution develops the prints rather slowly, and is especially suitable for prints from very flat negatives.

It may be remarked that although the Platinotype Company recommends its own developer for use with their paper, I have found the pure neutral oxalate of potash fully its equal. Their salts undoubtedly contain some phosphate of potash besides the oxalate.

Platinum prints may be toned in various ways.

The most common is the "Uranium" which changes the color to a rich-brown or red-brown. The ordinary platinum intensifier may be used for this purpose, the print simply being immersed in it for a time.

An excellent method for uranium toning is given by A. Horsley Hinton:

SOLUTION 1
Uranium Nitrate 48 grains
Glacial Acetic Acid. 48 minims
Water . 1 oz.

SOLUTION 2
Potassium Ferricyanide. 48 grains.
Water . 1 oz.

SOLUTION 3
Ammonium Sulphocyanide. ½ oz.
Water . 1 oz.

For use take ¼ oz. of each, Nos. 1, 2 and 3, and 25 ounces water.

A finished unmounted platinotype print, thoroughly cleared from all iron salts, is placed in a flat dish and flooded with the above solution and the dish rocked continuously.

The color of the print will gradually change, the toning should be carried on a little further than when the desired tint has been reached, as the picture will dry out a little colder in color than it appears in the toning bath. It is now brought into a dish of water containing a few drops of glacial acetic acid. The water must not be alkaline, as it would dissolve the uranium compounds deposited on the print and thus change its color again. This property of alkaline water may be made use of in case the desired color of the toned print is unsatisfactory, and one wishes to get it back into its original condition.

It has, as yet, not been conclusively proven that platinum prints treated with uranium are permanent.

It is possible to control this image during development and to make various changes in the various tones of the picture.

This can be accomplished by using the glycerine method, referred to in the platinotype instructions.

It consists essentially of painting the image by means of the oxalate solution, using a brush for the purpose, the paper having first been exposed to light under the negative in the ordinary way.

The method is so full of latitude, that prints have been produced by its means that look like fine wash drawings.

In short, it will be seen by the various matters referred to in this short résumé of the platinotype process, that it is beyond doubt the printing method par excellence for the amateur.

AMERICAN PLATINUM PAPER. In the production of the American Platinum Paper [made by the American Aristotype Company] two very serious defects in the platinum paper heretofore manufactured have been overcome. First, solarizing in shadows; second, the fuzzing or abrading of surface by handling. The manipulation of this paper is very simple, and with a reasonable amount of care there should be no difficulty in obtaining good results. The instructions, although simple, must be followed in every detail if the best results are desired. This paper will keep in good condition for a long time if

not exposed to heat or dampness. The unprinted paper should be stored in a cool, dry place. When paper is removed from the tube, see that the sheets not intended for immediate use are returned to the tube with the package of preservative, and the tube carefully sealed with the tape. If the tube is allowed to remain open, or the paper removed from the tube several hours before using, the effect of dampness will be noticed in the lack of strength and brilliancy in the prints. Dampness will also cause highlights to develop gray instead of pure white.

PRINTING. Although not absolutely necessary, it is advisable to use thin rubber pads in the backs of printing frames, especially in those sections of the country where the atmosphere is full of moisture. See that negatives and pads used in printing frames are perfectly dry, or the result will be the same as when paper is exposed to dampness before printing. In handling paper, care should be taken not to expose it to strong light. Put paper on negatives and examine prints in weak daylight or artificial light. Care should always be taken not to touch the sensitized surface of the paper with the fingers. This is very important where the hands perspire freely.

Print until the image is visible in all parts, although weak and only faintly outlined in the stronger portions of the negative. The exact depth of printing can only be determined by a little experience. When printing in bright sun-light, use one thickness of tissue or ground glass over the negative. Print weak negatives in the shade or use several sheets of tissue over the frames.

If prints are not to be developed immediately after printing place them in a tube with a package of preservative and seal the tube carefully.

DEVELOPING. The developer is simply neutral oxalate of potash and water; three ounces of neutral oxalate of potash dissolved in twelve fluid ounces of water. If tones more on the blue-black are desired, use the following developer: Water, ten ounces; oxalate of potash, one ounce; phosphate of potash, one-half ounce. In preparing developer containing phosphate of potash, always use warm water, as this chemical does not dissolve freely in cold water. Any amount of the developer may be made up and set aside for future use, but should be kept in a well-stoppered bottle. Use sufficient developer to cover the bottom of the tray at least one-half inch deep. Develop prints face

up. By sliding prints under developer face up, air-bells are avoided and the development may be closely watched from the start.

Development, as a rule, only requires from twenty to thirty seconds, but it will do no harm to leave a properly exposed print in the developer a full minute. Prints from strong negatives are very often improved in the half tones by prolonging the development a few seconds. Development should be carried on in a weak light. The temperature of developer must not be below 60° F. Keep up strength of developer by adding fresh stock solution from time to time. A developer which has become overcharged with chemicals from the paper will produce poor results. The development should therefore be watched carefully when using old developer, and if any change is noticed in the quality of prints, a new bath should be tried. Weak, granular prints may result from the use of weak or too-cold developer. Rock the tray or stir the developer between the development of prints to prevent markings caused by scum, which forms on the surface of the solution. A print which is known to be slightly under-exposed may be saved by warming the developer to 100° or 110°. Developer which has been used should not be returned to the bottle of stock solution. Have a separate bottle for old developer and do not allow it to stand in a strong light. When using old developer, pour off the clearing solution carefully, so as not to disturb the sediment which settles to the bottom of bottle.

CLEARING BATH. As soon as prints are fully developed they are placed face down, directly into a clearing bath of muriatic acid and water; one ounce of muriatic acid C. P., to sixty ounces of water. The quality of acid used is of much importance. It should be chemically pure, as ordinary commercial acid will cause yellow prints. Prints should have from three to four changes of acid clearing bath, allowing them to remain in each bath eight to ten minutes and keeping them separated. The last acid bath should be as clear as pure water, showing no yellow tint. This clearing of prints is very important, as permanent results depend on removing all the unacted-on chemicals from the paper. A properly treated platinum print consists of nothing but metallic platinum and paper. After clearing, prints are washed about one-half hour in running water. If not convenient to wash prints in running water, give them eight to ten changes in a tray, separating them well each change.

NOTE. The following are the most important points in connection with the manipulation of platinum paper and should receive careful attention.

Keep paper dry at all times.

When placing paper on negatives or examining prints, do not expose to strong light; weak daylight or gaslight will answer.

Keep up strength of developer, and do not use it too cold.

Slide prints under developer, face up, to prevent the formation of air-bells.

Place prints directly from the developer into the acid clearing bath without previous washing.

See that clearing of prints is thorough. The last clearing bath should be free from any yellowness.

Use chemically pure muriatic acid for clearing bath.

If developer crystallizes on surface of prints, causing numerous fine, dark spots to appear during development, reduce the strength of solution by adding from one to two ounces of water to twelve ounces of developer.

NOTES

FROM *The Modern Way in Picture Making.*
ROCHESTER, NEW YORK: EASTMAN KODAK CO., 1905

As previously noted, platinotype was so emphatically Stieglitz's favorite process that he would undoubtedly have been quite content to print on platinum paper for the rest of his life. In 1917, however, the Russian Revolution would disrupt the supply of platinum from the Urals, at that time the principal source. Manufacturers soon substituted palladium, which is next to platinum on the periodic table. Less expensive than its cousin, and available from Canada, palladium produced a paper that yielded a rich reddish-brown tone when developed. In December 1918 Stieglitz complained, "Palladium is all right but I yearn for Platinum. It has so much inner quality & black lives at all times—deep brown does not." Beginning in 1918 he would make most of his prints on palladium paper, though he gradually switched over to the gelatin-silver paper that he would use exclusively after 1924.

Alfred Horsley Hinton, whom Stieglitz twice cites in his article as an authority on developing and toning formulae for platinum printing, was a founding member of the Linked Ring. One of his fellow Links called him "the founder of the British School of Landscape Photography," and most of his few surviving prints are platinotypes of moody landscapes.

From 1893 until his death, in 1908, at the age of forty-five, he was the highly respected and influential editor of the British *Amateur Photographer*.

When Stieglitz writes of the glycerine method to make prints "that look like fine wash drawings," he is referring to a technique with which he and Joseph Keiley conducted a series of experiments between 1898 and 1900. Charles Caffin gave the following account of the process in his book *Photography as a Fine Art* (1901): "A print is made from the negative upon platinum paper in the usual way; unlike silver printing, in which the image prints out by the action of light, the image on the platinum paper is very faint, needing a further process of developing, and it is at this point that the photographer controls his results by means of glycerine. The print is coated with it, and the effect of this is to retard the action of the developing solution which, either pure or mixed with glycerine, is then applied with a brush. The pure developer brings out the platinum black, or, when diluted with glycerine, the lighter tones, while in the parts to which the pure glycerine is applied no development ensues. So the operator, by merely spreading the glycerine, can eliminate what he pleases from the print, and convert light parts into dark, or vice versa. [As Keiley explains,] 'The great merit of this method of development lies (a) in its corrective possibilities, and that through it the manipulator is enabled to reclaim the print from the rigid bondage of the hitherto unalterable renderings of values recorded therein during the process of printing, and (b) to introduce into it his own conception of the values, tonal qualities, feeling and artistic effect of the theme under treatment.' "

An article by Keiley about the process was published in the April 1900 issue of *Camera Notes* and was reprinted later that year by the firm of Tennant and Ward as a limited-edition monograph, illustrated with facsimiles of photographs by Keiley and Stieglitz.

An article by Stieglitz entitled "Sloppiness in the Platinum Process and Its Effect" was published in the *American Annual of Photography and Photographic Times Almanac for 1902*. There he wrote,

> It is our honest belief that the ease of manipulation of the modern platinum paper is partially responsible for the sloppiness of the modern photographer. The average platinotype of today, in purity of tone and scale of gradation, is in no way comparable to that produced some ten years ago. . . . Intimacy with the process has produced a certain contempt for the precautions and care absolutely essential to obtain the best results. . . .

> We hear much of the permanency of the platinum print, and while it is undoubtedly true that careful and conscientious technical handling of the process will insure a print practically as permanent as its paper support, yet with modern sloppiness this is no longer true. It has been shown by Dr. Jacoby,

of Berlin, in a paper published in Eder's *Jahrbuch der Photographie*, 1901, that the usual process of clearing is not sufficient. . . .

Let us call a halt to our slipshod and sloppy technical manipulations and methods and revert to some measure of the old-time care and thoroughness. By this we do not mean pedantic and slavish adherence to rules and formulae, for finickiness does not imply thoroughness, and good work can never be produced without some liberty and scope of action, nor without the liberal mixture of brains with our chemicals.

THE PROGRESS OF PICTORIAL PHOTOGRAPHY IN THE UNITED STATES

It has been openly questioned whether pictorial photography is making any progress in the United States.

In England, the home of the higher pictorial photography, with its [Alfred Horsley] Hintons, [J. Craig] Annans, [George] Davisons, [Henry P. and Ralph W.] Robinsons, [Joseph] Gales, etc., no startling advance or innovation has been made in the past year or two, although the general average of the pictures shown at the various exhibitions is said to have been unusually high, showing a general advancement chiefly amongst the minor lights, the leaders seemingly satisfied to hold their own.

In Continental Europe, on the other hand, enormous strides in the right direction have been made within the last few years. Vienna, with its influential club, full of enthusiastic workers like [Hugo] Henneberg, [J. S.] Bergheim, [Hans] Watzek, [Heinrich] Kuehn, [Julius] Strakosch, and many others, has led the way in founding a new school of pictorial photography, tearing itself away from the accepted conventionalities and bringing out individualism whenever possible. The results obtained by these artists were exhibited in all the important exhibitions, of which there were many, and it was not long before their influence was made manifest, France and Germany falling into line, Paris producing its [Robert] Demachy, [Constant] Puyo, and [René] LeBègue, and Hamburg its [Theodor and Oskar] Hofmeisters, [Georg] Einbeck, and others, whose work is so full of character and marked individuality.

The gum bichromate printing process did much to arouse this dormant talent, for by means of this method the artist has at last found an unlimited means of expression. A new field of possibilities has been opened to him, and the prospects for the future of pictorial photography have become much brighter with its advent.

Gum printing is bound to revolutionize pictorial photography. Here in the States but little has been done in that line, practically nothing. Unfortu-

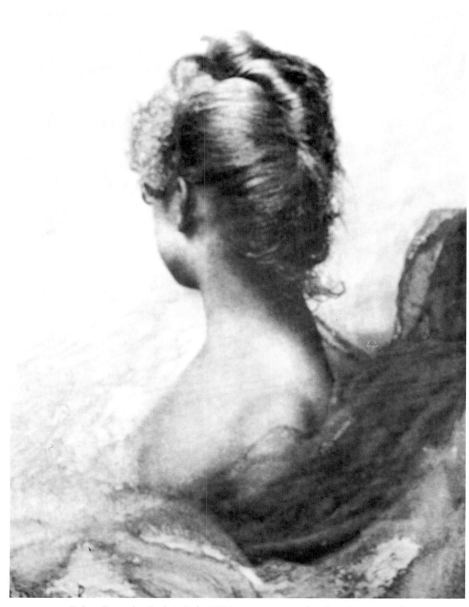

Robert Demachy, *Study in Red*, 1898 (gum print, reproduced as photogravure)

nately there has been no international exhibition in which the Viennese and French pictures might have been exhibited, and which, beyond doubt, would have renewed our lagging interest in pictorial photography.

Thanks to the lack of such exhibitions and our otherwise rather short-sighted photographic club management, we have at last managed to take the rearmost position in the race for pictorial photography supremacy, the unenviable position disputed by France and Germany but two or three years ago. True, our work is occasionally favorably commented upon when exhibited at the various European salons, still the critics there claim that as a rule our work lacks interest, vigor and individuality, and tends to prettiness and pettiness, lacking force, breadth, and strength. Strength is the backbone of art; it is strength that lives.

Gum prints have been condemned as illegitimate by many who do not seem to understand how they are produced. The writer is a strict believer in the legitimate, for he has never retouched a negative or print, and yet he claims that gum printing is as legitimate as printing with aristo. Local treatment is possible in either, that there should be more latitude in the former method in this particular is only to its credit.

We do not go so far as to advise pictorial photographers to discard all other methods of printing, for a beautiful picture in platinum or carbon remains a work of value, although it may not be quite so interesting as a photographic novelty to the photographer just at present.

Decided progress, on the other hand, has been made by a certain class of American professional portrait photographers in the last two years, so much so, that his work compares very favorably with that produced by the majority of his European colleagues.

NOTES

FROM *American Annual of Photography and Photographic Times Almanac for* 1899

It is very odd that in this article Stieglitz makes no mention of the fact that the year 1898 had seen the partial realization of one of his most cherished dreams. In October of that year, in Philadelphia, had been held a photographic salon, modeled closely on the Linked

Ring's Salon and sponsored jointly by the Photographic Society of Philadelphia and the Pennsylvania Academy of the Fine Arts. Stieglitz, who was involved in planning the Salon and who was on the jury, would, of course, have preferred for the salon to be held in New York, but the active participation of the Academy, acclaimed as the oldest and most prestigious art institution in the United States, was a powerful argument in favor of Philadelphia.

Fifteen hundred photographs were submitted from all over the world, though both the number and the quality of the entries from abroad were disappointing, and much of the American work was not impressive. The standards of the jury were so high that, according to Stieglitz, they "accepted unconditionally only 190 [photographs], placed about seventy in a doubtful class, and rejected the balance, which was about eighty percent of the whole."

One rule stipulated that no more than ten pictures by any one photographer could be hung. The only four to achieve that paramount distinction were Stieglitz himself, the seasoned and respected Mathilde Weil, and two brilliant newcomers: Clarence H. White and Gertrude Käsebier.

Despite the success of the 1898 Philadelphia Salon, Stieglitz was discouraged about the lack of progress in American pictorial photography. He claimed that the specific cause of his discouragement was the slowness of Americans to experiment with gum-bichromate printing, which was, so he reported in the October 1898 issue of *Camera Notes*, "all the rage in continental Europe," especially in Paris and Vienna.

On the other hand, continued Stieglitz, in some quarters conventional platinum and carbon prints, regardless of their actual merit, were being "generally decried as weak and ordinary" in comparison to gum prints. He felt compelled to state, therefore, that "while granting that pictures produced by the gum process may be exceedingly beautiful, and oftentimes possess a charm not obtainable by any other photographic printing process, yet a print produced by that interesting and novel printing method is not necessarily a picture. . . . [W]e contend that a real picture remains one whether produced in carbon, platinum, or gum."

Gum printing was not in accord with Stieglitz's personal aesthetic of "straight" photography, but he hoped that gum prints resembling drawings or watercolors could perhaps finally induce the philistine public to recognize photography as a fine art. Once photography had a foot in the door of the sacred precincts, and as the public was led to understand that the manipulations in gum printing were only exaggerations of what purists did in the darkroom, then "straight" photography should finally also be accepted as art.

William Henry Fox Talbot, the inventor of negative-positive photography, discovered in 1852 that an emulsion of gelatin and potassium bichromate (today called potassium dichromate) became very hard when exposed to light. This discovery eventually led to the invention of gum-bichromate printing, in 1855, by Alphonse Louis Poitevin, who

simply added carbon black to the emulsion. The thickness of the emulsion on the finished print would then determine the density of the pigment and would thereby register highlights and shadows. After 1890, photographers usually substituted gum arabic for gelatin in the emulsion, and the process became known as gum-bichromate.

To make a gum-bichromate print, the photographer first brushed onto a sheet of paper a mixture of gum arabic, bichromate, and pigment. Once the paper was dry, it was printed in contact with a negative. The greater the intensity of light that passed through a given area of the negative (and thus the darker the corresponding area of the print was to be), the deeper the hardening action extended into the emulsion. After the exposure, the print was soaked in water, which dissolved away most of the unhardened emulsion. The densest and thickest areas formed the shadows, while the thinnest areas—where the white paper backing was most visible through the translucent emulsion—formed the highlights.

Gum printing did not became popular until around 1890, when pictorialist photographers came to prize its "artistic" softness, imprecision, and coloration. The photographer could use in the emulsion a pigment of whatever color suited his fancy. He could also use any kind of artist's paper, emphasizing the prints resemblance to drawings or watercolors. Furthermore, while the surface of the print was wet, he could manipulate it with a paintbrush, illuminating details, changing tonal values, and making painterly brushmarks.

One of the foremost practitioners of, and propagandists for, the gum-bichromate process was Robert Demachy, a passionate amateur photographer who was the son of one of the wealthiest Parisian bankers. In addition to making pictorialist photographs of varying quality, Demachy wrote five books and hundreds of articles about photography. An outspoken, acerbic, and perceptive critic, he was among the principal organizers of the first Paris Salon, in 1894. Stieglitz and Demachy became close friends and carried on a warm and lengthy correspondence.

PICTORIAL PHOTOGRAPHY

About ten years ago the movement toward pictorial photography evolved itself out of the confusion in which photography had been born, and took a definite shape in which it could be pursued as such by those who loved art and sought some medium other than brush or pencil through which to give expression to their ideas. Before that time pictorial photography, as the term was then understood, was looked upon as the bastard of science and art, hampered and held back by the one, denied and ridiculed by the other. It must not be thought from this statement that no really artistic photographic work had been done, for that would be a misconception; but the point is that though some excellent pictures had been produced previously, there was no organized movement recognized as such.

Let me here call attention to one of the most universally popular mistakes that have to do with photography—that of classing supposedly excellent work as professional, and using the term amateur to convey the idea of immature productions and to excuse atrociously poor photographs. As a matter of fact nearly all the greatest work is being, and has always been, done by those who are following photography for the love of it, and not merely for financial reasons. As the name implies, an amateur is one who works for love; and viewed in this light the incorrectness of the popular classification is readily apparent.

Pictures, even extremely poor ones, have invariably some measure of attraction. The savage knows no other way to perpetuate the history of his race; the most highly civilized has selected this method as being the most quickly and generally comprehensible. Owing, therefore, to the universal interest in pictures and the almost universal desire to produce them, the placing in the hands of the general public a means of making pictures with but little labor and requiring less knowledge has of necessity been followed by the production of millions of photographs. It is due to this fatal facility that photography as a picture-making medium has fallen into disrepute in so many quarters; and because there are few people who are not familiar with

scores of inferior photographs the popular verdict finds all photographers professionals or "fiends."

Nothing could be further from the truth than this, and in the photographic world today there are recognized but three classes of photographers—the ignorant, the purely technical, and the artistic. To the pursuit, the first bring nothing but what is not desirable; the second, a purely technical education obtained after years of study; and the third bring the feeling and inspiration of the artist, to which is added afterward the purely technical knowledge. This class devote the best part of their lives to the work, and it is only after an intimate acquaintance with them and their productions that the casual observer comes to realize the fact that the ability to make a truly artistic photograph is not acquired offhand, but is the result of an artistic instinct coupled with years of labor.

It will help to a better understanding of this point to quote the language of a great authority on pictorial photography, one to whom it owes more than to any other man, Dr. P. H. Emerson. In his work *Naturalistic Photography* he says:

> Photography has been called an irresponsive medium. This is much the same as calling it a mechanical process. A great paradox which has been combated is the assumption that because photography is not 'hand-work,' as the public say—though we find there is very much 'hand-work' and head-work in it—therefore it is not an art language. This is a fallacy born of thoughtlessness. The painter learns his technique in order to speak, and he considers painting a mental process. So with photography, speaking artistically of it, it is a very severe mental process, and taxes all the artist's energies even after he has mastered technique. The point is, what you have to say and how to say it. The originality of a work of art refers to the originality of the thing expressed and the way it is expressed, whether it be in poetry, photography, or painting. That one technique is more difficult than another to learn no one will deny; but the greatest thoughts have been expressed by means of the simplest technique, writing.

In the infancy of photography, as applied to the making of pictures, it was generally supposed that after the selection of the subjects, the posing, light-

ing, exposure, and development, every succeeding step was purely mechanical, requiring little or no thought. The result of this was the inevitable one of stamping on every picture thus produced the brand of mechanism, the crude stiffness and vulgarity of chromos, and other like productions.

Within the last few years, or since the more serious of the photographic workers began to realize the great possibilities of the medium in which they worked on the one hand, and its demands on the other, and brought to their labors a knowledge of art and its great principles, there has been a marked change in all this. Lens, camera, plate, developing-baths, printing process, and the like are used by them simply as tools for the elaboration of their ideas, and not as tyrants to enslave and dwarf them, as had been the case.

The statement that the photographic apparatus, lens, camera, plate, etc., are pliant tools and not mechanical tyrants, will even today come as a shock to many who have tacitly accepted the popular verdict to the contrary. It must be admitted that this verdict was based upon a great mass of the evidence—mechanical professional work. This evidence, however, was not of the best kind to support such a verdict. It unquestionably established that nine-tenths of the photographic work put before the public was purely mechanical; but to argue therefore that all photographic work must therefore be mechanical was to argue from the premise to an inconsequent conclusion, a fact that a brief examination of some of the photographic processes will demonstrate beyond contradiction.

Consider, for example, the question of the development of a plate. The accepted idea is that it is simply immersed in a developing solution, allowed to develop to a certain point, and fixed; and that, beyond a care that it be not overdeveloped or fogged, nothing further is required. This, however, is far from the truth. The photographer has his developing solutions, his restrainers, his forcing baths, and the like, and in order to turn out a plate whose tonal values will be relatively true he must resort to local development. This, of course, requires a knowledge of and feeling for the comprehensive and beautiful tonality of nature. As it has never been possible to establish a scientifically correct scale of values between the highlights and the deep shadows, the photographer, like the painter, has to depend upon his observation of and feeling for nature in the production of a picture. Therefore he develops one part of his negative, restrains another, forces a third,

and so on; keeping all the while a proper relation between the different parts, in order that the whole may be harmonious in tone. This will illustrate the plastic nature of plate development. It will also show that the photographer must be familiar not only with the positive, but also with the negative value of tones.

The turning out of prints likewise is a plastic and not a mechanical process. It is true that it can be made mechanical by the craftsman, just as the brush becomes a mechanical agent in the hands of the mere copyist who turns out hundreds of paint-covered canvases without being entitled to be ranked as an artist; but in proper hands printmaking is essentially plastic in its nature.

An examination of either the platinum or the gum process, the two great printing media of the day, will at once demonstrate that what has already been asserted of the plate is even more true of these. Most of the really great work of the day is done in one or the other of these processes, because of the great facility they afford in this direction, a facility which students of the subject are beginning to realize is almost unlimited. In the former process, after the print has been made, it is developed locally, as was the plate. With the actual beauties of the original scene, and its tonal values ever before the mind's eye during the development, the print is so developed as to render all these as they impressed the maker of the print; and as no two people are ever impressed in quite the same way, no two interpretations will ever be alike. To this is due the fact that from their pictures it is as easy a matter to recognize the style of the leading workers in the photographic world as it is to recognize that of Rembrandt or Reynolds. In engraving, art stops when the engraver finishes his work, and from that time on the process becomes a mechanical one; and to change the results the plate must be altered. With the skilled photographer, on the contrary, a variety of interpretations may be given of a plate or negative without any alterations whatever in the negative, which may at any time be used for striking off a quantity of purely mechanical prints.

The latest experiments with the platinum process have opened up an entirely new field—that of local brush development with different solutions, so as to produce colors and impart to the finished picture all the characteristics of a tinted wash-drawing. This process, which has not yet been perfected, has excited much interest, and bids fair to result in some very beautiful work. By the method of local treatment referred to above, almost absolute control

Alfred Stieglitz, *A Decorative Panel* (On the Seine), 1894

of tonality, atmosphere, and the like is given to the photographer, on whose knowledge and taste depends the picture's final artistic charm or inartistic offensiveness.

In the "gum-process," long ago discarded by old-time photographers as worthless, because not facile from the mechanical point of view, but revived of recent years, the artist has a medium that permits the production of any effect desired. These effects are invariably so "unphotographic" in the popular sense of that word as to be decried as illegitimate by those ignorant of the method of producing them. In this process the photographer prepares his own paper, using any kind of surface most suited to the result wanted, from the even-surfaced plate paper to rough drawing parchment; he is also at liberty to select the color in which he wishes to finish his picture, and can produce at will an india-ink, red-chalk, or any other color desired. The print having been made he moistens it, and with a spray of water or brush can thin out, shade, or remove any portion of its surface. Besides this, by a system of recoating, printing-over, etc., he can combine almost any tone or color-effect. . . .

"Retouching," says Dr. Emerson, "is the process by which a good, bad, or indifferent photograph is converted into a bad drawing or painting." It was invariably inartistic, generally destructive of values, and always unphotographic, and has today almost disappeared.

With the appreciation of the plastic nature of the photographic processes came the improvement in the methods above described and the introduction of many others. With them the art-movement, as such, took a more definite shape, and, though yet in its infancy, gives promise of a robust maturity. The men who were responsible for all this were masters and at the same time innovators, and while they realized that like the painter and the engraver their art had its limitations, they also appreciated what up to their time was not generally supposed to be the fact, that the accessories necessary for the production of a photograph admitted of the giving expression to individual and original ideas in an original and distinct manner, and that photographs could be realistic and impressionistic just as their maker was moved by one or the other influence.

A cursory review of the magazines and papers the world over that devote their energies and columns to art and its progress will convince the reader that today pictorial photography is established on a firm and artistic basis. In

nearly every art-center exhibitions of photographs are shown that have been judged by juries composed of artists and those familiar with the technique of photography, and passed upon as to their purely artistic merit; while in Munich, the art-center of Germany, the "Secessionists," a body of artists comprising the most advanced and gifted men of their times, who (as the name indicates they have broken away from the narrow rules of custom and tradition) have admitted the claims of the pictorial photograph to be judged on its merits as a work of art independently, and without considering the fact that it has been produced through the medium of the camera. And that the art-loving public is rapidly coming to appreciate this is evidenced by the fact that there are many private art collections today that number among their pictures original photographs that have been purchased because of their real artistic merit. The significance of this will be the more marked when the prices paid for some of these pictures are considered, it being not an unusual thing to hear of a single photograph having been sold to some collector for upward of one hundred dollars. Of the permanent merit of these pictures posterity must be the judge, as is the case with every production in any branch of art designed to endure beyond the period of a generation.

The field open to pictorial photography is today practically unlimited. To the general public that acquires its knowledge of the scope and limitations of modern photography from professional show windows and photo-supply cases, the statement that the photographer of today enters practically nearly every field that the painter treads, barring that of color, will come as something of a revelation. Yet such is the case: portrait work, genre-studies, landscapes, and marine, these and a thousand other subjects occupy his attention. Every phase of light and atmosphere is studied from its artistic point of view, and as a result we have the beautiful night pictures, actually taken at the time depicted, storm scenes, approaching storms, marvelous sunset skies, all of which are already familiar to magazine readers. And it is not sufficient that these pictures be true in their rendering of tonal-values of the place and hour they portray, but they must also be so as to the correctness of their composition. In order to produce them their maker must be quite as familiar with the laws of composition as is the landscape or portrait painter—a fact not generally understood.

Metropolitan scenes, homely in themselves, have been presented in such a way as to impart to them a permanent value because of the poetic conception

Alfred Stieglitz, *September*, 1899

of the subject displayed in their rendering. In portraiture, retouching and the vulgar "shine" have been entirely done away with, and instead we have portraits that are strong with the characteristic traits of the sitter. In this department headrests, artificial backgrounds, carved chairs, and the like are now to be found only in the workshops of the inartistic craftsman, that class of so-called portrait photographers whose sole claim to the artistic is the glaring sign hung without their shops bearing the legend, "Artistic Photographs Made Within."

The attitude of the general public toward modern photography was never better illustrated than by the remark of an art student at a recent exhibition. The speaker had gone from "gum print" to "platinum," and from landscape to genre-study, with evident and ever-increasing surprise; had noted that instead of being purely mechanical, the printing processes were distinctly individual, and that the negative never twice yielded the same sort of print; had seen how wonderfully true the tonal renderings, how strong the portraits, how free from the stiff, characterless countenance of the average professional work, and in a word how full of feeling and thought was every picture shown. Then came the words, "But this is not photography!" Was this true? No! For years the photographer has moved onward first by steps, and finally by strides and leaps, and, though the world knew but little of his work, advanced and improved till he has brought his art to its present state of perfection. This is the real photography, the photography of today; and that which the world is accustomed to regard as pictorial photography is not the real photography, but an ignorant imposition.

NOTES

FROM *Scribner's* 26 (1899)

This important article for *Scribner's* was Stieglitz's first piece of writing to appear in a prestigious national magazine of general interest. Among the literary contributors to *Scribner's*, which was issued by the great book-publishing firm of the same name, were Edith Wharton, Henry James, Robert Louis Stevenson, and Rudyard Kipling.

When Stieglitz wrote disparagingly of "chromos," he was referring to chromolithographs. These non-photographic prints were lithographs printed in color (rather than being hand-colored) and issued by such firms as Currier and Ives. These immensely popular

prints—which ranged from reproductions of sentimental paintings to bird's-eye views of American cities—were so pervasive that American culture of the second half of the nineteenth century is sometimes referred to as "the chromocivilization."

In writing of the European "Secessionists," Stieglitz (who in 1902 would name the organization he then founded the "Photo-Secession") was referring to a movement then in the vanguard of the fine arts. Secessionism—a revolution against the waxwork nudes, the maudlin genre scenes, and the grandiose history paintings of the academic artists—had been rife in Europe, and even in America, during the 1890s. The Munich Secession was founded in 1892, the Viennese in 1897, Berlin's in 1898. In New York, the painters in the group that became known as "The Ten" (including Childe Hassam, J. H. Twachtman, and J. Alden Weir), seceded from the Society of American Artists in 1898. Secessionism embraced Realism, Impressionism, Symbolism, Art Nouveau, and the Arts-and-Crafts movement—all that was new and adventurous and modern in the arts. Because many European secessionists favored breaking down the traditional boundaries between the fine and the decorative arts, their exhibitions often included ceramics, glasswork, silverware, jewelry, furniture, and graphic designs. It was, therefore, quite natural for the secessionists to accept photography as an art form.

Secession and photography had been linked in Stieglitz's mind at least since November 1898, when the Munich Secession mounted an International Elite-Exhibition of Artistic Photographs in conjunction with an exhibition of graphic arts that included work by such artists as Aubrey Beardsley, Edvard Munch, and Henri de Toulouse-Lautrec.

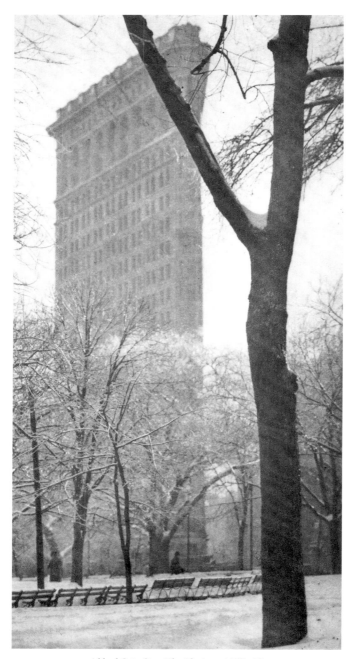

Alfred Stieglitz, *The Flatiron*, 1902–03

I PHOTOGRAPH THE
FLAT-IRON BUILDING

The Camera Club of New York was located at 3 West 28th Street when it was in its hey-day, and I was virtually its guiding spirit. It was the time when *Camera Notes*, which I founded and edited for the Club, was being published. It was the time of establishing a standard for lantern-slide making, and the standard we set affected the standard for the whole country. It even affected the standard in England.

Whenever there was a snow storm I would rush out into the street and somehow find time to make some photographs, hand-camera shots that I had had in mind for some years. The lumbering stage-coach, drawn by horses, with the driver sitting on a seat way up on top of the coach was a favorite subject of mine. I don't know how many photographs I made of this subject.

One day there was a great snow storm. The Flat-Iron Building had been erected on 23rd Street, at the junction of Fifth Avenue and Broadway. I stood spellbound as I saw that building in that storm. I had watched the building in the course of its erection, but somehow it had never occurred to me to photograph it in the stages of its evolution. But that particular snowy day, with the trees of Madison Square all covered with snow, fresh snow, I suddenly saw the Flat-Iron Building as I had never seen it before. It looked, from where I stood, as if it were moving toward me like the bow of a monster ocean steamer, a picture of the new America which was in the making. So day after day for several days, while the snow was still covering Madison Square Park, I made snapshots of the Flat-Iron Building.

One of these pictures I enlarged. That is, I had a photogravure made from the original negative, in fact, two photo-gravures, different sizes, both enlargements of the original negative, and proofs pulled under my direct supervision. One enlargement was to be inserted into *Camera Work*; the other one was larger, about 11-by-14. This larger photogravure was one of a series of large prints I had in mind to be made for a portfolio, to be called *Fifty Prints of*

New York. This series that I had in mind was never completed. I always permitted my own photographic work to be side-tracked by other affairs having to do with photography—affairs which needed constant attention: *Camera Notes*, the Camera Club, *Camera Work*, the Photo-Secession, 291, etc., etc.

When I look back to those days, when the Flat-Iron Building in the snow storm, in various lights, was such a passion of mine, I think of my father, who met me one day while I was standing in the middle of the Fifth Avenue thoroughfare, photographing it. He said, "Alfred, how can you photograph that hideous building?" I remember my reply, "Why, Pa, it is not hideous. That is the new America. It is to America what the Parthenon was to Greece." He was horrified. He had not seen the steel-work as the building had gone up, as it had started from the ground, and had also partly started from the top. He had not seen the men working as I had seen them. He had not seen the seeming simplicity of that, to me, amazing structure, the lightness of the structure, combined with solidity.

He did admire the photograph I had made when I showed it to him. He remarked, "I do not see how you could have produced such a beautiful thing from such an ugly building."

And when I saw the Flat-Iron Building again, after many years of having seen other tall buildings in New York City suddenly shooting into the sky, the Woolworth Building and then still others, the Flat-Iron Building did seem rather ugly and unattractive to me. There was a certain gloom about it. It no longer seemed handsome to me; it no longer represented the coming age. It did not tempt me to photograph it. What queer things we humans are. But the feeling, the passion I experienced at that earlier time for the Flat-Iron Building still exists in me. I still can feel the glory of those many hours and those many days when I stood there on Fifth Avenue lost in wonder, looking at the Flat-Iron Building.

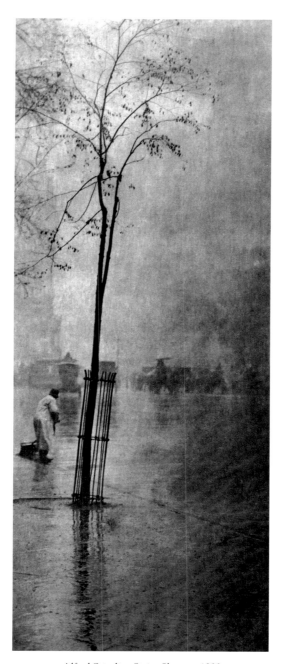

Alfred Stieglitz, *Spring Showers*, 1900

FROM *Twice A Year*, NO. 14/15 (FALL–WINTER 1946–47)

Construction of the twenty-story Fuller Building, at the intersection of Fifth Avenue, Broadway, and Twenty-third Street, began in 1901. It was nicknamed the Flat-Iron (or Flatiron) Building because its triangular ground-plan brought that implement to mind.

Stieglitz didn't photograph the building until the winter of 1902–03, by which time construction had been completed. Over the course of several days he photographed the building in various lights. The most famous of the resulting images—a view from Madison Square, looking down Fifth Avenue—he cropped to a narrow vertical, in which the Hiroshige-like forked tree that soars in the foreground echoes the triangular plan of the building.

He was pleased with his picture of the Flat-iron and published it, along with both an article and a poem by Sadakichi Hartmann celebrating the building, in the October 1903 issue of *Camera Work*, which featured F. H. Evans's photographs of cathedrals. Stieglitz even announced that when he died, he would like to have his ashes cast into the wind from the top of the building.

In 1900 he had stood in Madison Square and aimed his camera down Fifth Avenue to make the photograph he entitled *Spring Showers*; one can barely make out, on the right, the tall cupolaed building that still stands at Twenty-second Street and, on the left, the old Erie Railroad office, which was torn down to make way for the Flat-iron.

In a 1920 letter Stieglitz wrote that in his early work he had wanted to document "the New York of transition.—The Old gradually passing into the New. . . . the Spirit of that something that endears New York to one who really loves it—not for its outer attractions—but for its deepest worth—& significance.—The universal thing in it." Together, *Spring Showers* and *The Flat-Iron*—both of them cropped to narrow verticals—constitute Stieglitz's most beautiful before-and-after study of New York in transition.

from THE ORIGIN OF THE PHOTO-SECESSION AND HOW IT BECAME 291 (I)

The Camera Club of New York was in its hey-day. I had taken the dying Society of Amateur Photographers and the all but dead N. Y. Camera Club and called forth a live body. An amalgamation of the dying and the dead. The members of both bodies believed that photography as a passion had come to an end for all time. This was in the 1890s.

I gave the Camera Club all my time and thought. I had founded *Camera Notes* as a quarterly organ of the Camera Club. It was the making of the Camera Club.

As always, without a break, from 1883 in Berlin on, I was fighting for photography. *Camera Notes* was a battle field as well as a bugle call. Members of the club received *Camera Notes* free of charge and many sold the four numbers of a year for twenty to thirty dollars, so covering their membership dues to the Camera Club, which were twenty dollars a year. The edition was limited to a thousand.

The battle of photography was raging in this country as well as in Europe. Art institutions had become involved. I had very definite ideas, without any formula. From the very beginning I felt convinced that photography could be a new, additional medium of expression, possibly a creative one.

Gertrude Käsebier, Holland Day, Clarence H. White, Frank Eugene, Joseph T. Keiley, Steichen, Coburn, all unknown at the time, were gradually discovered by me and became an integral part of my fight for photography, as I understood photography. They were all Americans.

There was warfare finally in the club itself. The bulk of the members did not see why I shouldn't consider the Camera Club primarily as a social institution before considering photography itself.

It so happened that I had helped draw up the constitution of the club. Its first article read, "The Camera Club is founded to further the art and science of photography." I was guided by that.

Frank Eugene, *The Man in Armor* (Self-portrait), 1898

Everywhere in the world where photography played any role I was looked upon as the leading spirit in American photography, and as such I was called upon to send collections of American photographs to this and that international exhibition.

Such collections were never sent unless the conditions that I laid down were accepted without reservation. Only in this way, I felt, would the Art Institutions (for it was these that I was dealing with) respect the spirit of my endeavor. I was ever really fighting for a new spirit in life that went much deeper than just a fight for photography. Steichen's work, and that of Clarence White, Keiley and Käsebier was so "new" as photography that their work was looked upon in the conservative ranks that were in control in the world as preposterous, as so much insolence—a challenge to the decencies of photography and good taste. It was the old story of a new vision supplanting the dead, or supplanting the lack of all vision.

I did not know that in time I would be broadening the fight, a fight that involved painters, sculptors, literary people, musicians, and all that is genuine in every sphere of life.

A club had been formed called the National Arts Club. Charles de Kay, the art editor and late editor of the *New York Times*, brother-in-law of Richard Watson Gilder, the poet, and editor of the *Century Magazine* when the *Century Magazine* was a real force, was its founder and its director. As the latter he received a munificent salary.

One day he appeared at the Camera Club and said, "Stieglitz, why don't you show these American photographs in New York—the photographs that you send abroad to art institutions and that are creating such a stir there?"

I told him that there was no place in New York fit to hold such a show, and there wasn't. At the time the American prints I had sent to the opening of the New Glasgow Art Galleries at the request of J. Craig Annan, a great photographer himself, were on their way back to this country.

De Kay said, "Why can't we have those prints that were shown in Glasgow?"

"Well, de Kay," I said, "if your club will give me a room, in your gallery, to show such prints as I see fit, and let me hang them in my own way, not a soul coming into the room before I open the doors, it's a go."

"But how about our art committee?"

"I do not recognize committees. Either you want to show or you don't.

Your committee will probably say, 'Let that crazy man go ahead.' "

The next day he came and he said, "I was told, 'Let that crazy man go ahead.' "

So the exhibition found its way to the walls there. I made Steichen the concert master of the orchestra. Steichen himself was in Paris—when I say Steichen, I mean his prints.

As soon as de Kay had given me permission to go ahead he said, "Now we've got to have some publicity. What will we call this?"

I said, "Anything you like—preferably *An Exhibition of American Photographs*."

"That will attract no attention," he said. "Why not *Exhibition of American Photographs arranged by the Camera Club of New York?*"

"Why, the members of the Camera Club, the big majority, hate the kind of work I'm fighting for."

"Well, why not *Exhibition of American Photographs arranged by Alfred Stieglitz?*" he said.

"No, no, they'd hang me on the first lamp post. That I wouldn't mind, but I don't want my name exploited. De Kay," I said, "I've got it—it's a good one— call it *An Exhibition of American Photography arranged by the Photo-Secession*."

"What's that?" he asked. "Who is it?"

"Yours truly, for the present, and there'll be others when the show opens. The idea of Secession is hateful to the American—they'll be thinking of the Civil War. I'm not. Photo-Secession actually means a seceding from the accepted idea of what constitutes a photograph; besides which, in Europe, in Germany and in Austria, there've been splits in the art circles and the moderns call themselves Secessionists, so Photo-Secession really hitches up with the art world. There is a sense of humor in the word Photo-Secession."

He raced away and the next morning there was a long editorial in the *New York Times* about the coming exhibition of American photographs arranged by the Photo-Secession and to be held at the National Arts Club. At the opening, when Käsebier appeared—it was a blizzard night—she said to me, "What's this Photo-Secession? Am I a Photo-Secessionist?"

My answer was, "Do you feel you are?"

"I do."

"Well, that's all there is to it," I said.

Gertrude Käsebier, *The Red Man*, 1903

Then a man who was secretary of the Architectural League and a member of the Camera Club, a future president of the Camera Club, and who was on several committees in the National Arts Club and occasionally made a photograph of a nude which was halfway acceptable—one of them hanging on the walls of this exhibition—came to me and said, "Stieglitz, am I a secessionist?"

I said, "No."

It didn't take long before the Photo-Secession was known all over the world. It was a force for light.

NOTES

FROM *Twice A Year* 8–9 (1942)

In the fall of 1900, J. Craig Annan asked his fellow Link Stieglitz to select seventy photographs to represent America in the photographic section of the Glasgow International Arts and Industrial Exposition, to be held from May through October 1901, to mark the opening of the new Glasgow Art Gallery and Museum. This was to be the first international exposition in which photography would have its proper place in the fine arts section, to be housed in the new museum.

Stieglitz assembled a collection photographs by thirty Americans, dominated—as would be all of his projects for the next several years—by his own work and that of Eduard J. (later simply Edward) Steichen, Gertrude Käsebier, Clarence White, Joseph Keiley, and Frank Eugene, each of whom was represented by five prints.

Stieglitz invited F. Holland Day, a wealthy and eccentric Bostonian member of the Linked Ring, to send several prints, but he declined. Friction between him and Stieglitz had arisen in 1900, when Day assembled a collection of photographs to be shown in London as "An Exhibition of Prints by the New School of American Photography." Stieglitz persuaded the Linked Ring to refuse the show, which was then taken by the Royal Photographic Society. Stieglitz continued to admire Day's work, but the latter never forgave his rival and refused to participate in any of his ventures. Stieglitz sent two Days from his own collection to Glasgow.

Late in the fall of 1901, Stieglitz explored the possibility of renting gallery space in New York to exhibit the photographs that had been triumphantly shown in Glasgow. He also resolved that the time had finally come to found an American version of the Linked Ring, which would, in the coming years, mount an annual salon that would replace Philadelphia as the premiere event in American photography—and perhaps even eclipse the Linked Ring's Photographic Salon.

Before he could find a venue to rent, Stieglitz was approached by Charles de Kay—the

art editor of the *New York Times* as well as a founder and the managing director of the National Arts Club—about mounting "an exhibition of select artistic photographs" at his club. Although the exhibition would draw heavily upon the Glasgow prints, Stieglitz was to revise and enlarge that collection.

American Pictorial Photography, arranged by the 'Photo-Secession' opened on the evening of Wednesday, March 5, 1902, at the National Arts Club, which was then located at 37 West Thirty-fourth Street. Despite a raging blizzard, the audience attending Stieglitz's opening-night lecture, "Pictorial Photography and What It Means," included such celebrities as the Duke of Newcastle and the Pre-Raphaelite painter Sir Philip Burne-Jones.

Stieglitz had more than doubled the size of the Glasgow collection for the exhibition, primarily by increasing the number of prints by his favorites. He also added the work of nine minor photographers—presumably so that he could claim that "all recognized workers of repute who had proven themselves in thorough sympathy with the spirit of the modern movement were invited to contribute, regardless of their photographic affiliations."

Charles I. Berg, a member of the National Arts Club and a vice president of the Camera Club, with three prints in the exhibition, was the photographer who asked whether he was a Photo-Secessionist, only to be coldly told by Stieglitz that he was not.

As Stieglitz's conception of the Photo-Secession evolved during 1902, it would be dominated by a council of founding Fellows, which would include all of the American members of the Linked Ring. At the heart of the council he hoped to have, in addition to himself as Director, the seven photographers whose work he then admired most: Day, Eugene, Käsebier, Keiley, Steichen, White, and William B. Dyer, a Chicago professional photographer who specialized in portraiture and book illustration. One of Stieglitz's greatest disappointments was that Day declined his repeated invitations to join, as did C. Yarnall Abbott and Rudolf Eickemeyer, other American Links.

Also among the founding Fellows were *Camera Notes* editorial associates Dallett Fuguet and John Francis Strauss. Two others were John Bullock and Robert Redfield, talented photographers whom Stieglitz esteemed as much for having founded the Philadelphia Salons as for their own pictures. The remaining Fellows were Eva Watson-Schütze, Mary Devens, and Edmund Stirling, all of whom were members of the Linked Ring. The secondary status of Associate was at first granted to thirty photographers and patrons.

In the *American Annual of Photography and Photographic Times Almanac for 1904*, Stieglitz wrote, "The Secession admits to membership all who sympathize in its endeavors, regardless of their rank as picture-makers, but it jealously excludes even the greatest photographers, if these are not honestly in accord with its fundamental principles. It is for these reasons that membership has been divided into Associateship and Fellowship, and the latter bestowed only upon such of its adherents whose work in or for photography has entitled them to that distinction; and so strict has been the judgment upon those desirous of Fellowship that it has become an honor not easy to secure. To Associateship all honest friends are welcome." The Photo-Secession would eventually list 120 members, of whom nearly one quarter were women.

F. Holland Day, *Street in Algiers*, ca. 1900

THE PHOTO-SECESSION AT THE NATIONAL ARTS CLUB, NEW YORK

When, in 1898, the first Philadelphia Salon was organized by the Photographic Society of Philadelphia and the Pennsylvania Academy of the Fine Arts, it was doubtful in the writer's mind whether the management of the Salon appreciated how high a standard it was necessary to maintain in order to justify the pretentious appellation of "Salon" which had been given to the exhibition. It was this use of so high-sounding a title which was largely the cause of the misunderstanding and recrimination that ensued.

The first three of these Salons were more or less representative of the best in American photography, despite the attacks, criticisms, and abuse heaped upon all who were connected with them—such abuse becoming most pronounced in connection with the third and best of this series. In that year Philadelphia had reached a position in American photography comparable to that held by the "Linked Ring" Exhibition in London, although it was already apparent that the Philadelphia Society had not yet learnt that a Salon did not become such by dubbing it with that title, and in the selection of the Management of the fourth Salon it was proved that the intention of holding an ordinary old-fashioned photographic exhibition still obtained among the rank and file of its members. Clearly the Salon had outgrown the artistic capacity of the Society. This was made manifest by the action of the Society in deliberately turning its back upon all that had been thus far accomplished.

In direct consequence of inability to appreciate the ideals which had been striven for, a large majority of the best American pictorialists of the "New School" refused to support the exhibition of 1901, deeming it recreant to those principles which they had upheld in the past. Though deemed by some superior to any of its predecessors, the art critics as well as the more serious workers considered the fourth Philadelphia Salon a retrogression from past standards so marked as to stamp it a failure as a first-class exhibition. The Philadelphia Photographic Society, as well as the Pennsylvania Academy of the Fine Arts,

have since acquiesced in this conclusion and will make no attempt to hold a Salon in the present year, realizing that these Salons have lost the confidence of those whose support is essential to the success of any first-class exhibition.

So distasteful to me and my friends had become the endless bickerings and bids for notoriety engendered by these Salons, that I hailed as opportune any occasion which would enable me to cut loose from allegiance to any organized body. Nor had I long to wait for this opportunity. The National Arts Club of New York, at this time, expressed to me its wish that I should hold an exhibition of my own work in its galleries, but willingly acquiesced in my suggestion that such exhibition be made representative of all that was best in American photography according to modern ideas, rather than to hold only a one-man show. To achieve the end I had in view, I enlisted the aid of the then newly organized and limited "Photo-Secession," and it was determined to hold the forthcoming exhibition under the auspices of that group. All recognized workers of repute who had proven themselves in thorough sympathy with the spirit of the modern movement were invited to contribute, regardless of their photographic affiliations. Thus was gathered together an invitation exhibition of the picked work of the foremost American pictorialists, which proved an object-lesson of the seriousness and merit of modern American photography of which the public of New York had previously been comparatively in ignorance.

The details having been left to me by the National Arts Club, I deemed it in the best interests of photography to limit contributions to this exhibition to invited exhibitors only, reserving the right to reject such prints as were not the choicest examples of the subject extant. The heartiness of response which was accorded these invitations proved to my mind the timeliness of this innovation in the conduct of photographic exhibitions of this character.

The interest displayed by the hordes of visitors amply repaid us for our efforts. For the first time the art-loving public of New York was made acquainted with the claims of photography for recognition as an art; and art critics, public, and the National Arts Club unanimously accorded this exhibition a first place among the many exhibitions held in the galleries of that institution. The daily press devoted much space in their art columns and editorials to criticisms and reviews, and even so conservative a monthly magazine as *The Century* became converted from its long opposition to the pretension of pictorial photography, to an appreciation great enough to publish a lengthy

illustrated article on the Photo-Secession and modern pictorial photography. Naturally not all criticisms were equally favorable, but even those hostile to the artistic claims of our craft appreciated the earnestness of the workers, and some went so far as to admonish painters that for originality, feeling, serious-ness, and truth underlying this whole exhibition they could learn much from these photographers.

Many pictures exhibited had been loaned by private collectors and were not for sale—yet the public expressed its appreciation by the purchase of some at substantial figures, and the offer in one case of as much as three hundred dollars for a single well-known print, an offer which was refused by the owner.

In the hanging, all the work of each contributor was grouped together, to enable the visitor to make a comparative study of the individual work and scope of the photographer. Great care had been taken to place each picture so that its tone, color, and line would harmonize with its surroundings, and in consequence many of the pictures which had already been shown at previ-ous exhibitions were imbued with new beauty, and their full worth was for the first time displayed. Let this be a hint to hanging committees generally, that a modern pictorial photograph, in which tone is so important an ele-ment, may be as easily "killed" by inappropriate surroundings as any oil painting. The good taste and judgment displayed in the decorative scheme, and in the hanging, which played such important parts in the success of the whole, were mainly due to the personal efforts of Mr. Joseph T. Keiley.

The exhibitions comprised the work of the following ladies and gentle-men, the numeral in parentheses following the name showing the number of frames of each hung:

C. Yarnall Abbott (5); Prescott Adamson (2); Arthur E. Becher (3); Chas. I. Berg (3); Alice Boughton (2); John G. Bullock (2); Rose Clark and Eliza-beth Flint Wade (3); F. Colborn Clarke (1); F. Holland Day (11); Mary M. Devens (5); Wm. B. Dyer (14); Thos. M. Edmiston (2); Frank Eugene (10); Dallett Fuguet (1); Thomas Harris, deceased (1); Gertrude Käsebier (14); Joseph T. Keiley (15); Mary Morgan Keipp (1); Oscar Maurer (2); Wm. B. Post (2); Robert S. Redfield (2); W. W. Renwick (1); Eva Watson Schütze (8); T. O'Conor Sloane, Jr. (1); Ema Spencer (1); Eduard J. Steichen (14); Alfred Stieglitz (17); Edmund Stirling (3); Henry Troth (1); Mathilde Weil (3); and Clarence H. White (13).

Not only was the exhibition national in the localities represented, but, strangely enough, all printing media from aristo to "gum-bichromate" on the one hand, and bromide to "glycerine platinotype" on the other, were embraced, thus showing that the Photo-Secessionist is committed to no other medium than that which best lends itself to his purpose.

The huge success of this first exhibition held under the auspices of the Photo-Secession has led to an expansion of its organization. It is to be expected that its influence will be potent in guiding many future important exhibitions along the lines thus mapped out. Rumor has it that it has already drawn to itself a considerable body of the lovers and patrons of pictorial photography, as well as most of those workers who are laboring in behalf of similar ideals. How influential this organization will prove time will demonstrate, but no doubt the spirit which has governed its first exhibition will be extended hereafter, and the only road to the endorsement of the Photo-Secession will be that of an artistic and progressive spirit. For the present, the details of organization of this body must be denied to the public, but suffice it that it has drawn to itself almost all of those who have made American pictorial photography what it is today.

————— NOTES —————

FROM *Photograms of the Year* 1902

The jury of the Philadelphia Salon of 1900, composed of Stieglitz and four of his friends—Gertrude Käsebier, Clarence White, Frank Eugene, and Eva Watson-Schütze—selected for hanging only 112 prints out of the approximately 1,000 that had been submitted. An additional eighty-six photographs by the judges and their cronies were hung *hors concours.* "Of course, the photographic world is in a great stew over it all," crowed Stieglitz, "but that will end in good instead of harm." He felt that the Philadelphia Salon had finally achieved a position in American photography comparable to that of the Linked Ring exhibition in Britain. But many photographers and editors were outraged by such elitism.

In the spring of 1901 the conservative members of the Philadelphia Photographic Society, calling themselves "the Rationalists" or "the Old School," revolted against the domination of the New School, which they ridiculed as the "Mop and Pail Brigade" or the "Photographic Oscar Wildes." The Rationalists announced their intention of making

the Salon inclusive rather than exclusive. Running on that platform, one of their number was elected president. The Rationalists also gained control of the Salon committee, which promptly resolved to exhibit scientific and documentary photography together with artistic. To serve on the jury, the committee chose a conservative Philadelphia photographer, along with Charles I. Berg and Frances Benjamin Johnston, both of whom were sympathetic to the Old School. Stieglitz boycotted the exhibition and persuaded most of his friends at home and abroad to do likewise. F. Holland Day was the only major Pictorialist to show. In the wake of this fiasco, the Philadelphia Photographic Society and the Academy decided not to hold a salon in 1902.

Many conservative photographers naturally blamed Stieglitz for the death of the Philadelphia Salons, and that accusation haunted him for years. When it resurfaced in 1910, at which time he was organizing a major exhibition in Buffalo, New York, he defended himself by privately printing a pamphlet that he entitled *Photo-Secessionism and Its Opponents: Five Letters.* It opens with Stieglitz's statement that "self-seeking and jealousy are the root of virtually all intrigue. In no field of activity is this truer than in that of photographic ambitions. . . . " He goes on to speak of "the petty intrigue that has been going on continuously for some years in the photographic world."

The second of the pamphlet's letters—dated June 16, 1910—was addressed to Walter Zimmermann of the Philadelphia Photographic Society. In it Stieglitz wrote: "It is true that ten years ago the Philadelphia Society achieved a 'world-wide reputation' through its Salon. But is it not a fact that the Society as at present constituted was actually directly responsible for the killing off of these very exhibitions?"

Clarence White, *Spring*, 1898

PAINTERS ON
PHOTOGRAPHIC JURIES

Most of the leading pictorial photographic workers of the world have long since definitely come to the conclusion that jurors for their exhibitions must be drawn from their own ranks. This conclusion has been arrived at after long experience and many experiments. For years, photographers have resorted to the cooperation and assistance of such painters and sculptors as were available, these, as a rule, representing the conventional idea of an "artist"; by which is meant such painters and sculptors as have virtually no prestige amongst the artists themselves, but who frequently stand very high in the estimation of the average public.

As pictorial photography advanced, and the leading photographers came to have a truer comprehension of the real artistic possibilities of their medium of expression, it was realized that, in order to establish pictorial photography as a recognized art, those interested and practicing it would have to select their judges from their own ranks. This idea, together with other causes, was one of the prime factors in the establishment of the London Salon, in which, for the first time in the history of photographic exhibitions, pictorial photography stood absolutely on its own feet. The prime movers in this secession from the exhibition of the Photographic Society of Great Britain (now the Royal Photographic Society), until then the most famous and oldest of photographic exhibitions, were men who for years had been practicing pictorial photography, who had forced its first real serious recognition, and who had been singled out, by artists and even not infrequently by the "artists," as men worthy of artistic recognition, and fully competent to judge the artistic worth of pictorial photographs generally.

With the advent of this organized movement, British photography advanced by leaps and bounds, notwithstanding the ridicule of almost the entire British photographic press and the large majority of British photographers. As the Salon encouraged individuality, new ideas and methods, it

received recognition from sources better able to judge the artistic value of its endeavors than are the mass of conventional photographers and the equally conventionalized press. What the Salon has been to pictorial photography, those honestly and impartially interested in its history and progress know so well as to make it unnecessary for us to dwell upon here. The very fact that these photographers depended entirely upon themselves has resulted in making them infinitely more competent to deal with all matters affecting their art than they would have been had they remained in the old rut.

It was only through the adoption of this independent course, much as it may have been ridiculed by press, photographers at large, artists, and even "artists," that respect for the earnestness of the worker was gradually forced from their most bitter opponents, and eventually it also proved to have been the direct cause of the recognition today universally accorded to pictorial photography.

Though there were photographers on the continent working along advanced lines, no organized or recognized pictorial movement then existed outside of England. In America, at this same time, pictorial photography was in its embryonic state and in a seemingly hopeless condition. Developed and fostered by the enthusiasm of a few individuals, it was instilled with life by their seriousness and steadfastness of purpose. With the advent of the first Philadelphia Salon, 1898, came the adoption of all the London Salon ideas except those relating to the selection of its judges and the awarding of diplomas to those having pictures hung. Why the method of selecting the judges was excepted can readily be explained. At that time, this country had but few pictorial photographers whose names carried enough weight in the photographic world to permit the formation of a jury composed entirely of photographers, even though the management had desired to secure such a jury.

Owing to the ignorance of the American public, including the bulk of the American photographers themselves, as to the seriousness and real purpose of this movement, it was absolutely essential to imbue this first exhibition with an artistic tone so convincing that the public mind could be left in no doubt as to the artistic character of the photographic Salon. The writer, a member of the "Linked Ring," when he accepted, together with Robert Redfield (photographer), and three painters of repute (Chase, Vonnoh and Mrs. Stephens), the invitation to act as one of the judges at this Salon of '98, fully

realized the shortcomings of the system there adopted; as he had served on innumerable mixed juries in Continental Europe he had had ample opportunity to note artists' idiosyncrasies as displayed in judging photographs. Despite the assurances of the management of this first American Salon, the writer was nevertheless skeptical whether the appointed painters would do justice to that task which they had undertaken. As was anticipated, at the day appointed, Messrs. Chase and Vonnoh failed to put in an appearance, having *"more important duties to perform elsewhere."* Thus, history again repeated itself. The photographers, more conscientious than the artists, performed that duty which the latter shirked, and the jury, instead of being constituted with painters in the majority, as originally designed, was, in reality, a jury on which photographers predominated. That the artists were entirely satisfied with the artistic judgment of the photographers on this jury is placed on record beyond any possible dispute, by the confirmatory act of having affixed their signatures to the diplomas issued by the management on this occasion.

This Salon called forth much new talent, amongst whom the following were most conspicuous: Clarence H. White, Käsebier, Day, Keiley, and Eva L. Watson[-Schütze]. The pictures of these photographers created such a sensation that at the second Salon, the Philadelphia Photographic Society appointed as its jurors: Miss Johnston, F. H. Day, and H. Troth; while the Art Academy, recognizing the entire ability of certain photographers to replace the painter and to pass final judgment on the artistic merit of a pictorial photograph, forewent its prerogative to appoint painters or sculptors and appointed Clarence H. White and Gertrude Käsebier as its representatives upon the jury. Thus, in the second year of the Salon, practically all the principles of the "Linked Ring" were finally officially confirmed and established by the Pennsylvania Academy of the Fine Arts.

In the meantime, American photography was beginning to attract attention throughout the world, astonishing the art-loving public by its unusual and revolutionary productions and ideas. The earnestness of purpose displayed in these Salons and the serious recognition accorded to the pictorial worker in his efforts to advance the "Cause," resulted in drawing from their retirement many who hitherto had refrained from exhibiting at all because of the insincere character of most of the former so-called pictorial photography

exhibitions in this country. American photography, in consequence, suddenly acquired such an impetus as to make itself felt wherever interest was taken in the development of this new branch of art expression.

And how was all this accomplished? Solely through the uncompromising attitude of the leaders in proclaiming the independence of their art and maintaining its entire ability to look after its own interests.

The cry for painters on juries is doubly absurd at this time, when Mr. Steichen, whose ability as an artist, indeed an artist of exceptional merit, was first recognized and proclaimed by *photographers*, at last has forced the most conservative of all Art Juries, that of the Champs de Mars Salon, to acknowledge his photographic work worthy of ranking with the arts.

As is well known, the Salon of the Champs de Mars, at Paris, is universally considered as *the* Art Exhibition of the year, and it is the great ambition of all artists to win the favorable recognition of its jury.

The Photo-Salon of Paris has been cited as an example of the advisability of having a jury composed of non-photographic artists solely, and it is worthy of note, that the Paris Photo-Salon in no way approaches artistically that of the "Linked Ring" of London or any Philadelphia Salon prior to that of 1901. Messrs. Demachy, Steichen, Day and others, who are familiar with these exhibitions and who rank amongst the foremost of pictorial photographers, bear testimony to this. In fact, we understand that it is the opinion of Mons. Demachy that French photography does not rank with that of England, Austria or America, although it has undeniably produced some of the most prominent and active of pictorial photographic workers. Judging by the results achieved in England and America, where aggressive methods to force issues were employed by the original leaders, is it not probable that, if French photographers were more independent, aggressive and possessed of greater faith in the possibilities of photography, this foremost of all art-countries would take the lead? French photography certainly seems to have suffered through its dependence upon the painters for its advancement.

Mons. Demachy himself, although one of the ablest and foremost of the world's pictorial photographers, did not anticipate that his own Paris would be the first to recognize the right of a photograph to admission to an exhibition such as the Champs de Mars. The mere idea of insisting that photography receive recognition as a fine art on equal basis with the other means of

graphic art expression at the Paris World's Exhibition of 1900—a condition insisted on by the writer, when requested by the American Government to collect pictorial photographs to represent the United States officially at this exhibition—this Mons. Demachy considered as most ridiculous and unreasonable. And it was left to an American now to prove the logic of this request by forcing the recognition so long sought for.

Painters as a class, notwithstanding all that has been accomplished, do not today take pictorial photography seriously. Nor is this surprising, as they have not devoted any time or attention to the study of the possibilities of the camera as a medium of art expression. They have confined themselves to the study of their own specialty, and have been acquainted with photography only in a casual way. The leading photographic workers on the other hand, have not only studied the technical side of photography, but have likewise devoted their energies and talents to acquiring such an artistic training as is essential to all those desirous of doing honest and sincere work. By technique, as here used, is meant such knowledge of the nature and application of the tools and methods employed as is necessary for the proper expression of those ideas or themes intended to be portrayed. Possibly the main reason which prompts the urging of painter-juries is the popular conception that, because the great mass of photographers have had little or no training in art and are unfamiliar with its simplest principles, advanced pictorial photographers likewise have acquired no knowledge in this direction. Nothing could be further from the truth. The example of these leaders, together with the results achieved by them, has shown to the new workers the necessity of equipping themselves for their calling by a thorough training in art, as a preliminary to a knowledge of photography.

When artist-bodies at length begin to realize that pictorial photographers *may be* artists in feeling and education, their attitude must change. When this changed condition is reached, we predict that at exhibitions open to all media of art, photographers will be called upon to judge photographs, just as the sculptor is called upon to judge statues; the landscapist, landscapes; the marine painter, marines; the "figure-man," figure work; the etcher, etchings; the architect, architecture, etc.

It may not be generally known that at the big art exhibitions the jury, though composed of representatives of all the arts exhibited, make it a practice

of requiring the specialists to pass judgment upon the exhibits representing their own class of work, and that only in those cases in which the specialists fail to agree, does the mixed jury undertake to decide. It follows that this rule must be applied to photography, as only a photographer has sufficient knowledge to pass upon photographs. Then it will be considered just as absurd to require a painter to pass judgment upon photographs, as it is considered today for a painter to pass upon statuary.

NOTES

FROM *Camera Notes* 6 (JULY 1902)

By the turn of the century Stieglitz was fed up with the Camera Club's philistinism, and he was thinking about creating a new organization, which he originally intended to call the Pictorial League, with "no president no secretary no dues no club rooms no regular meetings."

Events at the Camera Club finally brought matters to a head. At a special meeting of the club in December 1901, called to discuss Stieglitz's elitism, one of the anti-Stieglitz members, Ferdinand Stark, proposed that the club should hold regular intramural competitions in which the members would vote for their favorite pictures. The three receiving the largest number of votes would be reproduced in *Camera Notes*. For once, Stieglitz agreed on a compromise. He would accept the proposition if he could also reproduce three prints chosen by a jury of artists—by which he meant painter-photographers drawn from the ranks of the Pictorialists he most admired. It would be an interesting and perhaps even instructive exercise, for the Camera Clubbers would yet again be reminded how far their taste fell short of true artistic judgment.

There the matter rested until February 17, 1902, when Messrs. Stark and C. H. Crosby (who was soon to be elected president of the club) released a circular announcing the rules of the first competition, to be held from May 1 to 15. All was pretty much as had been agreed, except that the jury of three artists was to be composed of non-members chosen by Stark and Crosby, thereby excluding such painter-photographer members as Gertrude Käsebier and Frank Eugene. Stieglitz correctly assumed that the jury would therefore consist of minor painters; invitations were soon issued to the undistinguished William A. Coffin, Louis Loeb, and Frederick S. Church (not to be confused with the famous Frederic Edwin Church).

Stieglitz, surely feeling tricked and betrayed, must have been furious over this victory for the philistines. He felt he would have to print six dreadful photographs in *Camera Notes* instead of edifyingly juxtaposing three bad and three good. That was the last straw.

He immediately resolved to establish a new organization, which he decided to call "The Photo-Secession." He always cited February 17, 1902, as the date it had been founded—though historians, failing to understand the significance of the Stark-Crosby circular, have expressed puzzlement about what happened on that day to precipitate his move. The July 1902 issue of *Camera Notes*, in which "Painters on Photographic Juries" appeared, was the last issue that Stieglitz edited. Although he resigned from the magazine, he would remain a member of the Camera Club until 1908.

The question of the composition of photographic juries would figure largely in Stieglitz's public statements over the course of the next year. In the lecture he gave at the opening of the National Arts Club exhibition he made a special point of stressing that a painter was by no means necessarily an artist—a remark that those in the know would have understood to be a criticism of Coffin, Loeb, and Church.

In an unsigned editorial published in the second issue of *Camera Work* (April 1903), Stieglitz would write that he strongly opposed juries composed of "painters and sculptors ignorant of photographic technique." Nevertheless, he went on to concede that "given a jury of painters, etc., familiar with the processes, scope and limitations of photography and themselves imbued with the full spirit of art, untrammeled by convention or prejudice, we stand ready to hail them as *the ideal jury*." In other words, to have one's work admired by an artist such as Whistler would be the ultimate accolade.

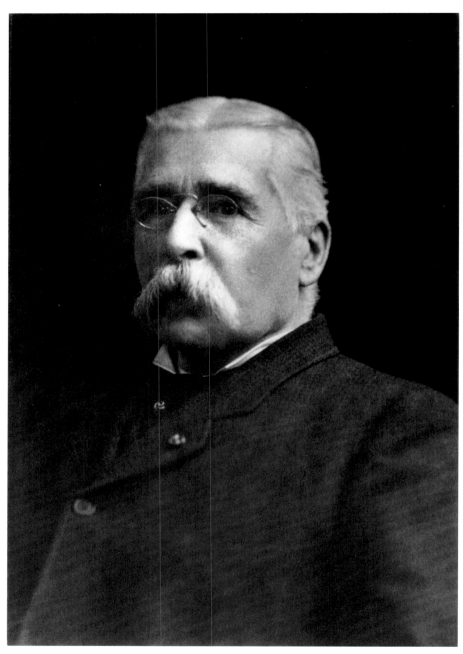

Anonymous, *Portrait of Louis Palma di Cesnola*, n.d.

GENERAL CESNOLA AND
THE METROPOLITAN

The founder of the Metropolitan Museum was General di Cesnola. The museum had a small beginning, not in a building in Central Park—but in a small house in midtown.

After the Museum was built in Central Park and had become an important institution, one fine day General Cesnola's secretary appeared at the Camera Club. It was in the very early nineteen hundreds.

"Mr. Stieglitz?"

It was at the time when I was the moving spirit of the Camera Club, the moving spirit of American photography, that is, when battles for its recognition in a modern sense were raging fiercest. Those were days that produced real forces, when the museums of Europe called on me to send them what I felt was most representative of American work, when the Photo-Secession was internationally the leader, when whatever terms I demanded from the museums, whether in Europe or at home, were accepted. The terms were invariably that the group sent should be hung as a unit, separated from all other exhibits and that the group be catalogued as a unit. The institutions would assume all risks, insure all pictures against damage; the insurance was, when all is considered, pretty steep. Some photographs were insured for as much as five hundred dollars each.

The museums accepted all conditions without a murmur. What was sent proved always to be the focus of the exhibition.

Cesnola's secretary—I'd never met Cesnola personally—said, "Mr. Stieglitz, the general has just received a cable from Turin from Duke Abruzzi—who is at the head of the international art and decoration exhibition which is shortly to open in Turin. The exhibition is to have a section devoted to International Photography." The Duke was a passionate photographer himself. He cabled that his friend Cesnola, who was born in Turin, must, by hook or crook, send at once a collection of Photo-Secession photographs.

I told the secretary I'd see Cesnola, that Cesnola should designate an hour.

A few hours later I was at the museum in the office of Cesnola—a military looking man, flowing white mustache, white hair, very erect.

Cesnola said, "You know, Mr. Stieglitz, I know nothing about photography and I am told that I must come to you to get what the Duke wants for Turin."

I told the General what my fight for photography had been, still was, and that I would let him have the collection needed for Turin if he, Cesnola, guaranteed that when it came back it would be accepted by the Metropolitan Museum of Art *in toto* and hung there.

Cesnola gasped. He said, "Why, Mr. Stieglitz, you won't insist that a photograph can possibly be a work of art?"

I asked why his friend, the Duke, was so eager to have our work in an international exhibition devoted to the arts and crafts.

Furthermore I told Cesnola that much that was in the museum even though painted was not necessarily art and that there were photographs that I felt were art and could be hung next to any picture in the museum.

He said, "You are a fanatic."

"I am," was my reply, "but time will show that my fanaticism is not completely ill founded."

Cesnola, thinking for a moment, said, "No, I cannot accept your proposition."

"I respect your feelings but I also respect photography quite as much, so cable to your friend he cannot have the pictures."

Cesnola got up from his chair and said, "Is that final?"

"Yes, I have no choice."

"I've been told that you were a madman and now I see it for myself. I'll accept your terms. When can the collection be here?"

"Tomorrow," I said.

And so the pictures went to Turin—the Steichens, Käsebiers, Whites, Eugenes, Keileys, Stieglitzes, Coburns and a few others.

One day about six weeks later the museum called up and I was informed that the American collection had received the King's Prize and five of us were each to receive a gold medal. The collection had created a sensation.

Cesnola was made an honorary citizen of Turin (of course he had sent other things besides the photographs).

I didn't think of the medals or of the King's prize but of the victory for photography, for photographs were to be hung in the Metropolitan Museum of Art on an equal basis with the other art expressions.

My life work seemed done, but before the collection had come back Cesnola had died. There was no written agreement and even if there had been a written agreement I wouldn't have insisted on carrying out the letter.

What had happened, happened between Cesnola, director of the museum, and myself. The new director could not have understood and so the spirit would have been lost, and it is ever the spirit that interests me.

NOTES

FROM *Twice A Year* 5–6 (1941)

The meeting with General Louis Palma di Cesnola that Stieglitz describes here occurred early in 1902. Cesnola, the Met's first director, had just been appointed the American commissioner for the Esposizione Internationale d'Arte Decorativa Moderna, to be held in Turin, and his friend the Duke of Abruzzi, the patron of the exposition, had asked him to arrange for Stieglitz to send a collection of photographs.

Stieglitz, assisted by Joseph Keiley and Charles Berg (the head of the Camera Club's Print Committee, who was mustered into service despite Stieglitz's dislike for him), within twenty-four hours assembled sixty prints by thirty photographers, most of them members-to-be of the Photo-Secession. Since Stieglitz was then collecting the very finest prints for the National Arts Club exhibition, he had to include a number of seconds for Turin. Nevertheless, he learned in November 1902 that the collection had won the "special award offered by His Majesty the King of Italy, for the best collection of prints exhibited." However, because Stieglitz had given his address as in care of the Camera Club of New York, the prize was mistakenly awarded to the club. Stieglitz had the error corrected by the exposition authorities, and he deluged the editors of photographic magazines in America and England with the information that "the King's prize has been awarded to Alfred Stieglitz as an individual."

Although Stieglitz claimed in the account given above that Cesnola had died before the photographs were returned to New York, Cesnola did not in fact die until November 1904, and he remained in office until that time. He simply reneged on his promise to accession the photographs into the Met's permanent collection. No photographs would be acquired by that museum as works of art until 1928, when it accepted a group of prints by Stieglitz.

Franz von Stuck, Poster for the First Salon of the Munich Secession, 1893

MODERN
PICTORIAL PHOTOGRAPHY

For some years there has been a distinct movement toward art in the pho-tographic world. In England, the birthplace of pictorial photography, this movement took definite shape over nine years ago, with the formation of the "Linked Ring," an international body composed of some of the most advanced pictorial photographic workers of the period, and organized mainly for the purpose of holding an annual exhibition devoted exclusively to the encouragement and artistic advancement of photography. This exhibition, which was fashioned on the lines of the most advanced art salons of France, was an immediate success, and has now been repeated annually for nine years, exercising a marked influence on the pictorial photographic world. These exhibitions mark the beginning of modern pictorial photography. Exhibitions similar to those instituted by the Linked Ring were held in all the largest art centers of Europe, and eventually also in this country. Amer-ica, until recently not even a factor in pictorial photographic matters, has during the last few years played a leading part in shaping and advancing the pictorial movement, shattering many photographic idols, and revolutionizing photographic ideas as far as its art ambitions were concerned. It battled vig-orously for the establishment of newer and higher standards, and is at present doing everything possible still further to free the art from the trammels of conventionality, and to encourage greater individuality.

In spite of all derision, prejudice, and opposition, the serious character of many of the exhibitions, and the distinct individual worth of many of the pic-tures shown, together with their artistic promise, eventually attracted the interested attention of some of the more liberal-minded artists and art critics. The organization of artists known as the Munich Secession, one of the most progressive, liberal, and influential art associations in the world, was the first officially to recognize the possibilities of pictorial photography, inviting to exhibit at one of its own exhibitions certain of the pictorial photographers of

Austria, Great Britain, Germany, France, and America. Following in these footsteps, the Art Committee of the Glasgow International Arts and Industrial Exposition, in 1901, opened its arms to receive pictorial photography as a legitimate member of the family of the fine arts. In view of the importance of Glasgow as an art center, the welcome thus accorded was of special significance.

In the spring of the present year the painters and sculptors of the Vienna Secession likewise threw open their exhibition to photography, allowing photographs to be submitted to the jury of selection on the same terms as paintings, drawings, statuary, and other examples of individual artistic expression. Twelve pictorial photographs, representing the work of four Austrian photographers, were hung in this exhibition. They were not only well received by the public, but were favorably commented upon by many of those painters and art critics who had up to that time been among the bitter opponents of recognition of the possibilities of photography as a medium of serious and original artistic expression.

Simultaneously we find the jury of the Paris Salon (Champs de Mars)—probably the most popular of all the annual art exhibitions of the world, which up to this time had accorded no serious thought to the claims of the pictorial photographer—coming into line through its action of accepting for hanging ten photographs which had been submitted by a young American painter, Eduard J. Steichen of Milwaukee, together with examples of his painting and drawing. The arbitrary refusal of the management to hang *photographs* even after they had been adjudged by the jury as worthy of a place upon the walls of the celebrated art exhibition well illustrates the bias of those who allow their prejudices to influence their fairness of judgment in such matters. This refusal in no way affects the official recognition accorded pictorial photography by the artists of France. The liberal spirit shown in most of the more progressive European art circles has been sadly lacking in our own country, notwithstanding the exceptional recognition accorded abroad to the photographic work of many Americans.

In order to understand the general and sudden recognition of photography as a means of artistic expression, two things must be kept in view: first, the essentially artistic aims of the modern photographer; second, the means with which he endeavors to attain them. The modern photographer, through the introduction of a great number of improved printing methods, has it in his

power to direct and mold as he wills virtually every stage of the making of his picture. He can supply, correct, or eliminate; he can even introduce color or such combinations of color by means of successive printings—similar to those resorted to in lithography—as to produce almost any effect that his taste, skill, and knowledge may dictate. Years of study and practical application have familiarized the creative photographer with the possibilities of these processes, which originally were purely mechanical and automatic in their application, and as such comparatively simple in their use, and have made them pliant tools in the hands of the artist for the carrying out of his ideas.

With the modern methods at command, there are virtually no limitations to the individuality that can be conveyed in the photographic print. These methods are extremely subtle and personal in character. For this reason each individual print has a distinct identity of its own that reflects the mood and feeling of its maker at the time of its production, and, in consequence, it rarely happens in the case of the modern pictorial photograph that two identical prints are produced from the same negative. This fact is of special significance for the collector. The Brussels and Dresden art galleries were among the first to realize the individual value of pictorial photographs as original artistic creations, and have for some years been purchasing examples for their permanent art collections. Large prices are frequently paid for choice prints, as much as three hundred dollars having been refused for a picture exhibited this year at the National Arts Club of New York, in the exhibition of the Photo-Secessionists, probably the most radical and exclusive body of photographers.

In the large world of photography, with its myriads of picture-makers, there are already many men and women, using the camera instead of the brush or pencil as a means of individual artistic expression, who have won an international reputation because of the pictorial merit of their work, every example of which is readily distinguishable by its personal style and characteristics.

In Austria three photographers, Heinrich Kuehn, Hugo Henneberg, and Hans Watzek, have done Trojan work for the cause of pictorial photography. Their pictures are on a bold scale, and as a rule are executed in that medium popularly known as the "gum-bichromate," which allows greater latitude to the photographer than any other. With it it is possible to work in monochrome and color, as these artists have successfully demonstrated. In Germany, Theodor and Oskar Hofmeister, following in the footsteps of the

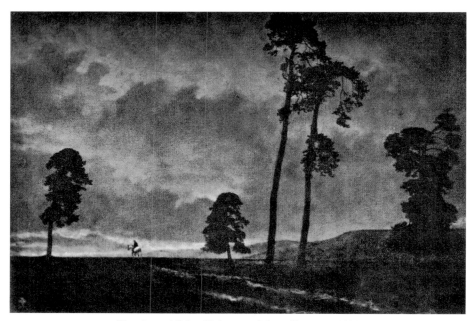

Theodor and Oskar Hofmeister, *Solitary Horseman*, 1904

Austrians, have produced many remarkable pictures, not a few of which, like those of the Austrians, have been purchased by art collectors and art galleries. France has few notable pictorial photographers, Robert Demachy being the most eminent both as producer and teacher. It was he who introduced the gum-bichromate process into pictorial photography, demonstrating through his own pictures the facility and range of this most pliant of art photographic mediums.

Great Britain, too, has her photographic celebrities, who have done their share in furthering the movement in pictorial photography by the individuality displayed in their work; the foremost are J. Craig Annan of Glasgow, and A. Horsley Hinton, George Davison, Eustace Calland, and P. H. Emerson of London.

Our own country, which has played so prominent a part in the advancement of art photography, and where the secession from the conventional ideas has been most extreme, boasts of a goodly number of active pictorialists, whose individual work, while not as large in area as most of the European, has, as a rule, more verve and is undoubtedly more subtle and delicate in both conception and treatment. Prominent among these are Eduard J. Steichen of Milwaukee; Gertrude Käsebier and Frank Eugene of New York; Clarence H. White of Ohio; Mrs. Eva Watson Schütze and W. B. Dyer of Chicago; F. Holland Day and Mary Devens of Boston; Rose Clark of Buffalo; and Joseph T. Keiley of Brooklyn, to whom the photographic world is indebted for the practical application of the glycerin manipulative platinum process, now so generally in use. Of these Steichen, Clark, Eugene, Käsebier, and Schütze are painters by profession.

It has been argued that the productions of the modern photographer are in the main not photography. While, strictly speaking, this may be true from the scientist's point of view, it is a matter with which the artist does not concern himself, his aim being to produce with the means at hand that which seems to him beautiful. If the results obtained fulfil this requirement he is satisfied, and it is to him of small consequence by what name those interested may see fit to label them. The Photo-Secessionists call them pictorial photographs.

FROM *Century Magazine* 44 (1902)

Richard Watson Gilder, editor of the prestigious *Century Magazine*, whom Stieglitz called "that most conservative of conservatives," was the brother-in-law of National Arts Club director Charles de Kay. Gilder was sufficiently impressed by the NAC exhibition to invite Stieglitz to write an article about pictorial photography for his magazine.

In March 1902 Edward Steichen, who was still living in Paris, submitted to the Salon de la Nationale, also known as the Salon du Champs de Mars, one painting, six charcoal drawings, and ten photographs—gum prints and ozotypes. There was much excitement in New York when the news arrived that for the first time ever a French fine-arts salon jury had admitted photographs. Stieglitz wrote in his article "Painters on Photographic Juries," published in the July 1902 issue of *Camera Notes* (see above), that Steichen had at last "forced the most conservative of all Art Juries, that of the Champs de Mars Salon, to acknowledge his photographic work worthy of ranking with the arts." The story even made it into the *New York Herald*. Stieglitz triumphantly wrote that "the approval of a body of such known talents . . . must put a stop forever to the sneer of those not willing to give certain photographic pictures rank as works of art."

Intense disappointment followed when it was learned that "notwithstanding acceptance by the Jury, jealousies and political intrigue within the salon itself proved powerful enough to prevent the hanging of photographs." It turned out that Steichen had submitted his photographs as "prints," and they had been accepted as etchings or lithographs. When members of the jury subsequently learned the truth, they forbade the hanging of the impostors.

Camera Work PROSPECTUS

WHY "CAMERA WORK" IS FOUNDED. In response to the importunities of many serious workers in photographic fields that I should undertake the publication of an independent magazine devoted to the furtherance of modern photography, I feel that I can not ignore the claims of the many friends who have supported my efforts in the past, and I have determined in consequence of these expressed wishes to begin the publication of *Camera Work*.

PARTICULARS OF PUBLICATION. This magazine will be begun as a quarterly, and will be edited and published by myself, owing allegiance only to the interests of photography. While the growth of an enterprise of such a nature must be dependent upon the support accorded it, it will nevertheless be my aim to make *Camera Work* the best and most sumptuous of photographic publications.

ILLUSTRATIONS & LITERARY MATTER. It is my intention to reproduce the best examples of all "schools," both American and foreign, in a style which will make the magazine of great value for its pictures alone, even to those who may not be interested in the literary contributions; but the latter will receive an attention not inferior to that accorded the illustrations.

ASSURED CONTRIBUTORS. I am already assured of the support of the most celebrated photographers, writers, and art critics, such as Charles H. Caffin, A. Horsley Hinton, Robert Demachy, Sadakichi Hartmann, Eduard J. Steichen, Gertrude Käsebier, Frank Eugene, J. Craig Annan, Clarence H. White, and others whose names should carry conviction.

EDITORIAL ASSOCIATES. In undertaking this task I will have as editorial associates the aid of Messrs. Joseph T. Keiley, Dallett Fuguet, and John Francis Strauss.

SIZE & PRICE. While binding myself to no stated size or fixed number of inserts (these factors being largely dependent upon the heartiness of the support accorded me), I guarantee that subscribers will receive a full equivalent of the amount of their subscription, which has been fixed at three dollars and fifty cents per annum for the United States and Canada, and four dollars for other countries. Single numbers will cost from one dollar upward, dependent upon circumstances.

DATE OF FIRST ISSUE. It has been planned to issue the first number of *Camera Work* some time toward the close of the present year, and in order to enable me to publish an edition large enough to supply the demand, I would deem it of assistance if you will intimate to me upon the enclosed blanks your intention and that of your friends to support this undertaking.

ALFRED STIEGLITZ
New York, August Twenty-fifth, 1902

———————— NOTES ————————

Camera Work PROSPECTUS, PRIVATE PUBLICATION, 1902

After Stieglitz's resignation from *Camera Notes*, Joseph Keiley wrote to many of his friend's supporters asking them to encourage him to begin a new magazine. It didn't take much to persuade Stieglitz.

In the above prospectus he made no mention of the Photo-Secession, averring that *Camera Work* would be edited and published by himself, "owing allegiance only to the interests of photography."

Camera Work was so sumptuous, and so closely associated with the exclusive and mysterious Photo-Secession, that Stieglitz had to run, in the July 1904 issue, a full-page "Appeal to Our Subscribers." In it he hastened to correct "the erroneous impression" that had "gone abroad that the edition of *Camera Work* is limited and that only the favored few are admitted to our subscription-list."

AN APOLOGY

The time appearing ripe for the publication of an independent American photographic magazine devoted largely to the interests of pictorial photography, *Camera Work* makes its appearance as the logical outcome of the evolution of the photographic art.

It is proposed to issue quarterly an illustrated publication which will appeal to the ever-increasing ranks of those who have faith in photography as a medium of individual expression, and, in addition, to make converts of many at present ignorant of its possibilities.

PHOTOGRAPHY being in the main a process in monochrome, it is on subtle gradations in tone and value that its artistic beauty so frequently depends. It is, therefore, highly necessary that reproductions of photographic work must be made with exceptional care and discretion if the spirit of the originals is to be retained, though no reproductions can do full justice to the subtleties of some photographs. Such supervision will be given to all the illustrations which will appear in each number of *Camera Work*. Only examples of such work as gives evidence of individuality and artistic worth, regardless of school, or contains some exceptional feature of technical merit, or such as exemplifies some treatment worthy of consideration, will find recognition in these pages. Nevertheless the pictorial will be the dominating feature of the magazine.

CAMERA WORK is already assured of the support of photographers, writers and art critics, such as Charles H. Caffin, art editor of the American section of *The International Studio* and art critic of the *New York Sun*; A. Horsley Hinton, editor of *The Amateur Photographer*, London; Ernst Juhl, editor of the *Jahrbuch der Kunstphotographie*, Germany; Sydney Allan (Sadakichi Hartmann), the well-known writer on art matters; Otto W. Beck, painter and art instructor at the Pratt Institute, Brooklyn; J. B. Kerfoot, literary critic; A. Radclyffe Dugmore, painter and naturalist; Robert Demachy, W. B. Cadby, Eduard J. Steichen, Gertrude Käsebier, Frank Eugene, J. Craig Annan, Clarence H. White, Wm. B. Dyer, Eva Watson-Schütze, Frances B. Johnston, R. Child Bayley, editor of *Photography*, and many others of prominence.

Though the literary contributions will be the best of their kind procurable, it is not intended to make this a photographic primer, but rather a magazine for the more advanced photographer. CAMERA WORK owes allegiance to no organization or clique, and though it is the mouthpiece of the Photo-Secession that fact will not be allowed to hamper its independence in the slightest degree.

An undertaking of this kind, begun with the sole purpose of furthering the "Cause" and with the intention of devoting all profits to the enlargement of the magazine's beauty and scope is dependent for its success upon the sympathy and cooperation, moral and financial, of its friends. And it is mainly upon you that the life of this magazine hangs. The many subscribers who have responded to our advance notice have encouraged us to believe that the future of the publication is assured beyond question; but we can not express too strongly the hope that you will continue your good offices in our behalf.

Without making further pledges we present the first number of *Camera Work*, allowing it to speak for itself.

ALFRED STIEGLITZ
Editor

JOSEPH T. KEILEY
DALLETT FUGUET
JOHN FRANCIS STRAUSS
Associate Editors

NOTES

FROM *Camera Work* 1 (JANUARY 1903)

Stieglitz's "apology" was presumably offered in the spirit of the punctilious gentlemanliness of the time, which would perhaps have viewed the establishment of a new magazine as rather forward. To request "the sympathy and cooperation, moral and financial," of one's friends, even for so worthy an undertaking, would certainly have been deemed cause for some measure of embarrassment.

An average issue of *Camera Work* contained about ten articles, the majority of them written by Stieglitz's cronies. Most dealt with individual photographers, with aesthetics, or

with exhibitions, technical articles being quite rare. Almost every issue also contained exhibition reviews; from late in 1904 on, many of them, pro and con, were reprinted from other publications.

Edward Steichen's work, and articles about it, appeared in fifteen of *Camera Work's* fifty issues, and the reproductions in three issues were entirely his. Altogether, sixty-five of Steichen's photographs were published in the magazine, more than by anyone else. Stieglitz was next with forty-seven, plus another four that he had made in collaboration with Clarence White. Nearly one quarter of the photographs published in the magazine were by either Stieglitz or Steichen.

During its fifteen years of publication, *Camera Work* published a total of 473 photographs. Of these, 357 were the work of a group of fourteen photographers. In addition to Stieglitz and Steichen, they were, in descending order, Frank Eugene, Clarence White, Alvin Langdon Coburn, J. Craig Annan, David Octavius Hill (in collaboration with the unacknowledged Robert Adamson), Baron Adolph de Meyer, Heinrich Kuehn, George Seeley, Paul Strand, Robert Demachy, Gertrude Käsebier, and Annie W. Brigman. The remaining 116 photographs were by a total of thirty-nine photographers, represented by from one to nine photographs apiece.

The most serious absences among pictorial photographers known to Stieglitz were F. H. Day and P. H. Emerson. Stieglitz had hoped to devote the third issue to Day, but Day scorned the offer. And in 1904 Stieglitz invited Emerson to send work to be published in *Camera Work*, but Emerson replied dismissively.

Stieglitz did everything to ensure that the printing of the photogravures for *Camera Work* would be superb. Indeed, in 1904, when a Photo-Secession exhibition failed to arrive in Brussels on time, a selection of gravures from the magazine was hung instead— and most viewers of the exhibition assumed they were looking at original photographic prints. The gravures were printed on very fine, thin Japan tissue paper, which was nearly grainless. They had to be hand-mounted—by Stieglitz and his associates—either directly on to the pages of the magazine or on to brown or gray mats that were then pasted on to the rich cream-colored pages. Stieglitz himself would check each example of each gravure and carefully ink out any light spots that had been caused by dust.

THE PHOTO-SECESSION

The progress of the ages has been rhythmic and not continuous, although always forward. In all phases of human activity the tendency of the masses has been invariably towards ultra conservatism. Progress has been accomplished only by reason of the fanatical enthusiasm of the revolutionist, whose extreme teaching has saved the mass from utter inertia. What is today accepted as conservative was yesterday denounced as revolutionary. It follows, then, that it is to the extremist that mankind largely owes its progression. In this country, photography also has followed this law, and whatever have been the achievements which have won it exceptional distinction, they have been attained by the efforts of the enthusiastic so-called extremists. True, however, to this general law of development, these results have been achieved only through bitter strife, until those most deeply interested in the advancement of photography along the lines of art have been compelled to register their protest against the reactionary spirit of the masses. This protest, this secession from the spirit of the doctrinaire, of the compromiser, at length found its expression in the foundation of the Photo-Secession. Its aim is loosely to hold together those Americans devoted to pictorial photography in their endeavor to compel its recognition, not as the handmaiden of art, but as a distinctive medium of individual expression. The attitude of its members is one of rebellion against the insincere attitude of the unbeliever, of the Philistine, and largely of exhibition authorities. The Secessionist lays no claim to infallibility, nor does he pin his faith to any creed, but he demands the right to work out his own photographic salvation.

FROM *Bausch and Lomb Lens Souvenir*. ROCHESTER, NEW YORK: BAUSCH AND LOMB OPTICAL COMPANY, 1903

The sentiments here expressed by Stieglitz are remarkably close in their underlying spirit to the doctrines that Lenin had set forth the previous year in his revolutionary handbook *What Is to Be Done?* In that book Lenin called for a disciplined party of full-time professional revolutionaries—intellectuals unswervingly dedicated to the cause—who would write and distribute propaganda, commit acts of terrorism, and otherwise strive to develop a revolutionary spirit within the proletariat. No factionalism or doctrinal dissent was to be tolerated.

In Stieglitz's case, the Photo-Secessionists were his Bolsheviks, his magazine *Camera Work* would be his seditious propaganda, and the exhibitions he organized would be—judging from the reactions of conservative critics—little short of acts of terrorism. Stieglitz even eschewed the term "artist," tainted by effete fin-de-siècle aestheticism, and preferred to call himself and his associates "workers" or "camera workers."

Stieglitz's actual political leanings were toward a non-violent anarchism. In 1912 he told a reporter that the Photo-Secession stood for the "idea of revolt against all authority in art, in fact against all authority in everything, for art is only the expression of life." By that time Stieglitz's friends included a number of avowed anarchists of the intellectual and artistic varieties, including painter Abraham Walkowitz, whose work he exhibited and published, and Emil Zoler, the handyman at Stieglitz's gallery.

THE PHOTO·SECESSION—
ITS OBJECTIVES

In order that the photographic world may be disabused of its notion that there is something mysterious and secret about the Photo-Secession, the editor of *Camera Craft* has requested me, if possible, to give the readers of his magazine a general idea of the Photo-Secession and its attitudes toward photographic exhibitions,

It seems to be generally believed that the Photo-Secession is a new thing and that its members are bound together by some iron-clad oath, when, as a matter of fact, there is but the slightest semblance of organization to be found in its body, and its members are free to do as they deem best. In fact, the spirit underlying the Secession has influenced the attitude of its founders for many years, though it is but recently that the sympathy and fellowship for one another of the men and women who have labored for the same ends and have been influenced by the same ideals have been given a local habitation and a name. There was nothing sudden in the banding together of these workers, and the fact of their having chosen a title and adopted the loosest kind of an organization did not in the least degree change in which each had individually stood in the past. Until the formation of the Secession, which was first formally introduced to the public through the medium of its exhibition at the National Arts Club, New York, it was the individuals who were accused of having adopted a "rule or ruin" policy. If they supported an exhibition, it was charged that the standard demanded by them was artistically and morally unhealthy and designed to exclude all but their own work. If they declined to support an exhibition whose standards fell short of the lowest to which they were willing to accord their assent, they were charged with narrowness, envy and exhibiting the proverbial "dog in the manger" spirit. They were damned if they did, and doubly damned if they didn't.

Was it not natural that under these circumstances the men and women who had been in thorough sympathy with one another, through all the interminable

controversies that had furnished so much material for the photographic penny-a-liners and ink-spillers, should have so wearied of misunderstandings and mis-representations that they at length determined to have the game as well as the name of being unwilling "to play along" except upon terms that embod-ied their hopes and ideals for their art? Therefore, there was formed in deed the organization which had previously existed but in spirit.

Like all secessions the Photo-Secession is but an active protest against the conservatism and reactionary spirit of those whose self-satisfaction imbues them with the idea that existing conditions are akin to perfection, and that the human race cannot improve upon the attitude and accomplishments of the good old days. This stick-in-the-mud policy, this complacent self-satisfaction, this belief that the standards of yesterday must be the standards of all time to come, this spirit which Matthew Arnold characterizes as barbarism and Philistinism, has been the bane of all efforts toward "sweetness and light." The object of the Photo-Secession is not, as is generally supposed, to force its ideas, ideals and standards upon the photographic world, but to insist upon the right of its members to follow their own salvation as they see it, together with the hope that by force of their example others, too, may of their own free will see the truth as they see it. This hope can never be realized by weakly accept-ing standards in which we have no faith, nor by compromise, which never yet has satisfied either party to a question. If the "way" we have chosen leads nowhere we have but fooled ourselves; but if ours is a path toward truth, then it argues but a weak faith on our part willingly to follow any other.

Our attitude is not one of pique or envy, nor do we intend to hold aloof from photographic activities that display an earnest desire for improvement, although it has been forced upon us to insist upon our own standards insofar as our own pictures are concerned. The sham of so-called high standards and the exploitation of the names of painters, known and unknown, who have been induced to pat photography patronizingly upon the head, the ministra-tion to the vanity of individuals, the substitution of injudicious praise for honest criticism, the complacent acceptance of the mediocre as perfection, all have injured photography and have forced the issue. Those who charge us with an unwillingness to take part in exhibitions which are not run under our own direct or indirect management speak without knowledge. During the past year, the first of the organized existence of the Photo-Secession, we

have not declined a single invitation to contribute to exhibitions great or small throughout the world—Turin (Italy), St. Petersburg (Russia), Paris Photo-Club Salon (France), Wiesbaden Art Gallery Germany), *L'Effort* (Belgium), Hamburg (Germany), Toronto (Canada), Denver (Colorado), Minneapolis (Minnesota), Cleveland (Ohio), Rochester (New York)—each has received a collection of the work of the Photo-Secessionists assembled often under great difficulties and inconvenience. It has been our policy to refuse none of whose earnestness we were assured. It is true that certain conditions were first insisted upon in order that no action of ours could be construed as a compromise with our principles. We demanded, first, moral assurance of the good faith and high intentions of the management of all such exhibitions whose previous history was not sufficient guarantee of their endeavor; second, the right to send a collection which would be accepted as a whole without submission to a jury; third, that such collection be hung as a unit and be catalogued as "Loan Exhibition of the Photo-Secession"; fourth, that the shipping expenses be borne by those who had extended the invitation. We have yet to hear that any of the societies mentioned had found ought to regret in their acceptance of our seemingly high-handed and dictatorial demands. The standards by which the Photo-Secession selected the work of its members which went to make up these collections was in each case far more severe than that of the jury of the respective exhibitions, and it was, no doubt, because of these high standards that our work attracted the attention it did. It must not be understood that membership in the Secession denies the right of the individual to exhibit personally at any exhibition. On the contrary, the individual is free to follow his own inclinations, except that in such cases where the council feels that in any proposed show the interests for which the Photo-Secession stands would be jeopardized by any support whatever, it so advises its members. There is no compulsion to accept this advice, though the thorough sympathy amongst its members is probably sufficient to deter any individual from according any such exhibition his support.

These few remarks generally explain the attitude of the Photo-Secession toward exhibitions not held under its auspices. There are no hard and fast rules to which we must adhere. New conditions would bring with them new changes. For the present it may be assumed that such is our stand. It is our intention to encourage with our support whenever possible, and we shall feel

no grievance if those who deem our demands extravagant shall refrain from extending to us their invitations. We are but a handful who, while denying to no man nor body of men the right to follow their own light, yet insist upon our right to do likewise.

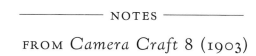

NOTES

from *Camera Craft* 8 (1903)

The Photo-Secession was a very curious organization, not least because its members did not in fact secede from the Camera Club of New York. Indeed, a note in the July 1902 issue of *Camera Notes* stated, "Any person wishing to know further particulars concerning . . . the organization 'Photo-Secession' may address Mr. Alfred Stieglitz, No. 3 West 29th Street, Manhattan." That was, of course, the address of the Camera Club. Stieglitz did not want to hurt the club, and he still hoped to elevate its standards by example. There was also a less idealistic factor. Neither Stieglitz nor most of his friends had darkrooms of their own. They remained members of the Camera Club so that they could use its magnificent facilities—"the like of which I had never seen before," wrote Steichen. The Camera Club even continued to mount occasional exhibitions of work by a Photo-Secessionist; Alvin Langdon Coburn had his first one-man show, which included sixty photographs, at the club in January 1903.

In its early days, the primary function of the Photo-Secession was to send collections of photographs to museums and expositions throughout the United States and around the world, a function that was simply the continuation of the work Stieglitz had done for Glasgow and other international exhibitions.

Stieglitz claimed that by the end of 1903 he had received from 147 American and European organizations "urgent" requests for exhibitions. Invitations from the organizers of "salons" in Minneapolis and Denver were all very well, but such triumphs were overshadowed by the Linked Ring's infuriating refusal to accept Stieglitz's suggestion that the 1903 London Photographic Salon include an *hors concours* section of work by the Photo-Secession. The predictable response of Stieglitz and Steichen was to lead a boycott of that year's Salon.

Edward Steichen, *Sadakichi Hartmann*, 1903

COLLECTORS AND ARTISTS' PROOFS

In response to the publisher's request to contribute a few lines to this new book on Art-Photography, it seems to me desirable to call your attention to a subject, the importance of which should not be underestimated simply because it has not, to my knowledge, received the serious consideration in the photographic literature that it deserves.

In the course of the gradual development of Art-Photography, collectors and connoisseurs have learned to judge the qualities of different prints made from the same negative. The number of people who collect original prints of outstanding Art-Photographs is today still small, but it is increasing steadily. Connoisseurs already show so much discernment in choosing for their collection that they are often willing to pay for a single print a price that—when judged by the unknowledgeable—seems greatly excessive.

As with all art objects that captivate the perceptions and the taste of the collector, connoisseurs are gradually beginning to develop an appreciation for the finely nuanced, but not to be underrated, distinctions among prints from the same negative. They are coming to recognize that it is impossible to produce two absolutely identical prints. This fact naturally affects the price of the individual prints, even though the ignorant do not understand the reasons for such differences in value. The average photographer and collector must come to realize that the value of a picture is dependent not only upon the suitability of the process employed, but that even among several prints from the same negative, and even among those produced by the same methods, differences can be seen. Each individual print may have its own merits, but one print will always stand out as best reflecting the artist's intentions and conceptions.

Let me illustrate this by mentioning a situation in which I was recently involved as the victim. In putting together a photographic collection, I had resolved to obtain only pictures with superlative artistic values. Thus my attention was drawn to a portrait whose maker has recently been highly

praised by the entire art world. The gum print was one of the finest originals that I had ever encountered. I was so sure of my judgment that I purchased it immediately for a price that struck most people as outrageous. In fact, the price seemed ridiculously low to me when I compared my print with other prints from the same negative for which the same price had been paid.

I was very satisfied with my new possession until, sometime afterward, the artist showed me a new print, which excelled mine to the same degree that my print had surpassed the other prints in artistic value. The artist was so conscious of the difference that he was unwilling to part with this perfect specimen, fearing that he would never be able to produce another like it. However, I finally succeeded in persuading him to let me have his treasure for a pretty penny. His fears were justified, since all of his attempts to produce a comparable print have so far been futile.

We may draw a parallel between the photographer's art and that of the engraver and etcher, where only the finest examples enjoy the honor of being called "art prints" and fetch accordingly high prices. Even in this select company, the connoisseur will reject one impression after another until he finally finds one that he considers worthy of being incorporated into his collection. To many, the differences between impressions seem purely imaginary, but I consider this claim due to a lack of training. Just as the musically trained ear is more discriminating than is the untrained, and the cultivated mind more perceptive than the uncultivated, so is the artist's eye much more sensitive to subtle gradations of tone and color than is the eye to which "all cats are grey."

What may seem an exorbitant price today may perhaps be regarded tomorrow as low. I cannot better prove the truth of this fact than by relating the following episode.

In 1895 an American collector paid fifty dollars for a print of a well known image by one of the most famous photographers. An intimate friend of the artist, upon hearing of the sale, said to him, "So there is at least one da———ed fool in this country, and you have had the luck to find him!" It was amusing when, about three years later, the gentleman who had made this remark, and who had since then begun to collect art-photographs, paid the unheard of sum of $110 for another print by the same photographer—a price that probably remains the highest ever fetched by any picture produced photographically.

The moral is obvious, and we need no better evidence of the increasing esteem given to original and artistically valuable photographic prints. Where

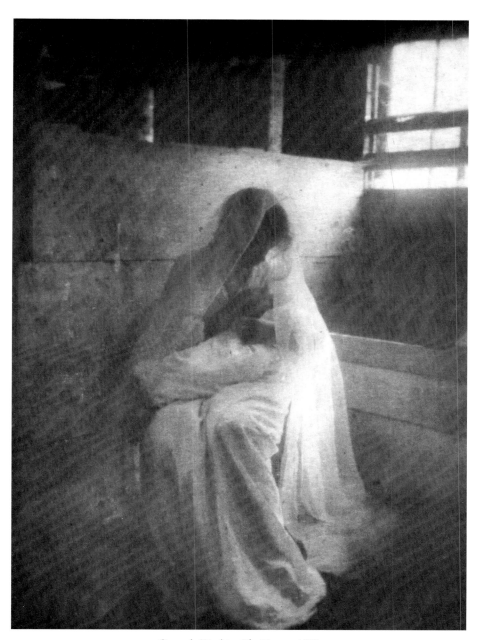

Gertrude Käsebier, *The Manger*, 1899

formerly a few dollars was regarded as an exceptionally high price for a print, it is now not unusual—at least in the United States, the leader in this field—to pay $50 to a $100 for a single photographic art print. I firmly believe that time will show that the buyer has gotten a bargain despite the high price. This may sound too enthusiastic and optimistic, but the history of the world has a strange habit of always repeating itself.

<div align="right">Translated from German by R.W.</div>

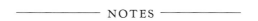

NOTES

FROM *Camerakunst*. BERLIN: GUSTAV SCHMIDT, 1903

In the fall of 1899 Gertrude Käsebier's photograph *The Manger* was the sensation of the Philadelphia Salon. Shot in a white-washed stable in Newport, Rhode Island, in which town she maintained a portrait studio during the summer, it showed a woman dressed luminously in white, with a white veil flowing from her head to the floor, holding what is ostensibly an infant swaddled in white. (There was, in fact, no child inside the swaddling clothes.) That year a print of *The Manger* was sold for $110, which was widely said to be the highest price yet paid for a pictorial photograph.

It is quite typical of the intensely competitive Stieglitz then to state in his article that in 1898 a collector paid one hundred ten dollars for a print by "one of the most famous photographers"—"a price that probably remains the highest ever fetched by any picture produced photographically." We may be fairly certain that either the collector or the photographer was Stieglitz himself.

In 1921 Stieglitz sent his friend and patron Aline Meyer Liebman, whom he wanted to have "something AA + 1," a magnificent reddish-brown palladium print of his 1920 photograph of Georgia O'Keeffe's hands sewing, one of his masterpieces. On October 8, 1993, that print was sold at a Christie's auction for $398,500, a new world record for a single photograph at that time.

When Stieglitz writes of "a portrait whose maker has recently been highly praised by the entire art world," he is presumably referring to Edward Steichen. It is likely that the image of which Stieglitz replaced a fine print with one even finer was a portrait of the critic Sadakichi Hartmann, dating from 1903. The print in the Stieglitz collection at the Metropolitan Museum of Art, the technique of which is "plain gum-bichromate or unidentified oil pigment process," is one of the very few pre-1904 Steichen portraits owned by Stieglitz that was not a gelatin-carbon print made from a copy negative of a gum-bichromate original.

SOME IMPRESSIONS OF
FOREIGN EXHIBITIONS

After an interval of just ten years I once more found myself in Europe. During that period I had witnessed the evolution of pictorial photography and had watched its struggles against the hostile environment of ignorance, prejudice, selfishness, vanity, conceit, intrigue, provincialism and a host of other malign influences.

After a short stay in Europe, I returned to America in 1894 and found that modern pictorial photography, as that term is understood by a few people, had just begun its infancy, though it gave promise of the qualities it has since developed. In Great Britain, at this same time, it was already approaching its maturity; in Austria it had reached its period of adolescence; in Germany it was yet unborn; in France it was expected; while to the rest of the world it was unknown. Since that time American photography has reached its maturity and has won for itself a recognized position as a leading influence in the development of the art. At times I felt within myself some doubt whether I had not attached an exaggerated importance to the pictures which we had produced. It is true that my faith in the ultimate success of photography as a means of pictorial expression had never wavered since first (1885) it claimed me as its own, and it was not until my present visit to Europe that I gained the perspective which enabled me to judge the true proportions of photographic accomplishments. At last I found the opportunity to personally weigh the picked American work in the same scale with the best of the European.

DRESDEN. It was in no very cheerful frame of mind that I visited the International Art Exhibition at Dresden. For, though I had expected to find much-needed rest and recreation in Europe, I had scarcely landed when my health collapsed completely and I found myself spending the first four weeks of my pleasure trip in a private hospital in Berlin. Hardly out of the sick bed,

and against the express instructions of my physician, the ruling passion asserted itself. Photography allured me to Dresden and I went. The attraction was more than I, in my enfeebled condition, could resist. Had not the authorities of the Grosse Internationale Dresdner Kunstausstellung—the foremost exhibition of its kind in Europe at present—conceded all the claims that the most enthusiastic pictorialists had made? And had not the Photo-Secession sent a small, but choice, collection thither? Imagine then, my feelings when I found myself at the gates of the Exhibition on inquiring where the photographs were hung and was directed to a small auxiliary building! So great was my disgust at what seemed to me the duplicity of the management which had held out such fair promises that I was upon the point of leaving without looking at either photographs or anything else. Sober second thought overcame this impulse and, disappointedly, I entered the building. Once more I underwent a revolution of feeling. I was indeed pleasantly surprised at what I saw. Here was a large hall divided into alcoves, in which were hung together the pictures which represented the Photo-Secession, the Hamburg School, the Viennese, Dresden, British, etc., etc., each group being segregated. It was delightful to see with what feeling, taste and judgment the hanging of the Secession and of the Viennese collections had been accomplished, and how effectively each picture stood out by itself, at the same time harmonizing with the remainder of its group. All this was due to Herr F. Matthies-Masuren, who had personally hung these two groups.

What an opportunity to judge by comparison! Here on the one hand were the Viennese, artistic, powerful, daring and broad in their treatment, masterful in their knowledge of multiple-gum technique, sensuous in their strength, yet displaying great taste; on the other, the comparatively tiny Secession prints, full of subtle charm, delicacy and spirituality, unaggressive in size, color and presentation, yet quite as masterful in their technique, and covering a much greater range of media. Watzek, Henneberg, Kühn and Spitzer, although each a strong individuality, were yet so complementary to each other that the whole impression of their collective work was one of uniformity. No doubt this impression was due mainly to the more or less uniformity of size and medium. On the other hand, the work of the Secession, while betraying a common school, was marked by an individuality of conception, of technique and in the media employed.

It was clear at a glance that Hamburg had followed the Viennese lead, but they could readily be differentiated by the grosser and more brutal technique of the former. Though oftentimes poetic in conception, the Hamburg photographers seem to revel in an orgy of color that often offends. The Hofmeisters are not only the founders of but easily the foremost of the Hamburg school.

In the British exhibit but two deserve mention—[David Octavius] Hill, the painter-photographer of fifty years ago, and J. Craig Annan. Their pictures will always hold their own in the very best of company—sane, honest, temperamental. Of the French, nothing can be said because France was not adequately represented. After having spent several hours in careful study of the photographs, I hied me to the "real article." In the exhibition proper had been gathered together no end of beautiful painting, statuary—in fact, all forms of art except photography, which Cinderella-like was left by itself in the cold. Fairly has Dresden earned its title. It is not my purpose to speak of ought but photography, but after surfeiting myself with the best in painting, and cloyed with an excess of beauty, I determined to put photography to its crucial test—I returned to the photographs. Another half hour with them convinced me finally and for all time that the best photographs could be hung in juxtaposition to the best of other arts without ment to themselves or to those who might have the courage so to place them.

That I am not alone in this enthusiastic judgment is proven by the verdict of the Dresden management that photography has stood the test and would in future years be housed with the other arts.

LONDON SALON. Three months later saw me at the opening of the Salon of the Linked Ring in London. They told me that it was the best ever held. America had for the first time judged its own pictures and had contributed about one-third of the entire collection. I had never had the opportunity of seeing previous Salons of the Linked Ring. My first impression was of keen disappointment—a small hall, none too well lighted, overcrowded with frames, although there were but 230 in all.

Upon closer examination the average of individual pictures seemed good; exceptional work was scarce. The work of the Americans, with one exception, disappointed me—it seemed as if the prints of many of the subjects

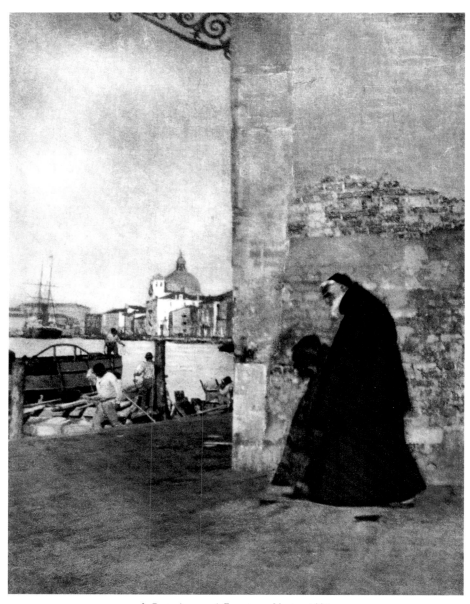

J. Craig Annan, *A Franciscan*, Venice, 1894

shown were not the best from the plates—in many cases as a matter of fact, I had previously seen far better prints of the same subjects. The tendency seemed toward overprinting, darkness and muddiness, although making due allowance for London fog and poor lighting. It seemed to me a great pity that the American pictures could not have been hung together, for they would have given each other mutual strength and support. A comparison with Dresden could not be avoided, and London suffered in consequence. And yet, to my way of thinking, the artistic average of the American prints was far in advance of that of the English. A striking feature in some of the English exhibits was the marked influence of the American school, and notably that of Gertrude Käsebier. In fact, throughout Europe I found her influence dominant.

The hanging of the exhibition as a whole was decoratively done, though the individual prints undoubtedly suffered. It is of interest to note that even there in London, where big prices for photographs have been pooh-poohed, two Steichens were sold for fifteen and ten guineas respectively, that a Käsebier platinotype and one by White brought five guineas each, a Demachy sold for a similar price, etc., etc. At Dresden too, good prices prevailed, a Kühn brought 300 marks, two Eugene 5-by-7 platinotypes, 200 and 100 marks respectively, etc.

THE ROYAL. To visit the Salon without seeing the Royal is to do an injustice to the Salon. Beautiful galleries, good lighting—for London—and the walls plastered with pictures from very good to very bad—the average tended to lowness. It is indeed a pity that with its opportunities the premier society of the world should fail so lamentably. If there had been picked from these reams of paper the *pictures* and if these had been hung with some taste, the Royal indeed could have been well satisfied with its showing. But as it was, I returned thither but thrice, whereas the Salon I visited seven times; showing that neither exhibition was examined lightly.

That my estimate of American work as represented by that type of photography of which the Secession and *Camera Work* are exponents has not been due to the personal element is proven by the avowed recognition of its value, not only in itself but also as an exemplar, by the leaders of pictorial photography throughout Europe. Their enthusiastic appreciation, expressed not only verbally but in letters as well as in articles, is shared by a class of art-lovers

and painters who until very recently absolutely abhorred the word *photography*. Among this class *Camera Work* has met with an approval naturally most gratifying in view of the lack of harmony amongst photographers generally. After all, it is to the connoisseurs, the painters and to the big men and women in photography that we look mostly for the culmination of our ambitions. The squally appearance of the photographic sea is more apparent than real, for the recognized leaders and their friends throughout the world are working in entire harmony toward an end which in our next number we hope to make public.

——— NOTES ———

FROM *Camera Work* 8 (OCTOBER 1904)

Badly needing a rest, Stieglitz sailed for Europe in May 1904 with his wife, their daughter, and her governess. It was his first trip to Europe in ten years, and he had planned an ambitious itinerary of photographic exhibitions, meetings, and excursions. But he was forced to spend the first four weeks of his European stay in a Berlin clinic.

After his visit to the International Art Exhibition in Dresden, described above, Stieglitz and his family went to the lovely Tyrolean village of Igls, near Innsbruck, where Alfred could continue to recuperate. They stayed in a charming hotel, and Alfred spent many days photographing the beautiful countryside, accompanied by two men whose work he respected, Frank Eugene and the Austrian photographer Heinrich Kuehn (anglicized from Kühn).

In 1904 Stieglitz was hoping for an alliance among the Photo-Secession, the Linked Ring, and the leading French, German, and Austrian societies, which would retain their individual identities. The new super-organization would be governed by the combined councils of the member societies, these councils already being composed mostly of Links. Joseph Keiley suggested that the new organization be called the World's Secession, but the British hoped for the International Society of the Linked Ring. Stieglitz, who believed that the British would never agree to the society unless it was headed by one of their own, proposed J. Craig Annan as president.

In an attempt to prepare the photographic community, Stieglitz would publish six gravures by Annan in the October issue of *Camera Work*. In an accompanying article, Keiley called Annan "one of the foremost artists in photography, not only in England, but of the whole world" and stated that "the character and influence of his work, his known views, his conservativeness of action and broad catholicity of taste, have all gone to make him what he is today, the real leader of British Pictorial Photography."

In 1867 Annan's father had photographed a huge painting by the Scottish artist

David Octavius Hill (whose photographic collaborator Robert Adamson went unmentioned until fairly recently), and when Hill moved out of his house in Edinburgh in 1869, the Annan family moved in. J. Craig, who was only six when Hill died in 1870, had fond memories of the old man. During the 1890s he began to print and to exhibit many of the hundreds of magnificent paper-negative portraits made by Hill and Adamson. Stieglitz, who had not seen Hill's work before Dresden, was so impressed that he thereafter referred to Hill as the founder of pictorial photography and would publish a total of twenty-one of his photographs in three issues of *Camera Work*.

Despite all of Stieglitz's efforts and optimism, the international society never materialized.

While he was in London, Stieglitz attended the opening of the Linked Ring's Photographic Salon, on September 16, and he also visited the Royal Photographic Society's concurrent exhibition. Although for the past eleven years he had been citing the Linked Ring's annual Salon as the best example of all that he was trying to achieve in America, he had, amazingly, never before actually seen one. The 1904 Salon would be of special interest to him, because for the first time (as a result of the 1903 boycott) the American photographs had been selected in New York by the American Links and sent over as a collection. Since Stieglitz was in Europe the entire summer, he had not participated in the selection.

from THE ORIGIN OF THE PHOTO-SECESSION AND HOW IT BECAME 291 (II)

In 1904, though a very sick man, I went with my wife, my six-year-old daughter, and her nurse to Europe. I had been on the firing-line for fourteen years in New York, fighting the fight of photography. The fight I am still fighting.

This fight includes everything in life as far as I am concerned. A fight for my own life as well as a fight for the lives of all true workers, whether American or any other—with perhaps an emphasis on Americans because I believe they have needed it most, since the true worker in America has seemed to become rarer and rarer in the sense in which I use the term "true worker." In other countries—Europe, or China or Japan—at the time, there was an understanding of the true worker which did not exist in America. By that I mean the "quality worker," not in a theoretical but in a living sense.

American photography had been placed on the map. Steichen, Käsebier, White, Coburn, Eugene and others had been given to the world. Their work had made the rounds of art museums in Europe. The exhibitions of the group under my direction—the Photo-Secession—had aroused great interest, relatively as much interest as later on was aroused by so-called "modern art."

Eventually there were factions in the making. Photography was being made safe for Democracy as early as 1902. I was considered a tyrant, un-American and heaven knows what not. While I was in Europe, Mr. Curtis Bell, who was a photographer and steward of the Lotos Club, became imbued with the idea that it was time to save photography from Stieglitz and what Stieglitz represented. As I had said, it was time for him to milk the cow and castrate the bull.

Mr. Curtis Bell was going to go into the business of photography, and as an introduction he created an organization with the purpose of holding a photographic exhibition as a challenge to all I had stood for and worked for in my country. He gathered about him all of America, including the Morgans, the

Goulds, the Havemeyers—people of that class. They were the patrons. They were to give the money and prestige. He gathered about him as jury the great artists, I do not know how many of them. They included La Farge and John Alexander and, I believe, Kenyon Cox. It was to be a great international affair.

Announcements were sent all over the world. While I was in Europe, prominent and revolutionary photographers who had been in touch with my work for years, and who were following my lead in the battle for photography, wrote to me and asked whether the invitation they had received had any connection with me. My reply was a simple one. I wrote a letter to the London *Times* and to some London photographic weeklies. I let it be known that neither I nor any of the Photo-Secession could in any way be identified with this noisy project for popularizing the "art" side of photography, under the auspices of the so-called professional art patrons and the professional artists. Finally, when I returned to America, I, imagining that the exhibition would be held in some very large place, was informed that it was to take place on the top floor of a small brownstone building owned by Clausen, the art dealer, the same Clausen who some years later was forced to go out of business because he had been found selling fictitious Innesses and Wyants and Blakelocks to members of the Lotos Club and other art clubs. Clausen may have been innocent but he had to go out of business nevertheless.

In the meantime there was quite some excitement among the shining lights about me. The names of Morgan and Gould and Vanderbilt seemed to symbolize much money. Of the men about me, many were poor. And if I, holding aloof should be making a mistake, it would be fatal possibly to their future. So one night at the corner of 31st Street and 5th Avenue (the Camera Club was in 31st Street, and Steichen was living at 291 Fifth Avenue), Steichen said to me, "Look here, Stieglitz, don't you think you are making a terrible mistake in standing up against the Lotos Club with the Morgans, the Goulds, the Vanderbilts and Astors backing this enterprise of Curtis Bell's?" And I said, "If you feel that way why you still have a chance to join with that crowd and show your work, but personally I feel that these people have no more to do with that exhibition than I have. They lend their names in courtesy to Mr. Bell. The American likes to be courteous, especially when it costs him nothing. It is part of his education." Whether Steichen would decide to show or not, I didn't know. He was his own master. After a moment or so, he suddenly asked,

"Stieglitz, haven't you any ideas? We ought to have an exhibition in New York, but where is the place for it? You always insist that it is impossible to show photographs as they really should be shown—I mean, shows like you arranged in all those European cities, and even for some American cities—like the Chicago Art Institute's, the Pennsylvania Academy's in Philadelphia, and the Carnegie's in Pittsburgh. Something must be done to give New York at least a chance to see what we have been doing all these years."

And as we stood there he suddenly said, "There is a room in my house, a couple of rooms, where two women artists are living. The whole building seems to be filled with the odor of their cooking. I think that they have a monthly lease and could be persuaded to vacate and I have a feeling that these two rooms plus a front room could be had for not a very large amount of money—for about six hundred dollars a year—and the rooms could be turned into galleries and a series of photographic exhibitions could take place there covering a year, and in that way New York would at least have a chance to understand what we have been talking about, as well as what we have already done." So I said to Steichen, "We'll look into the matter and when I see you tomorrow give me a definite idea of what you feel can be done."

The next day Steichen was filled with enthusiasm. He told me that he had seen the agent of the landlord (at the time Marshall Field). The rent would be $600 a year—$50 a month. Steichen himself would decorate the rooms and get them into shape for exhibitions. The cost of installing the electric fixtures and the necessary carpentry would not be more than three hundred dollars. Mrs. Steichen lived across the hall. She would have the key and could take care of the visitors who wanted to see the galleries.

As I was eager to have New York see the photographs made in all countries and see them in the proper way and in the proper surroundings, and relying on Steichen's enthusiasm, and, above all, on his ability, I then and there told him we would go ahead. I signed a lease.

In due time—actually in 1905—what were then called the Photo-Secession Galleries were opened and these galleries were a revelation to all of New York. Columns were devoted in the editorial pages of the daily press to this new spirit. In the course of a year the masterpieces of photography of the world, from the earliest days to the most recent, were shown in these small and beautiful rooms.

The rooms were also started with the idea that there might be things shown there other than photography so that photography could be measured in juxtaposition to other media of expression. These exhibitions were the beginning of what gradually evolved into what was then known as 291. I might add that the great enterprise of Curtis Bell that Steichen seemed so afraid of turned out to be a flat failure from every point of view.

Curtis Bell's venture—to make photography safe for Democracy—was really the beginning of the popularization of photography of a very low standard. Popularization inevitably means low standards. Mr. Bell opened his professional gallery with his American Salon exhibition and Mrs. Clarence Mackey as his chief patroness. He became a flourishing photographer on Fifth Avenue. The great combination of Morgan, Vanderbilt, Astor, Mackey, Clausen *et al.* had in no way interfered with the development of that work which was my life. Nor with Steichen's, nor White's, nor any of the other Secessionists.

That is the story of the beginning of 291.

NOTES

FROM *Twice A Year* 8–9 (1942)

During the spring of 1904 Stieglitz heard the first rumblings of the plan of the Metropolitan Camera Club of New York, recently founded by photographers in northern Manhattan, to hold a photographic salon in December. The organizers, who had the temerity to call their exhibition the First American Photographic Salon, claimed that it would be the first salon "under the control of a committee from all sections of the United States." With tacit reference to the Stieglitz-dominated Philadelphia Salons the organizers insisted, "There will be no favors to any and no discrimination against any. All work, whether from the famous or the comparatively unknown artist, will be exhibited equally, and the jury will not know the names of contributors until after the selection has been made."

The mastermind of this project was Curtis Bell, a professional portrait photographer who had opened a studio on Fifth Avenue after his recent arrival in New York from the Midwest. Bell was the president not only of the Metropolitan Camera Club but also of the Salon Club of America, which was composed of about twenty photographers, scattered across much of the nation, who circulated among themselves a monthly portfolio of work for mutual criticism. Bell was also the president of the American Federation of Photographic Societies and cashier of the prestigious Lotos Club, New York's foremost club

devoted to the arts, whose members included Pierpont Morgan, Jay Gould, and Henry O. Havemeyer.

As his chief publicist, Bell recruited Sadakichi Hartmann, a prolific *Camera Work* contributor who had come to feel that Stieglitz did not treat him with proper respect. The critic's first thrust was in the form of an article about the Salon Club and the upcoming salon. Written under the pseudonym "The Chiel" and published in the July 1904 issue of the *American Amateur Photographer*, it concluded, "All this sounds like open revolt! . . . A duel between Messrs Alfred Stieglitz and Curtis Bell would prove indeed a great attraction. . . . It will stir up the stagnant waters of pictorial photography—they surely need it—and make us all more happy at the end."

In June 1904, Hartmann wrote to the leading European photographers inviting them to send work to Bell's salon. As soon as he learned of this, Stieglitz—who was then in Europe—sent letters to the major British and continental photographic magazines stating that he had nothing to do with the exhibition—and that, in fact, it had been organized specifically to counter his influence. Hartmann retaliated with a series of vitriolic articles deploring Stieglitz's malign influence upon American photography.

Stieglitz, who had assumed that Bell's Salon would be hung in one of the city's large and prestigious galleries, or perhaps even at the Lotos Club, was greatly relieved to learn that it would be held on the top floor of the small brownstone building, on Fifth Avenue, housing the Clausen Galleries. Although the Salon, which ran from December 5 to 17, attracted a considerable amount of foreign work, almost all of Stieglitz's friends, at home and abroad, boycotted it. The public response to the exhibition was not sufficiently encouraging for Bell to repeat his venture in subsequent years.

Early in 1905 Stieglitz had hopes of organizing a great international photographic salon in New York. His plan, which was supported strongly by Steichen, was to rent one of the big New York art galleries for a few weeks early in the spring of 1906 and to mount "an exhibition consisting of the very best that has been accomplished in pictorial photography throughout the world, from the time of Hill . . . up to date." He went so far as to assemble many prints for the exhibition, and he intended to show others that were already in his rapidly growing personal collection. In September 1905, however, he found himself forced to accept "the impossibility of securing at any price adequate gallery accommodations during the desirable New York season."

One night shortly thereafter Stieglitz and Steichen hit upon a brilliant idea during a long conversation at the corner of Fifth Avenue and Thirty-first Street. They decided that even if they could not find a space in which to mount a large exhibition, they surely could at least rent a small space in which to present the American, British, French, Belgian, German, and Austrian sections of the aborted exhibition serially over the course of a few months. Steichen suggested renting the top-floor studio apartment that he had recently vacated, along with the two rooms behind it, at 291 Fifth Avenue.

Stieglitz was at first reluctant to sign the lease, for he was worried that he and Steichen would not be able to find enough first-rate photographs to fill the galleries with an uninterrupted series of exhibitions throughout the six-month New York art season. Steichen then countered that since the established art galleries still refused to show photographs, the new gallery could turn their flank by exhibiting paintings and other works of art, either together with photographs or in alternation. Such exhibitions could confirm the artistic claims of photography and inspire photographers to strive for more sophisticated artistic standards in their own work. Stieglitz naturally approved.

Since Steichen was so enthusiastic, so capable, and so willing to take care of transforming the rooms into a gallery, Stieglitz finally agreed to sign the lease.

Stieglitz called his exhibition space "The Little Galleries of the Photo-Secession," though regulars were soon calling it simply "291," from its street address. Eventually, "291" came to be the mystical, numerological symbol of the conflation of Stieglitz's personality, the gallery, and all that it represented. One could never be quite sure, when Stieglitz uttered the pregnant trinumeric formula, whether he was referring to the gallery or to himself.

Letter to the Members of the Photo-Secession

The Council of the Photo-Secession had planned to hold, in the city of New York, early next spring, an exhibition consisting of the very best that has been accomplished in pictorial photography throughout the world, from the time of [David Octavius] Hill, the father of pictorial photography, up to date. Many of the prints had been selected for this purpose, but owing to the impossibility of securing at any price adequate gallery accommodations during the desirable New York season, this exhibition must be deferred.

The Photo-Secession, for the present thus unable to hold the proposed big exhibition, has determined to present in detail some of the work which had already been selected and which would have been embraced therein, and for that purpose has leased rooms at 291 Fifth Avenue, New York City, where will be shown continuous fortnightly exhibitions of from 30 to 40 prints each. These small, but very select, shows will consist not only of American pictures never before publicly shown in any city in this country, but also of Austrian, German, British, French, and Belgian photographs, as well as such other art productions, other than photographic, as the Council of the Photo-Secession can from time to time secure.

It is planned to make these rooms headquarters for all Secessionists, and to open them to the public generally without charge, upon presentation of a visiting card. The exhibitions will commence about November 1, All Saints Day, with a collection of work by Secessionists, to which all Members, Fellows, and Associates are invited and urged to contribute. The plan of decoration in the rooms is such that it is deemed in the interests of harmony to show the prints under large sheets of glass. . . . You are assured that at least one of your pictures will be hung. . . .

An effort will be made to show the photographs in a manner worthy of Secessionist methods and generally to make the rooms as attractive as possible to all art lovers, who will find there, besides the exhibitions, art magazines and publications, foreign and American.

FROM *Photo-Era* 15 (OCTOBER 1905)

According to the description of the new galleries at 291 Fifth Avenue published in *Camera Work*, the main room, in which photographs were displayed mostly in dark wooden frames, was "kept in dull olive tones, the burlap wall-covering being a warm olive gray; the woodwork and moldings similar in general color, but considerably darker." The pleated canvas hangings that concealed storage below the shelf running all around the room were "of an olive-sepia sateen," and the ceiling and scrim were "of a very deep creamy gray." In the smaller gallery, where matted photographs were hung unframed or in simple white frames, the walls and doors were "covered with a bleached natural burlap," boldly outlined by rectangles of white, with hangings of grayish yellow. The little hallway gallery was "decorated in gray-blue, dull salmon, and olive-gray." A few Japanese vases were placed on the shelf in the main room. On the burlap-covered table in the center of that room, filled with flowers or branches, was a large, nearly spherical bowl of hammered brass.

On the evening of November 25, 1905, the Little Galleries of the Photo-Secession opened with an exhibition that amounted to a miniature but superb salon of American photography. Of the approximately sixty photographers who belonged to the Photo-Secession at that time, thirty-nine were represented in the exhibition of one hundred prints.

The opening show was followed by one of French photographs selected by Robert Demachy (January 10–24, 1906) and then an exhibition of Herbert G. French's series of photographic illustrations for Tennyson's *Idylls of the King* (January 26–February 2). After that came a Käsebier and White duet, followed by a show of work by Stieglitz's favorite British photographers: David Octavius Hill and his partner Robert Adamson, J. Craig Annan, and Frederick Evans.

Next was a Steichen retrospective (March 16–31) , and, bringing the first season to a close at the end of April, a show of large multiple-gum prints by the self-styled Viennese Trifolium (Heinrich Kuehn, Hugo Henneberg, and the late Hans Watzek) and by the brothers Theodor and Oskar Hofmeister, of Hamburg. Stieglitz had thus succeeded in presenting all but the projected Belgian section of his serial salon.

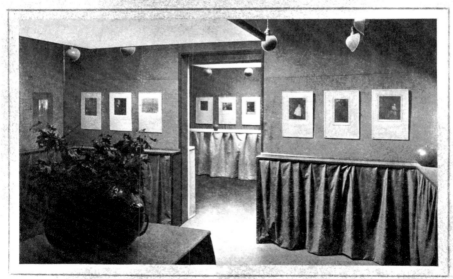

Alfred Stieglitz, *The Photo-Secession Galleries*, 1905–06

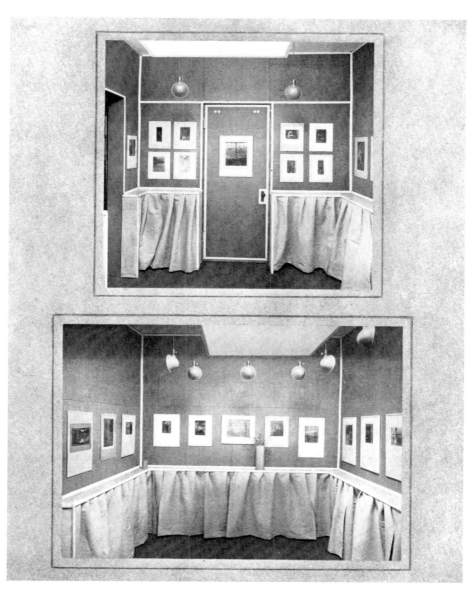

Alfred Stieglitz, *The Photo-Secession Galleries*, 1905–06

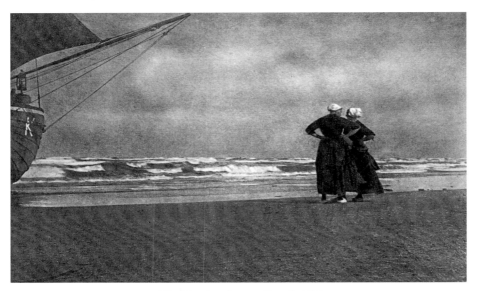

Alfred Stieglitz, *Gossip—Katwyk*, 1894

SIMPLICITY IN COMPOSITION

The request of the publishers of this book to write for them an article of 1,500 words upon Simplicity in Composition reminds me of the college professor who was accustomed to call upon his students for extempore dissertations upon subjects which he would suddenly propound. Unconscious of the humor of his demand, he one day called upon one of his favorite scholars in the following terms: "Mr. Thompson," he said, "your time will be five minutes and your subject, 'The Immortality of the Soul.' " I, too, can sympathize with the feelings of Mr. Thompson, for the subject of Simplicity in Composition is as difficult and complex as is often the most simple appearing pictorial composition.

The popular conception of a simple pictorial composition is apparently not one in which the elements are reduced to the fewest possible terms, but one in which such elements are so subtly arranged as to impress the beholder so directly and forcibly with the central or dominant idea of the picture that everything else, even though covering a goodly portion of the picture area, is so subordinated as to appear of but little moment. To achieve such a result presents to the artist a problem which becomes more complex in proportion to the so-called simplicity of the composition. In fact, one can truthfully say that the ratio of difficulty varies directly as the square of the simplicity. Just as in music we find that the simpler the theme, the more thorough must be the knowledge of the musician in order to compose acceptable variations thereon. So, in fact, in every art this rule obtains, and the simpler the apparent result—assuming, of course, that such result is really beautiful—the greater are the care, knowledge and taste required.

The problem that is presented is practically one of elimination. To include all that is necessary for the elucidation of the composition, and to exclude *everything* that is unessential to a clear statement of the dominant underlying idea, taxes the abilities of even the best artists to their utmost. I must not be

misunderstood to say that every great work of art must necessarily be simple in its composition, for many of the great masterpieces in painting are built up upon very complex geometric lines. In fact, the nature of the composition is largely dependent upon the subject and the manner in which it is intended to be represented. I am now alluding mainly to linear compositions, there being also tonal compositions, mass compositions, color compositions and combinations of all these. This holds true in varying degree in photography as well as in painting. Those modern pictorial photographs which have attracted so much attention, especially in Europe, because of their composition and tonal treatment, have been subjected in their development to the same influences that have affected the modern painter generally. Their keynote is simplicity in arrangement and the true rendering of tonal values.

The one element absolutely essential in every composition is balance, without which no picture can ever be satisfying. Lacking this, a picture becomes restless and irritating, and the beholder turns from it with a sense of relief.

No formula can be drawn up for the simplification of the course of study necessary to an understanding of what constitutes good composition. To a natural taste must be added a careful and understanding study of the best accepted work of all forms of art, old and new. In photography this is even more essential, if possible, than in painting, for the photographer, usually working in monochrome, has not the resource of color upon which the painter can draw. Consequently, the only advice is to study the best pictures in all media—from painting to photography—and to study them again and again, analyze them, steep yourself in them until they unconsciously become part of your esthetic being. Then, if there be any trace of originality within you, you will intuitively adapt what you have thus made a part of yourself, and tinctured by your personality you will evolve that which is called style.

The ultimate result of the before-mentioned elimination will bring us to a representation in which there appears one single, simple object which the average photographer would say was incapable of composition because it stood in no relation to anything else. In this he is woefully mistaken. It first of all stands in relation to the boundary lines of his print; and in the position it occupies, it divides the surface into spaces. This relation constitutes space composition. Next it stands in relation to its background and here ends the problem of aerial composition. Again it must be illuminated from some

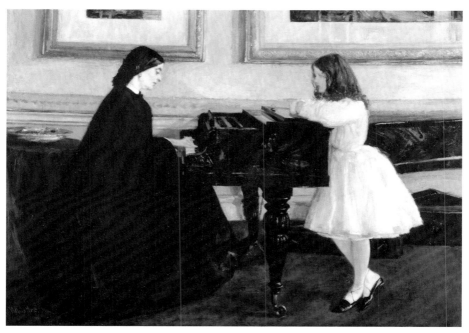

James Abbott McNeill Whistler, *At the Piano*, 1858–59 (oil on canvas)

source of light and this brings in the problem of light and shade or chiaroscuro. Given a single subject, to produce with these elements alone a truly big picture calls for the display of the greatest art. So apparently simple and yet important are the elements that a slight error in any one particular assumes the proportion of a gigantic fault and the whole composition falls to pieces. Herein lies one of the fascinations of Steichen's photographs. In his direct and simple handling of light and shade and spacing there is a subtlety of which even the average photographer is conscious without being able to analyze why. This lack of understanding is often due to all lack of art schooling and above all to his want of proper association. Nothing educates and refines more than proper association.

Taking now our single, simple object and introducing another simple object into the composition, there immediately springs up a more complex sense of relation. The newly introduced object must now be studied not only in its relation to the three factors previously enumerated and to object No. 1, but its relation to each one of the three factors operating upon our first object.

This becomes thus a geometric progressive and so *ad infinitum*. The more involved these relations become, the less important are errors in these minor relations—yet should all these relations be harmonious the result, though seemingly simple, is wonderfully fascinating to the mature student of composition. An instance of this can be found in Whistler's *At the Piano*.

I have often been told that one of the main characteristics of my own photographs lay in their simplicity of composition, and *The Hand of Man* is frequently instanced as an example of this quality. As the lines of composition in this picture are anything but simple, I have come to the conclusion that the average person confounds simplicity and directness of subject with the totally different quality of simplicity in composition.

Had *Gossip—Katwyk* been instanced as a picture showing simplicity in composition, it would have been nearer the truth—yet this picture presented to me in its composition one of the hardest nuts I ever tried to crack. Given a homelike, everyday subject presenting familiar objects, the tendency is to cry: how charmingly simple in its composition! Unconscious of the fact that the subject appeals to us and not its linear or even pictorial treatment.

And now I must return to my anecdote with which I began. So complex is the simple subject "Simplicity in Composition" that these stray and random

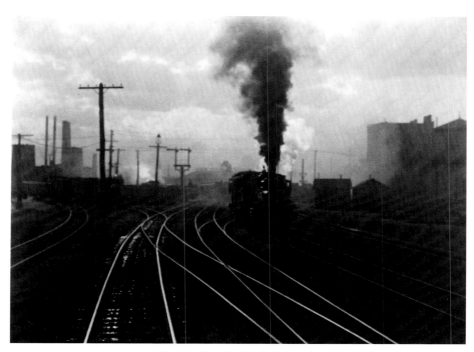

Alfred Stieglitz, *The Hand of Man*, 1902

thoughts have not begun even to outline it. There is one piece of simple and direct advice which I wish to iterate and reiterate—for I believe this is written for one who has mastered the A B C of the technique of photography and is about ready to dive into the mysterious deep of art: Observe the work of recognized artists—I do not mean look at it, but observe it—make it your own. Then study the appearance of nature more closely than ever before *everywhere*. And there is also one simple and direct warning I would like to give: Avoid books on composition as you would the plague, lest they destroy in your mind all other considerations than the formulae which they lay down. If you must be taught by others, not being able to teach yourself, seek out a broad-minded teacher, but guard your originality as the one precious possession which may save you from turning out machine-made work.

FROM *The Modern Way in Picture Making.*
ROCHESTER, NEW YORK: EASTMAN KODAK CO., 1905

In "A Plea for Art Photography in America" (*Photographic Mosaics*, 1892), Stieglitz wrote, "Simplicity, I might say, is the key to all art—a conviction that anybody who has studied the masters must arrive at. Originality, hand-in-hand with simplicity, are the first two qualities which we Americans need in order to produce artistic pictures. These qualities can only be attained through cultivation and conscientious study of art in all its forms."

The word "simplicity" is rather misleading, for what Stieglitz sought was a bold and sophisticated directness of composition that managed to exclude extraneous elements. He is quite correct in objecting to the use of his photograph *The Hand of Man* (1902) as an example of simplicity in composition, for it is one of his most complex images. The title of this Dreiserian image is a *double entendre*, referring not only to mankind's blighting impact upon the natural landscape but also to the fact that the tracks seem to outline the fingers of a great hand reaching forward. That picture marked a turning point in Stieglitz's career. It was a kind of manifesto, declaring that it was no longer necessary to travel to "picturesque" and idyllic or unspoiled places like Gutach—where he had been pleased by the absence of trains and factories—in order to make pictorialist photographs. Stieglitz claimed that *The Hand of Man* marked the beginning of a new era in photography, since it successfully demonstrated the "pictorial possibiliities of the commonplace."

from THE ORIGIN OF THE PHOTO-SECESSION AND HOW IT BECAME 291 (III)

The Photo-Secession became the leading factor in the international pictorial photographic world. Its "founding" had led to the opening of its own gallery at 291 Fifth Avenue.

At the end of the series of exhibitions held there—at the end of the first year—Steichen, who had had a one-man show in our Photo-Secession galleries and a one-man painting show in the "high class" galleries of Eugene Glaenzer not a block away on Fifth Avenue, decided that America was no place for him. He would go to Paris with his wife and his child.

When I came home and told my wife that Steichen was going, she said, "Thank God, he's going. Now we two can travel and you can give up all that nonsense, for without Steichen you can't go ahead."

The very next morning I told Steichen of what had happened.

So I called up the real estate agent and asked him whether he could renew the lease for two years at the same rate we had been paying, which was six hundred dollars a year. My proposition was accepted.

When I came home and told my wife what I had done she burst out crying.

"You can thank yourself," I said. "I had no idea of doing this until you spoke as you did."

Steichen moved to Europe and I continued with the Photo-Secession Gallery.

Jealousies had been developing over the years amongst the Secessionists. I was getting sick and tired of the arrogance of the photographers who had banded about me. They had come to believe that my life was to be dedicated solely to them and did not realize that my battle was for an idea bigger than any individual. Although the battle of photography had been established from my point of view, it had not yet been clearly won. Then one day a strange woman appeared, Pamela Colman Smith. She had several portfolios of drawings. She imagined that the Photo-Secession Gallery might be interested in

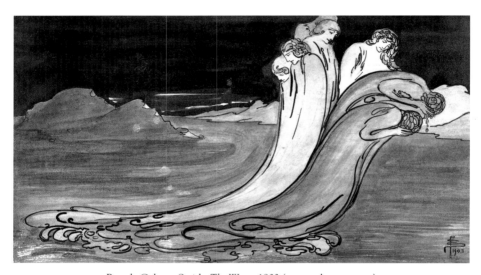

Pamela Colman Smith, *The Wave*, 1903 (watercolor on paper)

her work. There was a drawing in washes, an illustration called "Death in the House." The moment I saw this picture I decided to show her work. "Death in the House" really illustrated my feeling at the time.

Steichen, whom I kept in close touch with what I had been doing, one day wrote to me from Paris: "You seem to have opened the doors of the Photo-Secession to things not photography. Do you want an exhibition of selected Rodin drawings?" I cabled back: "Yes." Then Steichen arrived shortly afterwards with a wonderful lot of selected Rodin drawings—Steichen being very close to Rodin, a sort of foster son. He had photographed Rodin innumerable times and had photographed his sculpture. When Steichen arrived he had brought with him a collection of the evolution of a painter I had never heard of: Matisse. The evolution was in the form of drawings, watercolors, and an oil contributed by George F. Of, the painter. This was the real introduction of modern art to America.

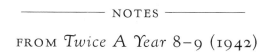

NOTES

FROM *Twice A Year* 8–9 (1942)

One day early in December 1906 an eccentric, 28-year-old American named Pamela Colman Smith appeared at 291 and proceeded to show Stieglitz several portfolios of her drawings and watercolors. Many of them were in the spirit of the French Symbolist painter Odilon Redon, and most had been inspired by the theater (Shakespeare and Maeterlinck) or by music (such as Schumann's *Carnaval*). Stieglitz immediately decided to exhibit Smith's drawings the following month.

He and Steichen had planned all along to show non-photographic works. Upon his return to Paris, Steichen had told the great sculptor Auguste Rodin that he and Stieglitz wanted a show of his drawings to be the first such exhibition at 291. Rodin had expressed his enthusiasm for the project, but Steichen had not been quick enough to select and send the drawings to New York. When Steichen received Stieglitz's letter informing him of the upcoming Smith exhibition, he was furious. The Rodin exhibition did not take place until January 1908.

At 291 Stieglitz presented the first American one-person exhibitions of work by Henri de Toulouse-Lautrec, Paul Cézanne, Henri Matisse, Francis Picabia, and Elie Nadelman; and the first one-person showings anywhere of Pablo Picasso, Constantin Brancusi, and Le Douanier Rousseau. He also pioneered displays of African sculpture and of children's drawings. Beginning about 1910 he concentrated on nurturing a group of American

Henri Matisse, *Nude in a Wood*, 1905 (oil on panel)

artists that eventually included Charles Demuth, Arthur Dove, Marsden Hartley, John Marin, Georgia O'Keeffe, Abraham Walkowitz, and Max Weber.

Stieglitz began to exhibit modernist art not because he was repudiating photography, but because he believed that looking at such works would help photographers and others to understand what photography was *not*, and would thus provide valuable insights into what it could and should be. The essence of his argument was that since the camera naturally surpassed even the most talented painter in the accurate depiction of form, it was pointless for painting and the graphic arts to attempt to do what photography did better—and absurd for photography to imitate its second-rate cousins.

Stieglitz maintained that photographers should devote themselves to the straightforward and purely photographic representation of form and that painters should attempt to render not the outward appearance of things but rather their own emotional responses to what they saw. In other words, photographs should not be painterly, and paintings should not be photographic.

During April 1908 Stieglitz exhibited a selection of Matisse's watercolors, drawings, etchings, and lithographs along with one oil painting. The latter was borrowed from George F. Of, who made his living as a framer and did all the framing for 291. In the summer of 1906, when Gertrude Stein's sister-in-law Sarah visited New York, she had with her two Matisse nudes, one a drawing and the other an oil sketch. After seeing them, Of asked her to select a small Matisse painting for him when she returned to Paris; that fall she sent him *Nude in a Wood*, the first Matisse to be owned by a collector living in America. The painting is now in the Brooklyn Museum of Art.

HOW *The Steerage* HAPPENED

Early in June, 1907, my small family and I sailed for Europe. My wife insisted upon going on the *Kaiser Wilhelm II*—the fashionable ship of the North German Lloyd at the time. Our first destination was Paris. How I hated the atmosphere of the first class on that ship. One couldn't escape the *nouveaux riches*.

I sat much in my steamer chair the first days out—sat with closed eyes. In this way I avoided seeing faces that would give me the cold shivers, yet those voices and that English—ye gods!

On the third day out I finally couldn't stand it any longer. I tried to get away from that company. I went as far forward on deck as I could. The sea wasn't particularly rough. The sky was clear. The ship was driving into the wind—a rather brisk wind.

As I came to the end of the desk I stood alone, looking down. There were men and women and children on the lower deck of the steerage. There was a narrow stairway leading up to the upper deck of the steerage, a small deck right at the bow of the steamer.

To the left was an inclining funnel and from the upper steerage deck there was fastened a gangway bridge which was glistening in its freshly painted state. It was rather long, white, and during the trip remained untouched by anyone.

On the upper deck, looking over the railing, there was a young man with a straw hat. The shape of the hat was round. He was watching the men and women and children on the lower steerage deck. Only men were on the upper deck. The whole scene fascinated me. I longed to escape from my surroundings and join those people.

A round straw hat, the funnel leaning left, the stairway leaning right, the white draw-bridge with its railings made of circular chains—white suspenders crossing on the back of a man in the steerage below, round shapes of iron machinery, a mast cutting into the sky, making a triangular shape. I stood

spellbound for a while, looking and looking. Could I photograph what I felt, looking and looking, and still looking? I saw shapes related to each other. I saw a picture of shapes and underlying that the feeling I had about life. And as I was deciding, should I try to put down this seemingly new vision that held me—people, the common people, the feeling of ship and ocean and sky and the feeling of release that I was away from the mob called the rich—Rembrandt came into my mind and I wondered would he have felt as I was feeling.

Spontaneously I raced to the main stairway of the steamer, chased down to my cabin, got my Graflex, raced back again all out of breath, wondering whether the man with the straw hat had moved or not. If he had, the picture I had seen would no longer be. The relationship of shapes as I wanted them would have been disturbed and the picture lost.

But there was the man with the straw hat. He hadn't moved. The man with the crossed white suspenders showing his back, he too, talking to a man, hadn't moved, and the woman with the child on her lap, sitting on the floor, hadn't moved. Seemingly no one had changed position.

I had but one plate-holder with one unexposed plate. Would I get what I saw, what I felt? Finally I released the shutter. My heart thumping. I had never heard my heart thump before. Had I gotten my picture? I knew if I had, another milestone in photography would have been reached, related to the milestone of my *Car Horses* made in 1893, and my *Hand of Man* made in 1902, which had opened up a new era of photography, of seeing. In a sense it would go beyond them, for here would be a picture based on related shapes and on the deepest human feeling, a step in my own evolution, a spontaneous discovery.

I took my camera to my stateroom and as I returned to my steamer chair my wife said, "I had sent a steward to look for you. I wondered where you were. I was nervous when he came back and said he couldn't find you." I told her where I had been.

She said, "You speak as if you were far away in a distant world," and I said I was.

"How you seem to hate these people in the first class." No, I didn't hate them, but I merely felt completely out of place.

As soon as we were installed in Paris I went to the Eastman Kodak Company to find out whether they had a darkroom in which I could develop my plate. They had none. They gave me an address of a photographer. I went there.

The photographer led me to a huge darkroom, many feet long and many feet wide, perfectly appointed.

He said, "Make yourself at home. Have you developer? Here's a fixing bath—it's fresh."

I had brought a bottle of my own developer. I started developing. What tense minutes! Had I succeeded, had I failed? That is, was the exposure correct? Had I moved while exposing? If the negative turned out to be anything but perfect, my picture would be a failure.

Finally I had developed and washed and rinsed the plate. In looking at it, holding it up to the red light it seemed all right, and yet I wouldn't know until the plate had been completely fixed.

The minutes seemed like hours. Finally the fixing was completed. I could turn on the white light. The negative was perfect in every particular. Would anything happen to it before I got to New York?

I washed it. No negative could ever receive more care, and when the washing was finished, I dried the negative with the help of an electric fan. I waited until it was bone dry, and when it was completely dry I put the glass plate into the plate holder which originally held it. In that way I felt it was best protected. I would not remove it from that place till I had returned to New York. I had sufficient plate holders with me to permit myself that luxury—or, should I say, that insurance?

I wanted to pay the photographer for the use of his darkroom, but he said, "I can't accept money from you. I know who you are. It's an honor for me to know you have used my darkroom."

How he happened to know me I couldn't understand. Later on I discovered that my name was written on a package which I had left in his office while in the dark room.

And when I got to New York four months later I was too nervous to make a proof of the negative. In making the negative I had in mind enlarging it for *Camera Work*, also enlarging it to eleven by fourteen and making a photogravure of it.

Finally this happened. Two beautiful plates were made under my direction, under my supervision, and proofs were pulled on papers that I had selected. I was completely satisfied. Something I not often was, or am.

The first person to whom I showed *The Steerage* was my friend and co-worker Joseph T. Keiley. "But you have two pictures there, Stieglitz, an upper

one and a lower one," he said.

I said nothing. I realized he didn't see the picture I had made. Thenceforth I hesitated to show the proofs to anyone, but finally in 1910 I showed them to [Paul] Haviland and Max Weber and [Marius] de Zayas and other artists of that type. They truly saw the picture, and when it appeared in *Camera Work* it created a stir wherever seen, and the eleven by fourteen gravure created still a greater stir.

I said one day, "If all my photographs were lost and I'd be represented by just one, *The Steerage*, I'd be satisfied."

I'm not so sure that I don't feel much the same way today.

NOTES

FROM *Twice A Year* 8–9 (1942)

Around June 1, 1907, Stieglitz, together with his wife, their daughter, Kitty, and Kitty's governess, sailed from New York, bound for Le Havre. It is ironic that Stieglitz's photograph (Plate 9)—which is frequently reproduced to represent hopeful immigrants on their way to America—actually depicts people returning to Europe. Although some of them may have been turned back because of failure to meet the financial or health requirements for entrance, most were probably "birds of passage," skilled artisans who worked in the construction trades and more or less commuted between Europe and America in two-year cycles. Moreover, although it is often assumed that the people on the upper deck are first-class passengers looking down at unfortunates, everyone in the photograph was actually traveling in steerage.

We must question whether Stieglitz did in fact realize immediately that he had made one of the most important photographs of his career. Tellingly, he neither exhibited nor published *The Steerage* until October 1911, though he had numerous opportunities to do so. Edward Steichen recalled that it was the painter Max Weber who, in 1911, first brought the photograph to Stieglitz's attention as a Cubist masterpiece. Stieglitz would later say of *The Steerage*, "You may call this a crowd of immigrants . . . To me it is a study in mathematical lines, in balance, in a pattern of light and shade."

In the October 1906 issue of *Camera Work* an advertisement for Graflex cameras features a letter in which Stieglitz writes: "Ever since the Graflex has been in the market I have used it for many purposes. At present I own a 5-by-7, 4-by-5, and a 3¼-by-4¼, and I confess the family has never caused me one moment of uneasiness. . . . If circumstances compel me to choose but one type of camera when off on a trip, it invariably means my taking a Graflex. A Pocket Kodak, a Graflex, and a tripod 8-by-10 is a complete outfit for any pictorialist."

THE NEW
COLOR PHOTOGRAPHY—
A BIT OF HISTORY

Color photography is an accomplished fact. The seemingly everlasting question whether color would ever be within the reach of the photographer has been definitely answered. The answer the Lumières, of France, have supplied. For fourteen years, it is related, they have been seeking it. Thanks to their science, perseverance, and patience, practical application and unlimited means, these men have finally achieved what many of us had looked upon practically as unachievable. Prof. Lippmann, of the Sorbonne at Paris, had a few years ago actually obtained scientifically correct color photographs, but his methods were so difficult and uncertain as to make each success very costly. In consequence his invention is only of scientific value. But the Autochrome Plate, as the plate invented and made by the Lumières has been named, permits every photographer to obtain color photographs with an ordinary camera and with the greatest ease and quickness. The Lumières evolved their plate from the theories of others, but the practical solution is entirely theirs. They have given the world a process which in history will rank with the startling and wonderful inventions of those two other Frenchmen, Daguerre and Niépce. We venture to predict that in all likelihood what the Daguerreotype has been to modern monochrome photography, the Autochromotype will be to the future color photography. We believe that the capitalist, who has for obvious reasons fought shy of color "fanatics," will now, in view of the beautiful and readily obtained practical results with the Autochrome plate, untie his purse strings and support the color experimenters whose numbers are already legion. The latter will thus receive a fair opportunity to work out their innumerable theories and countless patents. Who can predict what may yet be in store for us from these sources? In the meantime we rejoice in what we have. It will be hard to beat.

The Autochrome Plate photographs color automatically. A transparent support (glass) is covered with an adhesive matter which receives a coating

of potato starch grains dyed blue-violet, green, and red-orange. After isolating this with a waterproof varnish (zapon, we believe) it is coated with a panchromatic (collodion) emulsion. The exposure is made in the usual way, but with the glass side of the plate facing the lens, so that the light passes through the colored grains and only then reaches the emulsion. The lens is fitted with a special yellow filter made by the Lumières for the plate. The plate is developed and then, without fixing, is treated in broad daylight with an acid permanganate reducer, rinsed and redeveloped. The result is a positive print in natural colors. If the exposure has been correct—and correct exposure is the essential for ultimate success—the results are uncommonly realistic. Thus far only one picture can result from each exposure. It is a transparency which can only be seen properly by transmitted white light or, if small enough to put into the lantern, on the screen. The Lumières, as well as others, are now at work trying to make possible the multiplication of the original, but so far the experimental stage has not been passed. No print on paper will ever present the colors as brilliantly as those seen on the transparencies. This is due to the difference of reflected and transmitted light. The solution of the problem is but a matter of time.

It was in the beginning of June [1907] that the plates in small quantities were put on the market in Paris; a few plates had been sent to Germany to be tested by scientific experts. Elsewhere none were to be had. Fortunately for ourselves, Steichen and I were in Paris when Lumière was to demonstrate his process for the first time. The following letter sent by me to the Editor of *Photography* (London) speaks for itself. It is reprinted with the Editor's comments:

THE COLOR PROBLEM FOR PRACTICAL WORK SOLVED.
The characteristically outspoken letter from Mr. Stieglitz, which we print below, will be read with interest by those who have seen some of the amusing deprecatory statements as to the real meaning of the Autochrome advance.

Sir,—Your enthusiasm about the Lumière Autochrome plates and the results to be obtained with them is well founded. I have read every word *Photography* has published on the subject. Nothing you have written is an exaggeration. No matter what

you or anyone else may write on the subject and in praise of the results, the pictures themselves are so startlingly true that they surpass anyone's keenest expectations.

I fear that those of our contemporaries who are decrying and belittling what they have not seen, and seem to know nothing about, will in the near future have to do some crawling. For upwards of twenty years I have been closely identified with color photography. I paid much good coin before I came to the conclusion that color, so far as practical purposes were concerned, would ever remain the perpetual motion problem of photography.

Over eighteen months ago I was informed from inside sources that the Lumière had actually solved the problem; that in a short time everyone could make color pictures as readily as he could snap films. I smiled incredulously, although the name Lumière gave that smile an awkwardness, Lumière and success and science thus far always having been intimately identified. Good fortune willed it that early this June I was in Paris when the first results were to be shown at the Photo-Club. Steichen and I were to go there together. Steichen went; illness kept me at home. Anxiously I awaited Steichen's report. His "pretty good only" satisfied my vanity of knowing it all.

Steichen nevertheless bought some plates that morning, as he wished to see what results he could obtain. Don't we all know that in photography the manufacturer rarely gets all there is in his own invention? Steichen arrived breathlessly at my hotel to show me his first two pictures. Although comparative failures, they convinced me at a glance that the color problem for practical work had been solved, and that even the most fastidious must be satisfied. These experiments were hastily followed up by others, and in less than a week Steichen had a series of pictures which outdid anything that Lumière had had to show. I wrote to you about that time, and told you what I had seen and thought, and you remember what you replied. His trip to London, his looking you up and showing you his work, how it took you literally off your feet, how a glance (like with myself) was sufficient to show you that the day

had come, your enthusiasm, your own experiments, etc., etc., all that is history, and is for the most part recorded in your weekly. While in London Steichen did Shaw and Lady Hamilton (Plate 6) in color; also a group of four on Davison's houseboat. The pictures are artistically far in advance of anything he had to show you.

The possibilities of the process seem to be unlimited. Steichen's pictures are with me here in Munich; he himself is now in Venice working. It is a positive pleasure to watch the faces of the doubting Thomases—the painters and art critics especially—as they listen interestedly about what the process can do. You feel their cynical smile. Then, showing them the transparencies, one and all faces look positively paralyzed, stunned. A color kinematographic record of them would be priceless in many respects. Then enthusiasm, delighted, unbound, breaks loose, like yours and mine and everyone's who sees decent results. All are amazed at the remarkably truthful color rendering; the wonderful luminosity of the shadows, that bugbear of the photographer in monochrome; the endless range of grays; the richness of the deep colors. In short, soon the world will be color-mad, and Lumière will be responsible.

It is perhaps fortunate that temporarily the plates are out of the market. The difference between the results that will be obtained between the artistic fine feeling and the everyday blind will even be greater in color than in monochrome. Heaven have pity on us. But the good will eventually outweigh the evil, as in all things. I for one have learned above all that no problem seems to be beyond the reach of science.

Yours truly,
ALFRED STIEGLITZ
Tutzing, Munich, July 31st, 1907

When Steichen visited Mr. Bayley, the editor of *Photography*, he gave him a box of plates to try and judge for himself what could be done with them. It is needless to say that Bayley took the cue. *Photography* came out at once with a blare of trumpets about the wonderful invention. The Steichen interview was printed in full. As no plates could be had in Great Britain until very

recently—even France had virtually none in July and part of August owing to some trouble in the factory at Lyons—and as the editors had no opportunity of seeing any pictures, Bayley and his enthusiasm were laughed at with derision. It was then that my letter was written. As a result some of the English dailies which devote space regularly to photography had become keenly interested in color photography, although none had seen any actual results. In the United States also, most of the editors having followed the English press, were having great sport with the claims made about the pictures which they had not seen. Then followed, therefore, a second letter to Bayley. It is more suggestive than comprehensive:

MR. STIEGLITZ ON THE PERSONAL FACTOR IN AUTOCHROME. The following extract from a letter to hand from Mr. Stieglitz, which we have had his permission to publish, was written under the impression that the writer in the *Daily Telegraph* referred to had sufficient knowledge of the process and its results to give his opinion weight. We are informed that when the paragraph in question was penned he had seen no representative work on the Autochrome plates whatever. But the value of Mr. Stieglitz's views does not depend on the triviality or otherwise of the occasion that called them forth.

Why does a writer in the *Daily Telegraph* of August 23 rush into print and jump at erroneous conclusions not only about the Autochrome process, but about myself? I have overlooked nothing in considering the Lumière method of producing color photographs, I can assure him.

No one realizes more fully than I do what has been accomplished so far in color photography, what really beautiful results have occasionally been achieved in press color printing, and also in the other color processes thus far invented—Ives' Chromoscope, Lippmann, etc.* It is even my good luck now to be in Munich,

* NOTE—*Etc. includes Joly, Sanger Shepherd, Brasseur, Pinatypie, Miethe, McDonough and others.*

where color printing is probably carried to the most perfect degree of the day, and where Dr. Albert—undoubtedly one of the greatest of all color experimenters as far as theory and practical achievement are concerned—has his laboratory and his plant. I have seen him; seen his newest experiments and latest results, and these, I can assure my readers, are in their way as remarkable as Lumière's are in theirs. His methods are mostly still unpublished, and the world knows but little of what he has in store for it. A revolution as far as the production of color plates for letterpress printing is concerned is close at hand, thanks to Albert's genius.

Albert is a rare man in more ways than one; his is a scientific mind combined with a goodly portion of natural artistic feeling. Upon my showing him Steichen's color transparencies he granted at a glance—the glance of a student and expert—that in color photography he had seen nothing quite so true and beautifully rendered as Shaw's hands and wrists. Probably nothing in painting has been rendered more subtly, more lovingly, than has been by the camera in this instance.

We all realize that the Lumière process is far from perfection. It has its limitations, like every other process, but these limitations are by no means as narrow as we were originally led to believe.

We know that for the present at least the rendering of a pure white seems impossible.* Yet, artistically considered, this is not necessarily a fault. The photographer who is an artist and who has a conception of color will know how to make use of it. Steichen's newer experiments, as well as those now being made by Frank Eugene and myself (Plates 4 and 5), have proven to our satisfaction that the Lumière method has quite some elasticity, and promises much that will be joyous and delightful to even the most sensitive eye.

Certain results I have in my mind's eye may eventually lead to endless controversy similar to that waged not so very long ago about sharpness and diffusion, and to that now being waged about "straight" and "crooked" photography. But why consider that of

* Read scientifically pure white. —EDITOR.

importance? I wish to repeat that the Lumière process is only seemingly nothing more than a mechanical one. It is generally supposed that every photographer will be able to get fine artistic pictures in color merely by following the Lumière instructions, but I fear that suppositions are based upon mere illusions. Given a Steichen and a Jones to photograph the same thing at the same time, the results will, like those in black and white, in the one case reflect Steichen, and in the other case probably the camera and lens—in short, the misused process. Why this should be so in a mechanical process—mechanical and automatic are not synonymous—is one of those phenomena not yet explained, but still understood by some.

The Lumière process, imperfect as some may consider it, has actually brought color photography in our homes for the first time, and in a beautifully ingenious, quick, and direct way. It is not the ideal solution of color photography by any means, but it is a beautiful one, and, with all its shortcomings, when properly used will give satisfaction even to the most fastidious. Those who have seen the Steichen pictures are all of one opinion. Lumière's own examples which I have thus far seen, as well as those samples shown me at the various dealers in Munich, would never have aroused me to enthusiasm nor led me to try the process myself. That in itself tells a story."

My own opinion about the plates is reflected in the two letters, and little need be added to them. Eugene and I continued our experiments in Tutzing, but owing to circumstances over which we had no control, they were only of a comparatively short duration and made under great difficulties. We satisfied ourselves, nevertheless, that the scope of the plates was nearly as remarkable as the invention itself. The tests for permanency, and for keeping qualities, were all considered in the experiments. The varnishing question, an important one, is still unsettled in my mind. In short, the process received a thorough practical test in my hands, and my enthusiasm grew greater with every experiment, although the trials and tribulations were many, and the failures not few. On getting to Paris, on my way back to New York, I found

that Steichen had not been idle; he had far surpassed his early efforts. He had been experimenting chiefly to get quality and tone, and had obtained some beautiful pictures. In fact he had evolved a method of his own for treating the plates.* Handwork of any kind will show on the plates—that is one of the blessings of the process—and faking is out of the question. Steichen's methods are solely chemical ones, as must be everyone else's. This for the benefit of the many ready to jump at erroneous conclusions. On September 18th, I sailed from Europe with a series of pictures made by Steichen, Eugene, and myself. On the 24th I landed, and on the 26th the Press received the following notice:

To the Press: New York, September 26, 1907.

GENTLEMEN: Color photography is an accomplished fact. That this is actually true will be demonstrated at an exhibition, reserved exclusively for the Press, in the Photo-Secession Galleries, 291 Fifth Avenue, on Friday and Saturday, September 27 and 28, between the hours of 10 and 12 A.M., and 2 and 4 P.M.

Mr. Alfred Stieglitz, having just returned from Europe, has brought with him a selection of color photographs made by Eduard J. Steichen, Frank Eugene and himself.

They will demonstrate some of the possibilities of the remarkable Lumière Autochrome Process, only recently perfected and placed upon the French market. These pictures are the first of the kind to be shown in America. You are invited to attend the exhibition.

Yours truly,
ALFRED STIEGLITZ
Director of the Photo-Secession.

* A special supplement to CAMERA WORK is in the course of preparation. It is to deal with this new color photography. Steichen is preparing the text. The celebrated firm of Bruckmann, in Munich, early in July received the order to reproduce four of Steichen's early efforts for the book. They are the pictures of Lady Hamilton, Mrs. Alfred Stieglitz, G. Bernard Shaw, and the portrait group made on Mr. George Davison's houseboat. The date of publication will be announced later. — EDITOR.

On the days designated the Secession rooms were crowded with the best talent from the Press. One and all were amazed and delighted with what was shown them. A few had seen pictures done in Lyons by the Lumières themselves, and were not favorably impressed with them. Our early verdict was unanimously upheld. Thus, color photography and its wonders were set loose upon America. As I write, no plates are in the American market. The agents expect them daily. The practical uses to which the process can be put are really unlimited; the purely pictorial will eventually be but a side issue. Nevertheless, the effect of these pictorial color photographs when up to the Secession standards will be revolutionary, and not alone in photographic circles. Here then is another dream come true. And on the *Kaiser Wilhelm II*, I experienced the marvelous sensation within the space of an hour of marconigraphing from mid-ocean; of listening to the Welte-Mignon piano which reproduces automatically and perfectly the playing of any pianist (I actually heard D'Albert, Paderewski, Essipoff, and others of equal note while they were thousands of miles from the piano); and of looking at those unbelievable color photographs! How easily we learn to live our former visions!

NOTES

FROM *Camera Work* 20 (OCTOBER 1907)

Stieglitz had long been interested in the possibility of color photography. In the early 1890s he was a partner in a firm called at first Heliochrome, and then, after its bankruptcy and reorganization in 1891, the Photochrome Engraving Company. The firm did a modest business in black-and-white work, but the partners' dreams of wealth were based on their hope that Stieglitz would be able to develop a three-color process for printing halftone illustrations in color.

Alas, the German magazine *Photographische Mittheilungen*, in its issue of January 1, 1893, announced that William Kurtz, of New York, aided by Ernst Vogel, the son of Stieglitz's old professor, had worked out a procedure. They made three color separation plates—a yellow, a magenta, and a blue—and superimposed impressions of them by three successive runs through the printing press.

Stieglitz went on to develop a process sufficiently different from Kurtz's to avoid patent conflicts. Inserted as a frontispiece into every copy of the *American Amateur Photographer* for January 1894 was a color reproduction, printed by Photochrome, of a hand-colored platinum print of Stieglitz's photograph *The Last Load*, an alpine haying scene.

Edward Steichen's debut exhibition at 291, in March–April 1906, included some experimental color photographs made by exposing three separate black-and-white negatives through blue, green, and red filters, then printing them in superimposition with red, green, and blue gum-bichromate.

The Autochrome process was invented, and the plates manufactured, by the brothers Auguste and Louis Lumière of Lyons, who had already made important contributions to the early development of motion pictures.

Autochromes were transparencies, not prints. Like the daguerreotype process, the Autochrome process did not produce a negative from which positive prints could be made. An exposed and developed Autochrome was a unique positive transparency on a glass plate. It was best viewed by looking through it toward a bright source of light, in which case, as Edward Steichen wrote in a 1908 issue of *Camera Work*, it would display some of the color resonance of stained glass. As Steichen observed: "What may appear very beautiful as a transparency may when transferred to paper be absolutely horrible, for the richness and purity of color produced by transmitted light admits of color arrangements that would be impossible if attempted in the dull tones that reflected light would make of them." Small plates could also be projected on to a screen.

Autochromes were essentially gelatin-and-silver-bromide dry plates with—between the glass and emulsion—a layer of colored grains of potato starch that served both as filters during the exposure and as pigmentation in the final transparency.

To produce their Autochrome plates, the Lumière brothers first made three batches of starch grains, each dyed one of the additive primary colors: red, green, and blue. Steichen wrote that when examined under a microscope, the grains appeared to be "a rich vermilion, a yellowish green, and a reddish ultramarine blue." The Lumières referred to these colors as orange, green, and violet. Adding to the confusion, the vermilion tended to fade to orange and the blue to violet.

The three colors of starch grains were mixed together in more or less equal parts and dusted onto a glass plate coated with sticky varnish. The result was, in effect, a plate with three different color filter screens intermeshed on its surface. The plate was then dusted with carbon black, which filled in the spaces between the starch grains and intensified the colors of the finished transparency. (Colors always appear to be more intense and luminous against a black background than against a white one.) The next step was to roll the plates under enough pressure to flatten the starch grains and thereby make them transparent. Finally, a gelatin-and-silver-bromide emulsion was applied over the filter layer.

An Autochrome plate had to be placed in the camera so that the uncoated side of the glass faced the lens. The light coming through the lens would then have to pass through the filter layer before reaching the silver-bromide emulsion. Since the emulsion was not fully panchromatic, a yellow-orange filter had to be placed over the lens in order to compensate for the plate's oversensitivity to the blue-violet end of the spectrum.

If one were photographing, say, a red rose, the light from the rose that hit the plate would pass directly through the red starch grains, but it would be blocked by the green and blue ones. The emulsion behind the red grains would then receive the most light and would, during development, turn black, while the emulsion behind the green and blue grains would remain light. In theory, if one held the developed plate up to the light, the dark areas of liberated metallic silver would prevent any light from passing through the red grains, though light would stream through the green and blue grains, mixing to form cyan. (In practice, exposing the unfixed plate to light at this stage would ruin it.) At this intermediate step in processing an Autochrome, all colors were transposed to their additive complementaries.

In order to reverse this effect and to achieve true colors, the light and dark areas of the silver-bromide emulsion had to be reversed. To accomplish this, the plate was bathed in a solution of potassium permanganate and sulfuric acid that dissolved the metallic silver, which could then be rinsed away, leaving the emulsion behind the red grains clear and photochemically inactive. The emulsion side of the plate was then exposed directly to white light (i.e., the filter layer was turned away from the light), at which point the areas of the emulsion that had previously been protected by the green and blue grains were fully exposed. When the plate was returned to the original developing solution, these areas turned black, while the areas behind the red grains, of course, remained clear. When the washed and dried plate was held up to the light, only the red areas would transmit light—yielding an image of the rose resembling a pointillist painting, its mosaic of starch grains melding to create an effect of surprisingly naturalistic color.

During the summer of 1907, after their stay in Paris, the Stieglitzes vacationed with Frank Eugene at Tutzing, on the shore of the Starnberger See, not far from Munich. The principal problem encountered by Stieglitz and Eugene while working with Autochrome plates was the wrinkling ("frilling") of the emulsion on incorrectly developed plates.

The three Autochromes that Steichen had made in England were published in the April 1908 issue of *Camera Work* in the form of glowing four-color halftones, but the portrait of Emmeline Stieglitz was inexplicably missing from the magazine. The three Steichens were the only Autochromes, and indeed the only color photographs, ever published in *Camera Work*.

Stieglitz's enthusiasm for making Autochromes would last only about a year, and for exhibiting them only about two years. Early in 1909 Stieglitz would exhibit Autochromes, as well as black-and-white photographs, by Alvin Langdon Coburn and Baron de Meyer at 291. During the 1910–season, a show of Steichen Autochromes was the only photographic exhibition at 291. Thereafter, Stieglitz had nothing further to do with color photography. Please see the color insert at the beginning of this volume for examples of Eugene, Stieglitz, and Steichen's experiments with Autochromes. Plate 7, a portrait of Clarence White, is here attributed to Stieglitz on the basis of Weston Naef's research in his book, *The Collection of Alfred Stieglitz*.

TWELVE RANDOM DON'TS

Don't believe you *must* be a pictorial photographer. The world sorely needs more scientific and some first-class commercial photographers. Possibly your talents lie in that direction. Bad pictorial photography, like bad "art painting," is a crime.

Don't worry about innumerable formulae. Get a few tried ones and then shut yourself up in your workroom to fully digest them. The fewer formulae, the fewer failures; the more certain your progress.

Don't let the wiseacres lead you into believing that fuzziness, gum, varnish and Japan tissue are the secret paths which lead into the charmed circle of the Photo-Secession.

Don't plagiarize if you can help it. It can't give you any real pleasure to know yourself akin to a thief. Plagiarizing does not carry with it penal punishment; for that very reason it is more abominable than stealing in the ordinary sense.

(N.B. Photographic editors should discourage the vicious habit. See prizewinners in numerous magazines.)

Don't believe you became an artist the instant you received a gift Kodak on Xmas morning.

Don't believe that because of your lack of taste you are privileged to air your opinions on pictorial photography and art matters in general. The world in its entirety is not a camera club.

Don't believe that the snapshot you have made is a "genuine work of art" because some painter has asked you for a copy. It is just possible that he may need it for his next original painting. Your photograph, he argues, is an accident; his appreciation of that fact entitles him to its use. Some painters are unusually clever—some photographers are even more so.

Don't believe that experts are born. They are the results of hard work. Remember inspiration is usually nothing more than perspiration recrystalized.

Don't be discouraged because after a week of real hard work your print is not up to a best Steichen or a best White. Photography of that class is not quite as simple as it looks. Everything worthwhile means continuous struggle and concentration of effort—even in photography.

Don't believe that a semi-achromatic lens is preferable to an anastigmat, nor vice-versa. Both have their proper uses and are consequently invaluable; neither should be sacrificed for the other.

Don't believe that beauty reveals itself to him who thinks it only film deep.

Don't go through life with your eyes closed, even though you may have chosen photography as your vocation. The machine may see for you, but its eye is dead. Your eye should furnish it with life. But don't believe that all open eyes see. Seeing needs practice—just like photography itself.

P.S. Don't believe I claim any originality for the above random remarks. They have been called forth to satisfy the editor of this delightful little monthly. It is with him that you will have to quarrel if you must. But you won't *must*.

NOTES

FROM *Photographic Topics* 7 (JANUARY 1909)

Stieglitz considered *seeing* more important than photography per se. Early in 1908 he told Agnes Ernst, who was at that time a reporter for the *New York Morning Sun* but who was soon to become one of the leading patrons of Stieglitz's gallery:

> We are searching for the ultimate truth, for the human being who is so simple in every way that he can look at things objectively, with a purely analytical point of view. We are striving for freedom of experience and justice in the fullest sense of the word. . . .
>
> We have no formulated theories, like George Bernard Shaw's, because we believe that a formulated theory is a narrowing thing, lacking in that perfect freedom which we are looking for. . . . [W]e believe that if only people are taught to appreciate the beautiful side of their daily existence, to be aware of all the beauty which constantly surrounds them, they must gradually approach this ideal. . . . And we believe the camera is one of the most effective means of teaching people to distinguish between what is beautiful and what is not. It forces upon them a realization of line and composition

and forms in them the habit of looking for the pictorial side of everything." Unsigned [Agnes Ernst], "The New School of the Camera." *New York Morning Sun*, April 26, 1908.

The "gum" mentioned in the third "don't" refers to the gum-bichromate process. Some pictorial photographers often varnished their finished prints, both to protect the surface and to give a patina suggestive of an "old-master" work of art. Japan tissue was a very thin but strong and nearly grainless paper on which Stieglitz printed many of the photogravures published in *Camera Work*.

A semi-achromatic lens is one that partially eliminates color distortion. Such a lens would often be slower and less able to focus sharply than an anastigmatic one, which corrects astigmatic distortion, resulting from the failure of light rays to meet at a common focus.

In the original publication of Stieglitz's article, a typographical error caused the title to be given as "Twelve Random Dont's."

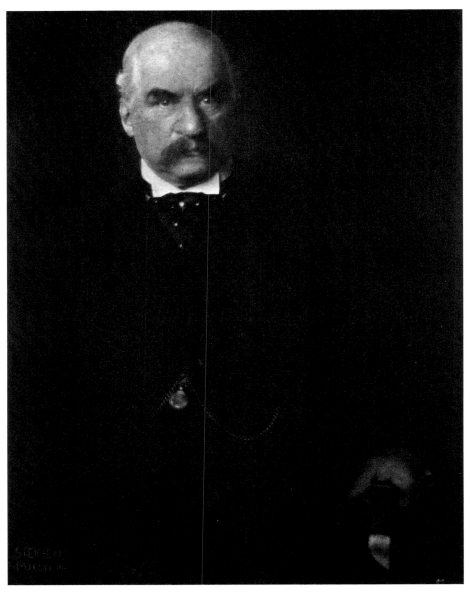

Edward Steichen, *J. Pierpont Morgan*, 1903

STEICHEN'S MORGAN AND THE METROPOLITAN

Agnes Meyer (Mrs. Eugene Meyer, Jr.) had been visiting Morgan when he asked her, "Did you ever see Baca-Flor's (South American) portrait of me?"

Agnes Meyer, who was at the time an ardent 291-er, said, "I don't have to see that portrait. There's only one portrait of you that exists."

"Which is that, may I ask?"

"Steichen's photograph."

Morgan asked, "Who is Steichen?" He turned to Miss Greene, the librarian of the Morgan Library, and asked, "Do you know anything about that?"

She and Agnes Meyer and Morgan went to the office of Miss Greene and there, over the desk, hung the Steichen Morgan.

"Where did that come from?" asked Morgan.

"It has been loaned to me."

"Loaned to you? Buy it."

Both Belle Greene and Agnes Meyer laughed and said, "Mr. Morgan, I'm afraid that all your money cannot buy that portrait."

"I cannot buy my own portrait?" He didn't seem to understand.

Agnes Meyer proudly said, "No, this time I'm afraid you can't."

I told Steichen the story. He was delighted.

The Morgan print belonged to me. Steichen had sent it to me from Paris in 1910 for the Albright exhibition in Buffalo, probably the finest photographic exhibition ever held in the world. It was arranged and hung by the Photo-Secession—291.

Paul Haviland, Clarence White, Max Weber and I spent nearly a week recovering the walls of that beautiful gallery and hanging the pictures.

Steichen insisted that I keep the print. It is one of the very few gifts I have accepted from artists.

A year or more later, one Sunday at the mid-day meal in my home—

Steichen and his wife at the table—Steichen suddenly said, "Say, Stieglitz, young Pierpont Morgan offers five thousand dollars for the print of his father. Will you accept?"

I said, "The picture is not for sale at any figure, but if Morgan will see to it that the print will be hung for a year next to the Baca-Flor painting in the Metropolitan Museum I'll present the print to him. Those are my conditions."

I never heard anything further about the matter.

NOTES

FROM *Twice A Year* 5–6 (1941)

By 1903, at which time he was living in New York, Edward Steichen was so popular as a photographic portraitist that on one day both J. Pierpont Morgan and the great actress Eleonora Duse sat for him. The Morgan portrait came about because Edward Stieglitz's old protégé Fedor Encke, who had been commissioned to paint an official portrait, wanted to work from a photograph in order to supplement his brief and frustrating sittings. In Steichen's dramatic image the position of Morgan's arm in relation to a reflection on the arm of the wooden chair in which he is sitting makes it look as though he is about to thrust with a dagger.

After vacillating between photography and painting for many years, Steichen finally became disillusioned with painting in 1922 and proceeded to burn all the canvases in his studio. Thenceforth he would devote himself exclusively to photography—and especially to portrait photography.

In 1923 he began working for Condé Nast Publications as Chief Photographer, and for the next fifteen years Steichen's sophisticated, theatrical portraits of celebrities would appear regularly in *Vanity Fair* and his fashion photographs in *Vogue*. His salary made him the highest paid photographer in the world, but his success dealt his friendship with Stieglitz the *coup de grâce*. From then on, Stieglitz would sneer at Steichen as an artist whose ambition and greed had led him to prostitute himself.

THE MAGAZINE 291
AND *The Steerage*

I n January, 1915, Paul Haviland and [Marius] de Zayas came into 291 and said, "Stieglitz, we and Agnes Meyer feel that 291 is in a rut. The war has put a damper on everything. We must do something. We have the idea that 291 should publish a monthly magazine devoted to the most modern art and to satire, presented in a spirit related to some of the most modern publications in France."

I'd always been hoping that there would be a magazine in this country devoted to real satire. The American is afraid of satire. Afraid of true caricature. He enjoys cartoons. Those everlasting cartoons. Was there a place for true caricature in the United States?

Had not Marius de Zayas made some grand caricatures and were they not shown at 291? They had met with but little response.

So this proposition that 291 publish a sheet devoted to satire and caricature met with my fullest approval. Maybe such a publication might bring some new life into 291.

Haviland and de Zayas were ready to act at once. It was really their idea. They had in mind a monthly publication that would cost a hundred dollars a month [to produce]. The numbers were to be sold at ten cents a piece, the subscription price to be a dollar a year.

Would I sanction the use of the name *291* as the name of the magazine and would I be one of the three guarantors assuming responsibility for the paying of bills—two other guarantors to be Paul Haviland and Agnes Meyer?

I assented.

Of course I realized that by the end of the year each of us would probably have to foot a liability of at least fifty per cent more than the original estimates.

My interest in the magazine was primarily based on the fact that I felt it would give de Zayas a free opportunity to use his genius as a caricaturist and satirist, and that it would give Agnes Meyer and Paul Haviland and Katharine N. Rhoades opportunities which I felt they should have.

Agnes Ernst Meyer's dream had been, before she was married and when she was working on the *Morning Sun* as a reporter, to write on art matters, to become an authority on the history of art and on the creative arts of the day. But having married a rich man and having become a mother, she was prevented from devoting much time to her original ambitious aspirations. Maybe a *291* magazine would give her a chance to do some Agnes Ernst work, for it was Agnes Ernst I originally was interested in.

Paul Haviland was in a position to afford the risk and would be heart and soul a real worker.

Katharine Rhoades wrote and painted. In her, too, I was deeply interested. Here was a possible outlet for her.

Then, also, there were [John] Marin, [Marsden] Hartley, [Abraham] Walkowitz, [Arthur] Dove and many others I hoped might find an added outlet. In short, *291*, the magazine, I saw as a real instrument of expression of the time.

One Sunday morning Agnes Meyer, living at the St. Regis Hotel, invited de Zayas, Haviland and myself to come to see her and talk over the magazine proposition.

Agnes Meyer asked how we were to determine what should be published in *291*—what was the policy to be—was the majority to rule? As we were four, I asked her what would happen in case of a tie.

I pointed out to her and the men that *291* was founded on a new idea, so why think of obsolete methods. I suggested that anything that be thought worthy of publication by any one of the four of us should be sufficient reason to incorprate it in the new publication. If we didn't have that much faith in each other, why begin?

Meetings and minutes and endless discussions were really anti-*291*. Agnes Meyer was elated with the idea, as were de Zayas and Haviland.

The difficult problem of majorities and discussions had been simply solved. Our meeting lasted less than ten minutes.

De Zayas and Haviland immediately set to work on the first issue. So did Agnes Meyer.

Soon thereafter I was told that Eugene Meyer, Jr., the husband of Agnes Meyer, thought that too much satire, too much truth telling about how the game of art and its business were played, should not appear in *291*. Meyer thought it would be a very bad policy.

Of course, I disagreed for I felt that the youngsters—for as such I looked upon them—should have their way. In a sense I was more or less an onlooker, but fully aware. I was curious to see what the young ones would do if left to themselves, how they would represent the spirit of 291.

The magazine 291 quickly came into being. It created great excitement. It was truly an eye-opener, not only for the United States, but for Europe. Instead of its being the sheet originally contemplated, it became more or less a deluxe affair as Haviland, de Zayas, and myself had rather expensive tastes—that is, we wanted good paper, good ink, careful printing, careful mailing—that meant the cost would be greater than originally figured on. Regardless, we went ahead. The result was what counted with us.

291, the magazine, was launched. There were eight single issues and two double issues. These soon were to play a role in the development of happenings in France. This, because Picabia arrived from France in June, 1915, directly from the war. When he saw what we were doing at 291, in magazine form, he immediately became an active factor. Several of the issues became primarily Picabia issues. We sent innumerable copies to France. It was these copies that helped crystallize the original Dada Movement when Picabia returned to France some months later.

Haviland was called to France. De Zayas eventually went into the art business, so split from 291. Agnes Meyer had become a "Freerite" with passionate Chinese art aspirations. But before the final disintegration of the group, Haviland and de Zayas came to me one day and said, "Stieglitz, we feel that a double number of 291 should be devoted to photography, with *The Steerage* as a basis." *The Steerage* was considered by many the most significant photograph I had ever made. It had even attracted the attention of Picasso in 1912. De Zayas had taken a print to Paris to show it to Picasso. Picasso was reported to have said, "This photographer is working in the same spirit as I am."

The print shown to Picasso was an eleven-by-fourteen photogravure proof of *The Steerage* made under my supervision.

A similar proof Dr. Jessen of the Berlin Museum had bought for his museum for a hundred dollars. There were nine other photogravures for which he also had paid a hundred dollars each. Several of the proofs were also bought by other collectors for a hundred dollars apiece. Whenever I have received money for any of my work I have turned it over to artists of

Marius de Zayas, Abstract portrait of Stieglitz, *291*, March 1915 (cover)

one kind or another. I never have kept any of such money for myself.

Haviland and de Zayas claimed that for the sake of photography, for the sake of the idea we were all working for, it would be a great thing if I were to have five hundred proofs of the photogravure plate pulled on Imperial Japan paper for a small special "de luxe" edition on thin Japan tissue.

Haviland and de Zayas each wrote an essay on photography for this number taking *The Steerage* as a basis. I had the editions printed under my direction and paid for the cost. It was a special contribution of mine.

The double number containing the Imperial Japan proofs was sold to subscribers for twenty cents each. The thin Japan ones for a dollar each. Hundreds of people, rich and poor, had been clamoring for *Steerage* prints. The poor could not afford the hundred dollars and the rich could not afford the hundred dollars. I was in no position to give away the few proofs I had before printing this edition for *291*.

I really printed the edition for *291* to see what would happen. The subscribers to *291*—there were about a hundred to the ordinary edition—duly received their copies. There were eight subscribers to the de luxe edition and they received their copies. These eight subscribers paid one dollar for their copies. The two editions called forth great admiration from all classes of people. No attempt was made to solicit subscribers or to sell the magazine. What interested me most was to see what the American people would do if left to themselves. That has been an underlying principle in everything I've touched for all these years.

When, in 1917, the place 291 had come to an end, and I had lost practically all of my friends—certainly those identified with the magazine *291*—I didn't know what to do with the upward of eight thousand copies of the magazine *291*. I called a rag picker. It was war time. The cost of paper was high. I had never done anything like this before. Maybe the gesture was a satirical one. The ragpicker offered five dollars and eighty cents for the lot. This included the wonderful Imperial Japan *Steerage* prints.

I handed the five dollars and eighty cents to the girl who had been part-time secretary to me and said to her, "Here, Marie, this may buy you a pair of gloves, maybe two pairs."

I had no feeling whatsoever about this transaction—this act of mine. It was merely another lesson to me.

I kept most of the de luxe edition but even in time I destroyed most of that.

And now I asked myself why was a Dr. Jessen, director of the Berlin Museum, willing to pay a hundred dollars for a copy of *The Steerage*, which my American friends did not seem to want even for one dollar, though for years they had been at me to give them a chance to acquire a print? Now that it was possible to get a print for a dollar they wondered why I didn't give them prints. As a matter of fact wasn't I "giving them away" at a dollar?

Outside of the hundred subscriptions to the regular edition of the magazine *291* and the eight subscriptions to the de luxe edition, how many single copies of either edition do you think were bought? Make your estimate as low as your imagination will permit—not a single one. This is America.

NOTES

FROM *Twice A Year* 8–9 (1942)

It was during January 1915 that Stieglitz's friends Marius de Zayas, Paul Haviland, and Agnes Ernst Meyer decided to start a folio-sized monthly magazine to be called *291*, which would feature modern art, caricatures, and satire of the art world. De Zayas was a distinguished Mexican caricaturist whose work Stieglitz had exhibited on three occasions at 291, two of them one-person shows.

Photographer and critic Haviland, whose half-American father directed the family's world-famous china-manufacturing firm in Limoges, France, was a financial backer of *291* and an associate editor of *Camera Work*. Late in 1909 Agnes Ernst, who wrote the *New York Sun* article about Stieglitz in 1908 (quoted above), married financier Eugene Meyer, Jr., whose fortune was estimated at something like forty million dollars. The Meyers donated five hundred dollars a year to 291's maintenance fund, and they bought many works of art from the gallery.

The impact of the contents and design of *291* magazine would, the planners felt, make up for the paucity of pages—usually between four and six per issue. Having decided that it would be a good project for "the youngsters," Stieglitz gave his blessing and agreed to join Haviland and Meyer in covering expenses not met through sales. The first issue was dated March 1915.

When Haviland and de Zayas proposed an issue of *291* devoted to photography, Stieglitz decided that since he had been deluged with requests for prints of *The Steerage*, he would commission an edition of large photogravures of it to be tipped in. The double number sold for two dollars, not included in the price of the regular subscription, but it

consisted of nothing but the gravure and two texts, short but pretentious, by de Zayas and Haviland, printed both in English and in French.

The French modernist painter Francis Picabia, whom Stieglitz mentions in his reminiscence, had visited New York during the Armory Show of 1913 and had spent much time at 291. In the spring of 1915, while serving in the French army, Picabia was assigned to travel to Cuba to buy sugar. Stopping over in New York on the way, the anarchistic and irresponsible young man impulsively decided that he would simply remain in the city. Excited about *291* magazine, he joined in at once, contributing drawings and helping de Zayas with the editing.

Haviland returned to France in July 1915. That fall de Zayas opened the Modern Gallery, at 500 Fifth Avenue, as an avowedly commercial adjunct to 291, where Stieglitz had developed a reputation for unwillingness to sell work to potential buyers of whom he disapproved. A few months into the new gallery's existence, Stieglitz severed his connection with it. The magazine *291* fell victim to the crisis; the last issue appeared in February 1916.

As for Agnes Meyer, she increasingly shifted her allegiance from Stieglitz to Charles Lang Freer, whose great collection of Asian art provided the nucleus for the Freer Gallery of Art, a branch of the Smithsonian Institution, in Washington, D.C.

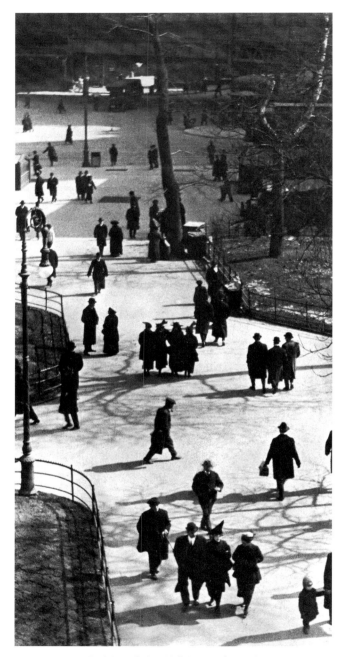

Paul Strand, *City Hall, New York*, 1915

OUR ILLUSTRATIONS

This number of CAMERA WORK is devoted entirely to the new work of Paul Strand. The last number too was devoted, in part, to Strand's photographs. In it we wrote:

"No photographs had been shown at 291 in the interim, primarily because 291 knew of no work outside of Paul Strand's which was worthy of 291. None outside of his had been done by any new worker in the United States for some years, and as far as is our knowledge none had been done in Europe during that time. By new worker, we do not mean new picture-maker. New picture-makers happen every day, not only in photography, but also in painting. New picture-makers are notoriously nothing but imitators of the accepted; the best of them imitators of, possibly at one time, original workers. For ten years Strand quietly had been studying, constantly experimenting, keeping in close touch with all that is related to life in its fullest aspect; intimately related to the spirit of 291. His work is rooted in the best traditions of photography. His vision is potential. His work is pure. It is direct. It does not rely upon tricks of process. In whatever he does there is applied intelligence. In the history of photography there are but few photographers who, from the point of view of expression, have really done work of any importance. And by importance we mean work that has some relatively lasting quality, that element which gives all art its real signficance."

The eleven photogravures in this number represent the real Strand. The man who has actually done something from within. The photographer who has added something to what has gone before. The work is brutally direct. Devoid of all flim-flam; devoid of trickery and of any "ism"; devoid of any attempt to mystify an ignorant public, including the photographers themselves. These photographs are the direct expression of today. We have reproduced them in all their brutality. We have cut out the use of the Japan tissue for these reproduction, not because of economy, but because the tissue proofs we made of them introduced a factor which destroyed the directness of Mr. Strand's expression. In their presentation we have intentionally emphasized the spirit of their brutal directness.

The eleven pictures represent the essence of Strand.

The original prints are 11-by-14.

FROM *Camera Work* 49–50 (JUNE 1917)

In 1907, as a student at the Ethical Culture School, Paul Strand enrolled in the extracurricular photographic course taught by Lewis W. Hine, who was then working on his great documentation of immigrants arriving at Ellis Island. That fall Hine took the class to visit 291, where an exhibition of work by Photo-Secessionists was on view. Dazzled by what he saw, Strand left the gallery with the conviction that photography was his vocation.

Strand eventually went into business as a commercial photographer, specializing in portraits, advertising shots, and hand-tinted platinum prints of college campuses and fraternity houses. Occasionally he would get up the courage to show a portfolio of recent photographs to Stieglitz, who advised him to throw away his soft-focus lens.

During the summer of 1915, Strand wandered the streets of New York with his camera, making pictures that captured a sinister and chaotic sense of the city. Stieglitz included a number of these in the one-man exhibition that he gave Strand in the spring of 1916, timed to coincide with the Forum Exhibition of Modern American Painters—just as Stieglitz had shown his own photographs at 291 during the legendary Armory Show of 1913. Strand's show was the only photographic exhibition hung at 291 between Stieglitz's 1913 show and the permanent closing of the gallery, in the spring of 1917.

Stieglitz published six Strand photographs in the October 1916 issue of *Camera Work*, and then devoted the entire final issue of the magazine (a double issue numbered 49/50 and dated June 1917) to gravure reproductions of eleven Strand photographs printed directly on rag paper, instead of on the usual Japan tissue mounted onto the pages, to emphasize "the spirit of their brutal directness."

On vacation in Twin Lakes, Connecticut, during the summer of 1916, Strand had begun a series of compositional experiments to see whether he could reconcile the "absolute unqualified objectivity" of photography with the abstraction of modernist painting. Stieglitz included two of these photographs, which minimized the recognizability of the objects depicted "without tricks of process or manipulation, through the use of straight photographic methods."

In the fall of 1916, Strand turned to a very different challenge: a series of close-up portraits of some of New York's poorest residents as they went about their business in the streets, unaware that they were being photographed. To make that possible, Strand at first deceived his subjects by attaching a conspicuously shiny false lens to one side of his camera and concealing the real lens with his sleeve. Later, he used a right-angle lens. Stieglitz published six of Strand's portraits and two of his abstractions among the eleven in the last issue of *Camera Work*.

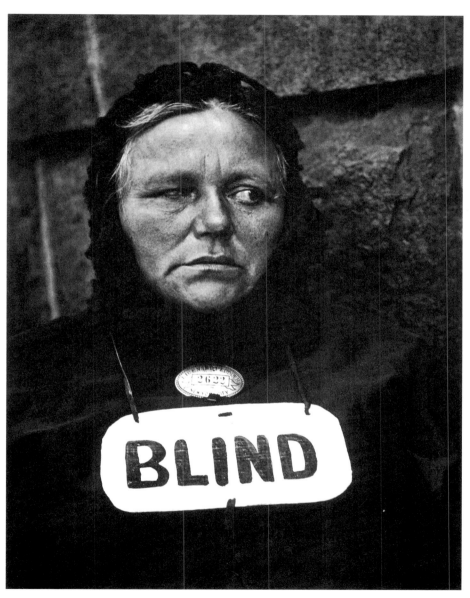

Paul Strand, *Blind Woman*, 1916

A STATEMENT

This exhibition is the sharp focusing of an idea. The one hundred and forty-five prints constituting it represent my photographic development covering nearly forty years. They are the quintessence of that development. One hundred and twenty-eight of the prints have never before been seen in public. Of these seventy-eight are the work since July, 1918. Some important prints of this period are not being shown, as I feel that the general public is not quite ready to receive them. The fifty other prints never shown before were produced between the years 1908–19. Of the earlier work I show but a few significant examples. With more the exhibition would become needlessly large.

The Exhibition is photographic throughout. My teachers have been life—work—continuous experiment. Incidentally a great deal of hard thinking. Any one can build on this experience with means available to all.

Many of my prints exist in one example only. Negatives of the early work have nearly all been lost or destroyed. There are but few of my early prints still in existence. Every print I make, even from one negative, is a new experience, a new problem. For, unless I am able to vary—add—I am not interested. There is no mechanicalization, but always photography.

My ideal is to achieve the ability to produce numberless prints from each negative, prints all significantly alive, yet indistinguishably alike, and to be able to circulate them at a price not higher than that of a popular magazine, or even a daily paper. To gain that ability there has been no choice but to follow the road I have chosen.

I was born in Hoboken. I am an American. Photography is my passion. The search for Truth my obsession.

ALFRED STIEGLITZ

PLEASE NOTE: In the above STATEMENT the following, fast becoming "obsolete," terms do not appear: ART, SCIENCE, BEAUTY, RELIGION, every ISM, ABSTRACTION, FORM, PLASTICITY, OBJECTIVITY, SUBJECTIVITY, OLD MASTERS, MODERN ART, PSYCHOANALYSIS,

AESTHETICS, PICTORIAL PHOTOGRAPHY, DEMOCRACY, CEZANNE, "291," PROHIBITION.

The term TRUTH did crop in but may be kicked out by anyone.

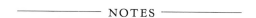

FROM *Exhibition of Stieglitz Photographs.*
NEW YORK: ANDERSON GALLERIES, 1921

Stieglitz's statement was printed in the catalogue of the major exhibition of his photographs that was held in New York in 1921, the first such exhibition since 1913. Hung in two large rooms on the skylighted top floor of the Anderson Galleries' building at Park Avenue and Fifty-ninth Street, the show opened on February 7 and ran for two weeks. Ranging in date from 1887 to 1920, the 146 prints were, in the words of critic Paul Rosenfeld, "majestic little harmonies of gorgeous shadows and burning lights . . . their colors lying within strangely pungent tonalities of black and white, gray, silver, bronze, fawn, and pearl."

Only seventeen of the images had been exhibited before, and more than half of the total had been made since Georgia O'Keeffe's arrival in New York in June 1918. Twenty-one of the photographs dated from 1887 to 1910, including *The Good Joke*; *The Terminal*; *Winter—Fifth Avenue*; *The Hand of Man*; *The Steerage*; and *The City of Ambition*. These were followed by nine views from the back window of 291 and three installation shots of exhibitions at that gallery.

More than two-thirds of the show was devoted to portraiture, as Stieglitz defined the term to include studies not only of faces but also of parts of the body—especially O'Keeffe's body. The section called "A Demonstration of Portraiture" featured forty-six photographs of O'Keeffe—whose name did not appear in the catalog, but whose identity was an open secret—arranged into groups entitled "A Woman," "Hands," "Feet," "Hands and Breasts," "Torsos," and "Interpretations." Stieglitz's tantalizing remark that "some important prints of this period are not being shown, as I feel that the general public is not quite ready to receive them," undoubtedly refers to his close-ups of O'Keeffe's pubic region and buttocks.

Stieglitz's disciples stressed the plainness, the objectivity, and the absolute straightforwardness of his photographs, which is to say, their complete dissimilarity to the painterly efforts of the Pictorialists, which he had long since repudiated as unphotographic. However, in an article in the vanguard *Dial* magazine, Henry McBride dissented. "In spite of Alfred's care not to rob the product of a machine of any of its machinelike attributes," he wrote, "a number of the photographs have painter-like aspects. One or two of the large

heads look like things by Rossetti or Courbet; and one—save the mark—bears a suggestion of the lamented Bouguereau."

McBride also feared that Stieglitz would never realize his stated ideal of "numberless prints" to be sold at "a price not higher than that of a popular magazine, or even a daily paper." The critic wrote that Stieglitz's "photography is essentially aristocratic and expensive. He spends an immense amount of time making love to the subject before taking it. His impressions are printed luxuriously upon the rarest papers to secure a richness of effect that must always lie beyond the appreciation of the multitude."

IS PHOTOGRAPHY
A FAILURE?

After more than a hundred years of experimentation and development, photography is said to have failed in the realization of the high hopes which were aroused by the early, pioneer achievements of the camera. Some magnanimous critics say that while much has been accomplished, photography has proven disappointing, even a failure.

I take issue with both these statements, for I hold that photography is a positive and additional medium of expression. This is not the opinion of a casual observer, but in my honest conviction resulting from nearly forty years' study of the subject. If it is a failure, then truth and everything else in life that we deem worth while is also a failure.

Photography is not an art. Neither is painting nor sculpture, literature nor music. They are only different media for the individual to express his aesthetic feelings; the tools he uses in his creative work. Consequently critics err who regard photography as a despised outcast from the sacred circle of "art."

What is a photograph? Anything that is drawn by the rays of light and which is so chemically treated as to be fixed and permanent.

Critics say that one of the weaknesses of photography is that it shows things "just as they are" in a dead way, and that all aesthetic and spiritual quality which painters and sculptors attain is missing in the photograph.

This is true in most photographs, but it is not chargeable to photography, but to the individuals who are photographing. If a photographer has the aesthetic perception; if he feels living beauty in anything concrete that he wishes to photograph; if he is actually searching for the truth; he can get the spirit of it through the camera as well as the painter can through paint.

For instance, portrait painting is doomed. Painting portraiture will become obsolete when the time arrives that photographers will have learned something about portraiture in its deeper sense and when the public is weaned from the stupid superstition that a thing painted is necessarily better

Alfred Stieglitz, *Marsden Hartley*, 1913–15

than a thing done through the new medium, photography.

There is abundant reason, however, for the criticism so freely directed against photography under existing conditions. It is not an exaggeration to say that ninety-nine and and nine-tenths of all photographs today professing to have some aesthetic value are merely "arty" and have no right to exist. This results from the lack of vision and understanding of his material on the part of the photographer, his trick work, his retouching and lack of every true perception of photography's inherent possibilities. But the same thing holds good of men and women who produce things called oil paintings.

Occasionally a picture out of the commonplace is produced, a creative work. This because the producer was not merely a "painter," but an artist, a person with creative ability—not merely an imitator of externals. Such a picture cannot be imitated, but thousands try to imitate it nevertheless, and the imitations are always disagreeable to the creatively receptive.

Color photography is still unsatisfactory. Millions of dollars have been spent in experiments and thousands of persons are at work on it everywhere the world over. The results thus far have been satisfactory commercially, perhaps, but from an aesthestic point of view thus far nothing has been accomplished. The reproductions of local color have nothing to do with aesthetic pleasure because of imitation.

The criticism has been made that no photograph can be as beautiful as an oil painting, because it is lacking in colors. This is not criticism, but stupidity, a lack of understanding of the underlying laws of beauty. It is the old story in another form: is a painting as beautiful as a sculpture, or is violin playing not greater than piano, and all similar nonsense.

It would be edifying to hear such critics express their preference between the paintings or the etchings of Rembrandt.

The attacks upon photography seemed to find their inception because of the "machine" which the camera was dubbed, as opposed to the handwork of painters and sculptors. Yet this "machine" can negate ninety-nine percent of what was and still is called painting. Through it a man who knows how to really photograph is able to channel the impulses of human beings and to register the objective world directly, through the science of optics and the chemistry of silver and platinum, translated into tonalities subtle beyond the reach of any human hand.

The early painter Memling, in his wonderful portraits, was in reality the first photographer. His idea of depicting his subject was photographic as I understand that term.

Photography is not superseding any living medium, but it has its own inherent virtues, as an additional tool which can be developed by those who recognize and feel their potential livingness.

Simply because the usual photograph can be done mechanically and easily, photography should not be despised as a mere matter of mechanism.

For that matter, though, you do not have to be a painter or sculptor to be an artist. You may be a shoemaker. You may be creative as such. And if so, you are a greater artist than the majority of the painters whose work is shown in the art galleries of today.

———————— NOTES ————————

FROM *The Sun* [NEW YORK], MARCH 14, 1922

During 1913, or early in 1914, Stieglitz began a new series of portraits of family and friends. In these photographs Stieglitz concentrated more than ever on physiognomy. That fall he would tell Edward Weston, "I have put my lens a foot from the sitter's face because I thought when talking intimately one doesn't stand ten feet away; and knowing that it takes time to get deep into the innermost nature of matter, I have given exposures of [three to four] minutes [with the lens aperture stopped all the way down to f-45 or even smaller]." It was, he continued, heartbreakingly difficult to get his sitters to forget about the headrest he used to keep them still during such long exposures. "The ear is given as much consideration as the nose," he told Weston, so that the eye would find "satisfaction in every portion" of the image. Ananda Coomaraswamy, of the Boston Museum of Fine Arts, wrote of Stieglitz's photographs: "Inasmuch as the lens does not in the same way as the pencil lend itself to the elimination of elements, the problem is so to render every element that it becomes essential."

Caricaturist Marius de Zayas claimed that photography "gives us only the exterior or objective appearance of the subject, and only so much of his character as we would be able to discover by looking at the person himself according to our faculties for judging of character." In response to that statement, Stieglitz redoubled his efforts to make photographic portraits that would rival or surpass caricatures as revelations of the subject's psychology. He would, as critic Paul Rosenfeld wrote, expose "the skyscraper civilization as it lies in the struggling psyche of the male. These are men, full of a marvelous potential life, full of

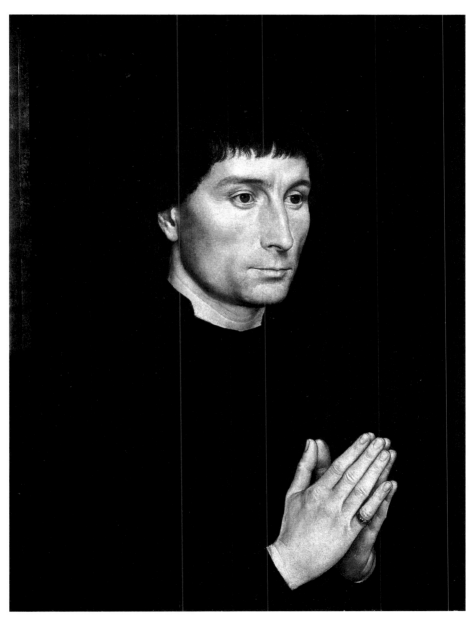

Hans Memling, *Tommaso Portnari*, ca. 1470

richness . . . but men caught and held and torn in the fearful psychic conflicts of our day."

Painter and writer Marsden Hartley, who was the subject of one of the greatest of these new portraits, wrote, "I am willing to assert now that there are no portraits in existence, not in all the history of portrait realization either by the camera or in painting, which so definitely present, and in many instances with an almost haunting clairvoyance, the actualities existing in the sitter's mind and body and soul."

A meticulous and sympathetic portrait of Tommaso Portinari by the great Flemish painter Hans Memling (1430/35–94), whom Stieglitz here calls "the first photographer," had been bequeathed to the Metropolitan Museum of Art by Benjamin Altman in 1913 along with a portrait of Portinari's wife.

HOW I CAME TO
PHOTOGRAPH CLOUDS

As for the cloud series perhaps it will interest you how that came about. Last summer when manuscripts were sent in by the various contributors for the issue of the publication, MSS. devoted to photography, and its aesthetic significance, Waldo Frank—one of America's young literary lights, author of *Our America*, etc.—wrote that he believed the secret power in my photography was due to the power of hypnotism I had over my sitters, etc.

I was amazed when I read the statement. I wondered what he had to say about the street scenes—the trees, interiors—and other subjects, the photographs of which he had admired so much: or whether he felt they too were due to my powers of hypnotism. Certainly a lax statement coming from one professing himself profound and fair thinking, and interested in enlightening. It happened that the same morning in which I read this contribution my brother-in-law (lawyer and musician) out of the clear sky announced to me that he couldn't understand how one as supposedly musical as I could have given up entirely playing the piano. I looked at him and smiled—and I thought: even he does not seem to understand. He plays the violin. The violin takes up no space: the piano does. The piano needs looking after by a professional, etc. I simply couldn't afford a piano, even when I was supposedly rich. It was not merely a question of money.

Thirty-five or more years ago I spent a few days in Mürren (Switzerland), and I was experimenting with ortho plates. Clouds and their relationship to the rest of the world, and clouds for themselves, interested me, and clouds which were most difficult to photograph—nearly impossible. Ever since then clouds have been in my mind, most powerfully at times, and I always knew I'd follow up the experiment made over 35 years ago. I always watched clouds. Studied them. Had unusual opportunies up here on this hillside [at Lake George]. What Frank had said annoyed me: what my brother-in-law said also annoyed me. I was in the midst of my summer's photographing, trying to

Alfred Stieglitz, *Equivalent, Mountains & Sky*, Lake George, New York, 1924

add to my knowledge, to the work I had done. Always evolving—always going more and more deeply into life—into photography.

My mother was dying. Our estate was going to pieces. The old horse of 37 was being kept alive by the 70-year-old coachman. I, full of the feeling of today: all about me disintegration—slow but sure: dying chestnut trees—all the chestnuts in this country have been dying for years: the pines doomed too—diseased: I, poor, but at work: the world in a great mess: the human being a queer animal—not as dignified as our giant chestnut tree on the hill.

So I made up my mind I'd answer Mr. Frank and my brother-in-law. I'd finally do something I had in mind for years. I'd make a series of cloud pictures. I told Miss O'Keeffe of my ideas. I wanted to photograph clouds to find out what I had learned in 40 years about photography. Through clouds to put down my philosophy of life—to show that my photographs were not due to subject matter—not to special trees, or faces, or interiors, to special privileges, clouds were there for everyone—no tax as yet on them—free.

So I began to work with the clouds—and it was great excitement—daily for weeks. Every time I developed I was so wrought up, always believing I had nearly gotten what I was after—but had failed. A most tantalizing sequence of days and weeks. I knew exactly what I was after. I had told Miss O'Keeffe I wanted a series of photographs which when seen by Ernest Bloch (the great composer) he would exclaim: Music! music! Man, why that is music! How did you ever do that? And he would point to violins, and flutes, and oboes, and brass, full of enthusiasm, and would say he'd have to write a symphony called "Clouds." Not like Debussy's but *much, much more.*

And when finally I had my series of ten photographs printed, and Bloch saw them—what I said I wanted to happen happened *verbatim.*

Straight photographs, all gaslight paper, except one palladiotype. All in the power of every photographer of all time, and I satisfied [myself that] I had learned something during the 40 years. It's been 40 years this year that I began in Berlin with Vogel.

Now if the cloud series are due to my powers of hypnotism I plead "Guilty." Only some "Pictorial photographers" when they came to the exhibition seemed totally blind to the cloud pictures. My photographs look like photographs—and in their eyes they therefore can't be art. As if they had the slightest idea of art or photography—or any idea of life. My aim is increasingly

to make my photographs look so much like photographs that unless one has *eyes* and *sees*, they won't be seen—and still everyone will never forget them having once looked at them. I wonder if that is clear.

NOTES

FROM *Amateur Photographer and Photography* 56 (1923)

During 1921 Stieglitz had encouraged his friends Paul Rosenfeld and Herbert Seligmann to start a new magazine, *MSS. [Manuscripts]*, which would publish fiction, poetry, essays, and satire. Early in 1922 Paul Strand accepted the task of editing a special issue of the magazine, to be published in December, devoted to the question "Can a photograph have the significance of art?"

Waldo Frank was an associate editor of the short-lived but influential magazine *The Seven Arts* (1916–17), the guiding thesis of which was that World War I was bringing about America's cultural and spiritual emancipation from Europe and a rebellion against the materialistic values that had led Europe into the cataclysm.

In his book *Our America*, published in 1919, Frank declared himself the spokesman for a new generation "consciously engaged in spiritual pioneering" and in revolt against the crassness of American industrialism.

Frank's submission for the special issue of *MSS.* stated that in his portraits "the work of Stieglitz is more than half upon his subject and this fact brings closer the old intuitive mechanism. By talk, atmosphere, suggestion and the momentum of a personal relationship, Stieglitz lifts the features and body of his subject into a unitary design that his plate records. His work in thus moulding material is analogous to the work of any good portraitist, who does his moulding with his eye and with his hand on canvas."

Stieglitz grouped together the best of his cloud images from the summer of 1922 as *Music: A Sequence of Ten Cloud Photographs*. Those he made in 1923 he called *Songs of the Sky*, and those dating from the later 1920s and the early 1930s he called *Equivalents*. He claimed that cloud photographs were "direct revelations of a man's world in the sky— documents of eternal relationship—perhaps even a philosophy."

Stieglitz was thrilled that his perfectly sharp, absolutely straightforward photographs of clouds seemed to him more purely abstract than did most "so-called" abstract paintings. In the sky he had found the solution to a problem that had been central to his work for more than a decade. "In looking at the photographs of clouds, people seem to feel freed to think more about the actual relationships in the pictures and less about the subject-matter," he said. "[T]rue meaning . . . comes through directly, without any extraneous or distracting pictorial or representational factors coming between the person and the picture." He felt his cloud photographs were "different from anything the eye has seen in any medium."

Paul Strand, *Alfred Stieglitz, Lake George, New York*, 1929

When Stieglitz looked up into the sky and saw configurations that seemed to embody his feelings at that moment, he felt in harmony with the divine order of the universe. It was as though he and God were experiencing the same feelings at the same moment, and God's emotions were manifested so potently in the clouds that anyone looking at one of Stieglitz's photographs would not only recognize, but actually experience, the particular state of mind that it represented. In December 1923, after having shown his summer's work to a few friends, he wrote to Hart Crane, "Several people feel I have photographed God. May be."

Stieglitz made contact silver prints of his new negatives on Eastman Kodak postcard stock. Stung by the criticisms of Henry McBride and Charles Sheeler regarding what they considered to be the extravagant cost of making platinum prints (see above, notes for *A Statement*, 1921), he was now determined to turn "poor innocent postal card paper" into "a living thing of beauty"—in order to prove that the beauty of his photographs did not depend upon luxurious materials. He would labor for hours, or even for days, to produce a perfect print on paper so cheaply made that he feared it wouldn't last more than thirty years. According to Herbert Seligmann, "Stieglitz often said that what he was aiming for was a small photographic print which would contain a maximum of detail together with a maximum of simplicity, his ultimate goal being a print the size of a postage stamp which would express everything he had experienced in life."

THE BOSTON MUSEUM (1922–23)
AND THE
METROPOLITAN MUSEUM (1926)

The doors of the Metropolitan Museum of Art were closed to photography. Billy Ivins, curator of prints of the Metropolitan Museum of Art, often asked me why I wouldn't give some photographs to the museum, primarily prints of my own.

Invariably I told him that as the museum bought paintings and sculpture and etchings and other things, I didn't see why, if photographs were deserving they should not be bought with museum funds.

At this he balked, and nothing ever happened. Finally one day [Robert] de Forest, who was president of the museum, and Billy Ivins appeared in the Intimate Gallery. They had become aware that the Boston Museum [of Fine Arts], that most conservative and possibly best museum in the country, had opened its doors to photography, that is to a collection of my photographs. It was through Coomaraswamy's interest in photography and his insistence, backed up by Lodge, both curators of Oriental Art in the Boston Museum, that the ultra-conservative trustees of that institution finally opened its doors. It was a case once more of a museum "not having any money,"—but here was a chance through their initiative to see my photographs hung on an equal basis with the black-and-white work of Goya and Dürer and others, and to see whether or not such photographs in that company would keep their identity.

In time the photographs were hung in the museum, flanked on one side by Goyas and on the other side by Dürers. I didn't see the exhibition but I received letters telling me about it, and saying, "You ought to see how your photographs stand up and sing."

Now it is not myself that I'm interested in but it is photography and its significance, its maltreatment, the stupidity with which it is looked at, even unto this day, that interests me.

De Forest and Ivins had come to tell me that the Metropolitan would

open its doors to photography if I were ready to present it with a collection of my own work, similar to the prints I had given to the Boston Museum.

Again I heard "there was no money." I should have a heart. Framing the prints sent to Boston cost me three hundred dollars. Of course, Boston did not insist on frames, but I did. I wanted to protect my prints, presented in my own way and no other.

So, were I to give a collection to the Metropolitan it would mean another outlay of three hundred dollars for frames and it should be remembered that as I had but very little money, and but little time for my own photography I hadn't many prints to give away.

I told De Forest and Ivins I'd consider the matter and would let them hear from me.

I was very ill that summer. Suddenly the thought struck me that the prints should be given to the Metropolitan. In this way the Metropolitan would open its doors to photography. That was after all my chief aim. I was told by de Forest and Ivins that in no other way could they plead the case of photography before the trustees to start a photographic section in the Print Department.

I gave the prints in the names of people who at various times had given or sent me monies to be used for the work I was doing at *291* and the Intimate Gallery. The monies received by me I gave to painters, sculptors, literary people, a dancer, and other workers in the arts. I also gave the donors a full equivalent of my own prints.

I eventually wrote to Billy Ivins that I was ready to act, that these individuals should be recognized publicly for their generosity. As for myself—it was not because the museum wanted my prints but because the Metropolitan was ready to open its door to photography.

Duly I was informed that it had happened—that the trustees would accept the collection and install it in the museum. I have never gone there to see my prints.

The collection in Boston I saw in 1931. It had been kept in its original immaculate condition. It was a wonderful day, that day in Boston. All of nature, above all the sky, seemed to be singing. The prints seemed part of that singing.

FROM *Twice A Year* 5–6 (1941)

One evening at the beginning of March 1923, Stieglitz gave a preview of the upcoming Anderson Galleries exhibition of his photographs to Ananda K. Coomaraswamy, "Keeper of Indian and Muhammadan Art" at the Boston Museum of Fine Arts and himself a dedicated amateur photographer. Coomaraswamy would later say that Stieglitz was "the one artist in America whose work truly matters," for "his photographs are 'absolute' art, in the sense that Bach's music is 'absolute' art."

During their meeting, the Bostonian, who championed the idea of beginning a photograph collection within his museum's print department, asked Stieglitz whether he might be willing to donate ten or twelve prints to form the nucleus of such a collection—since the trustees would certainly not agree to *buy* photographs. Although such a gift violated his principles, Stieglitz felt it would be a great victory to have the prestigious museum accession photographs as works of art and exhibit them together with etchings and woodcuts by the old masters. He stipulated that the museum would have to exhibit his prints at least once every five years and that they would always have to remain exactly as he would mount and frame them. On April 25, 1923, Coomaraswamy wrote Stieglitz to say the trustees would be willing to accept a gift on such conditions. Stieglitz ended up donating twenty-seven (not the originally planned ten or twelve) framed prints to the museum.

Robert W. de Forest was president of the Metropolitan Museum of Art from 1913 to 1931. William M. Ivins was the museum's Curator of Prints from 1916 to 1946. Believing that photography is the technological extension of the traditional graphic media (as he argued in his landmark book *Prints and Visual Communication*), Ivins had long wanted to extend the print collection to include photographs as works of art. He and de Forest visited Stieglitz at his Intimate Gallery—Room 303 in the Anderson Galleries building at Park Avenue and Fifty-ninth Street—which had opened in November 1925. The gallery closed in the spring of 1929.

In May 1928 (not 1926, as stated in the title of the article) Stieglitz's operating-and-artist's-welfare fund received an unusually generous donation of shares of stock from tobacco tycoon David Schulte, a patient of Alfred's brother Lee, who was a prominent doctor. The photographer, who gave his benefactor a group of his prints, then decided that he would also thank him publicly by giving what he called "seven of my finest prints" to the Met in Schulte's name. He thereupon resolved to give another fifteen photographs in the names of Rebecca Strand, Alma Wertheim, Paul Rosenfeld, and "an anonymous friend"—probably Georgia O'Keeffe.

His Byzantine scheme, which would allow him not only to thank his patrons (albeit in an odd manner) but also to get his photographs into the Met without losing face, was to

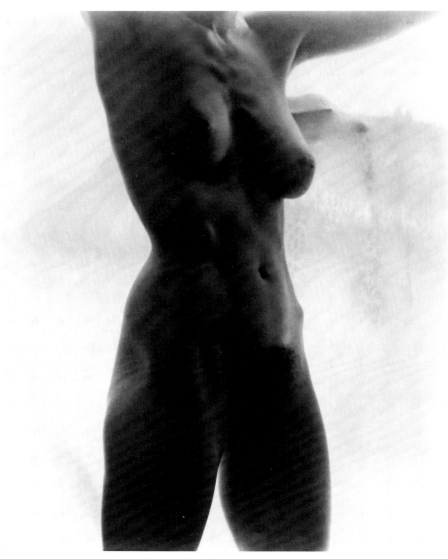

Alfred Stieglitz, *Georgia O'Keeffe*, 1919
(The Metropolitan Museum of Art, Gift of Mrs. Alma Wertheim, 1928)

present the twenty-two photographs (which the museum valued at one thousand dollars apiece) not as his gifts in honor of his patrons, but rather as their gifts in his honor! The ruse worked so well that an article in *Time* magazine seemed to take for granted that the gifts had come as a surprise to Stieglitz.

The prints were, according to Ivins, "representative of the various aspects of his work during the last several years. Among them are portraits, studies of the nude, landscapes, cloudscapes, and the well-known print of hands sewing, which some sensitive observers regard as one of the most extraordinary prints of modern times." The latter was designated as a gift of Rebecca Strand rather than, as one might have expected, of Schulte. Nothing if not contrary, Stieglitz gave the collection's two most voluptuous nude studies of O'Keeffe in the name of the elderly Alma Wertheim.

In the spring of 1933 Stieglitz resolved to rid himself of most of the photographs he had collected while editing *Camera Notes* and *Camera Work*. Since he had come to despise Pictorialism, had long since fallen out with many of the photographers, and had sadly abandoned his hopes for a museum of photography in which such a collection could be "of living significance," he thought about destroying most of the prints—which, he estimated, had cost him about fifteen thousand dollars to assemble and to store.

Stieglitz certainly wasn't willing to *present* the collection to the Metropolitan Museum of Art, for to do so would suggest that he deemed those prints worthy to represent photography in the museum. Instead, he mentioned his intention of destroying the prints to his friend Carl Zigrosser, who ran the art gallery at the Weyhe bookstore, and Zigrosser contacted the Met. Since William Ivins was then in Europe, his assistant went immediately to see Stieglitz at the Intimate Gallery, where she was told that he would allow the museum to salvage what he was discarding, as long as the prints were in no way regarded as a gift from him. The museum could have the collection "without any restrictions of any kind provided it would be called for within twenty-four hours." The next day a museum truck arrived to pick up 418 prints by about fifty photographers. Out of the prints that he had collected, Stieglitz kept only a small number that still pleased him, by such photographers as J. Craig Annan, Julia Margaret Cameron, F. H. Evans, Hill and Adamson, Steichen, and Strand.

Dorothy Norman, *Walls: An American Place*, New York, ca. 1940

DAILY BREAD

A finely set-up young man of about thirty came in to see me one morning. He had a large portfolio of photographs under his arm. He was a Canadian; had lived a long time in Japan; had gone to school there; and if I remember correctly, had taught there a few years. He had photographed for his own pleasure. He wanted to know would I look at his photographs.

How many people have asked me to look at their photographs in the last fifty years. As I have grown older it takes more and more out of me to look at other people's work. For if the work is good, what can I do for the people who have produced it? Words, unless supported by action, have become more and more meaningless. At least to me. And am I not always aware of what heartaches are hidden in really good work—and what heartaches are in store for those who wish to take such work into the world? The cold world—no matter how much it says it cares. And if the work I am asked to look at is not worthy, why must I be called upon to spend the energy of which I no longer have a surplus? And to sit in judgment has always been contrary to my feeling—and is more so than ever today. But somehow or other I looked at this young man and said, "Well, as long as you are here with your portfolio—and you have come a long way as you have said—open up and let me see."

And the photographs were really good. Some very good. Not the hackneyed kind. Good photographs with a personal feeling in them. Sensitive—alive. I told the man what I felt. He stood there before me expectantly. Then we both remained silent, and he began packing up his photographs. And as he completed the packing up he said, "I wonder could you advise me what to do. I have photographed for my own pleasure, but now I begin to think that I should possibly turn my photography into a practical channel."

I said, "You mean earn a living with it?"

"Yes," he answered, "I think I should earn my daily bread with my photographs."

I was sitting on a chair. He was standing before me. What was I to say? Daily bread.

I said to him, "You will have to find your own way. I cannot give you any advice. I am not in touch with the commercial world in any way. But you know as well as I know that the commercial world is overfilled. Daily bread," I smiled and continued, "does not the Lord's prayer begin with 'give us this day our daily bread'? Daily bread. What does daily bread include? Does it mean an actual loaf of bread and possibly a glass of fresh water? Or does daily bread mean a meal consisting of various courses, and possibly a cocktail as a stimulation to what is to come? Does daily bread include a car? And a radio? Does daily bread include the possibility of marriage? And a child or two? What does daily bread actually mean today to an American?"

The young man was very quiet and seemed to hear. Finally I said, "Go home and think over what the meaning of daily bread is. This daily bread you wish to earn with your photographs. I am sure that while doing that, you will eventually arrive at the solution of what you ought to do about your photographs, if you still feel that you ought to earn your daily bread with them."

The young man thanked me and said he was glad he had come. That his visit had cleared up much that was going on within him. And as he closed the door behind him, I thought to myself: what do these millions and millions of Americans really mean when they say their prayers beginning with "give us this day our daily bread."

NOTES

FROM *Twice A Year* 8–9 (1942)

During the final decades of his life, Stieglitz was repelled by what he viewed as the crass materialism of most young painters and photographers. In 1935 he complained to Arthur Dove, whose work he regularly exhibited, "[T]hey all want money & fame & what not."

It was easy for Stieglitz to remain an amateur, for he had an independent income of eighteen hundred dollars a year (which would have a buying power of about twenty thousand dollars today), and he was married to Georgia O'Keeffe, who—thanks in part to Stieglitz's effectiveness as an impresario—received a comfortable income from the sale of her paintings. It was she who paid the rent on their apartment and who met their living expenses. O'Keeffe's "daily bread" could easily include "a meal consisting of various courses, and possibly a cocktail" as well as a car and a radio.

Stieglitz's statement "I am not in touch with the commercial world in any way" must

Dorothy Norman, *An American Place—Window, Worktable with Books*, New York, ca. 1940

have struck his young visitor as a bit odd, for they were talking at An American Place, which most people assumed to be Stieglitz's gallery. But to Stieglitz it was emphatically not a gallery, just a "place" where art was exhibited. Certainly paintings and photographs were sometimes sold there—or, at least, were allowed to be acquired. In 1945 Stieglitz told the photographer Weegee (Arthur Fellig) that the money to cover the rent and expenses was "contributed by the artists when they sold the paintings which were on exhibit." It was, as Stieglitz saw it, the artists who did the selling, not himself.

A Letter Concerning
Exhibition Prints

The following letter was written by Stieglitz in reply to a letter from a Museum official, addressed to Stieglitz as one of a list of "professional" photographers, inviting him to send one or more of his prints for inclusion in an exhibition to be sent to Army corps. The Museum's letter stated that there could be no guarantee that prints sent would be returned, since careful handling would often be impossible during the rushed state of military preparation. The museum also stipulated a uniform size for the mounting of all prints to be submitted. *[Editorial note by Dorothy Norman]*

January 19, 1942

My dear Y.:

I have your communication of January 12th. What am I to say? In a sense I am horrified.

First of all, I am not qualified, according to your letter, to contribute a print, as I have not as yet become a professional photographer. But even if I ignored this, what I might look upon as a "slip," I could not possibly send you a print of mine as I have spent my life in fighting for the recognition of photography as an additional medium of expression ranking with the other media of expression such as painting, etching, lithography, drawing, etc., etc.

You seem to assume that a photograph is one of a dozen or a hundred or maybe a million prints, all prints from one negative necessarily being alike and so replaceable. But then along comes one print that embodies something that you have to say that is subtle and elusive, something that is still a straight print, but when shown with a thousand mechanically made prints, has something that the others don't have. What is it that this print

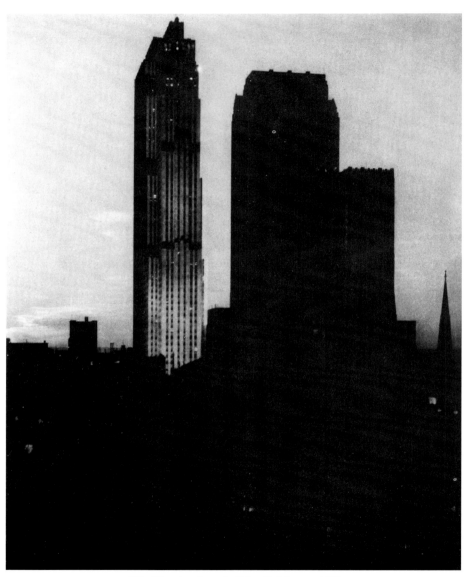

Alfred Stieglitz, from the "New York" series, 1935

has? It is certainly something not based on a trick. It is something born of spirit, and spirit is an intangible while the mechanical is tangible. If a print that I might send did not have this intangible, what would be the value of sending it out? If what I feel about life is not in a print of mine, then I might just as well say that any machine can take a picture, and turn out a print mechanically. You might get wonderful pictures as a result, but they would not contain that something called love or passion, both of which are the essentials needed to bring forth a living print—or any other living creative expression. A print lacking these elements is simply an illustration. And I have no objection to illustrations, but I am assuming that you have in mind something more than mere illustrations. Something life-giving, something inspiring. Something with a spiritual message. For I feel, whether you are aware of it or not, it is a spiritual message you are desirous of sending to the soldiers in the camps.

Photography per se is not creative in itself, nor is oil painting, nor water-coloring, nor etching, nor lithography, nor wood-engraving. Nor is writing a book necessarily a creative act in itself. But the very fact that you say that you cannot be responsible for a print which might be contributed to a collection you wish to show to the soldiers, shows complete disrespect for what the creative photographer may have produced. You would not dare approach a first-class self-respecting painter in this manner. I say this as I assume that, representing the Museum as you do, you felt that you were looking upon the collection of photographs you are planning to send to the camps at least as potential art examples.

And if the prints in transit become damaged and battered and filthy, will they still be circulated? And if so, won't what you are desiring to do, or I assume you are desiring to do, be completely negated? Please do not assume that I want to have prints treated as something more precious than life itself. I do not. But either you show the prints in a living condition, or they should not be shown at all. Wouldn't it be better to send around reproductions

of good photographs, which retain some of the spirit of the originals, than original prints which are neither fish nor fowl?

Now as far as I am concerned, I would either send you the best I am able to produce or send you nothing at all. The "good enough," which is nearly a religion in our country and is so apt to dominate the American world in so many phases of our life, I not only cannot subscribe to, but hate with all the hate within me. I hate all half-things, otherwise I am devoid of hate.

Perhaps I misread your letter. But I am certainly not mistaken in your having written to me as a professional photographer, when I am merely a human being with a sense of rightness and fitness, who happens to love photography in all its manifestations, except the manifestation of disrespect in all its forms. I am afraid that disrespect, not always conscious, dominates much in our American world.

You state: "To facilitate hanging, all prints must be mounted on 16-by-20 vertical white mounts. However, the Museum will gladly accept unmounted prints." If you will read this carefully and take the trouble to consider what you are really saying to the world, you may of your own accord discover how outrageously preposterous this suggestion is. And I might add, as far as I am concerned, it does not show the slightest respect for a photographic print worthy of the name "photograph," according to my lights, or any understanding of the role that presentation plays in releasing the spirit of a living print.

I am sorry to have to write thus frankly to you, but as an old man, a fighter all my life for what I consider right, I must go on record as far as this matter is concerned, that the letter sent to me is an insult to every photographer, whether professional or non-professional, who has any respect whatsoever for his work. I do hope that you won't take anything in this letter as personal. It is a question of principle.

Sincerely,
Alfred Stieglitz

FROM *Twice A Year* 8–9 (1942)

Stieglitz wrote this letter to James Thrall Soby, who was a curator at New York's Museum of Modern Art and director of the museum's Armed Services Program. Stieglitz was generally hostile toward the Modern, for he felt that it bought far too little work by living American artists.

At the end of his career Stieglitz still cherished as much as ever his status as an "amateur." Even though he had often received money in exchange for prints of his photographs—or, as he preferred to view matters, he had given prints by way of thanks for gifts of money he had received for his operating-and-artist's-welfare fund—he deeply resented being called a professional photographer.

Stieglitz wrote in his letter to Soby, "You seem to assume that a photograph is one of a dozen or a hundred or maybe a million prints, all prints from one negative necessarily being alike and so replaceable." One could say that Soby had simply made the mistake of assuming that Stieglitz had realized the ideal he had announced in his "Statement" that accompanied his 1921 exhibition. There the photographer had written, "My ideal is to achieve the ability to produce numberless prints from each negative, prints all significantly alive, yet indistinguishably alike, and to be able to circulate them at a price not higher than that of a popular magazine, or even a daily paper."

Another issue in Soby's letter that angered Stieglitz was that of mounting all prints on "16-by-20 vertical white mounts," either by the photographer or by the museum. It had always been Stieglitz's practice to exercise tremendous care in mounting his prints, sometimes giving weeks of thought to the proper size, color, and orientation (horizontal or vertical) of the mat for a fine print.

As for the likelihood that the prints would become "damaged and battered and filthy" in transit, Stieglitz had always been a stickler about such matters. It was not unusual for him to rush up to a gallery visitor who had picked up a worn catalog and to insist on giving him or her a fresh one, asking rhetorically if the visitor didn't hate fingerprints and smudges on such things as much as Stieglitz did himself.

Stieglitz's militantly self-righteous letter to Soby may seem somewhat hypocritical in light of a statement he would make in an issue of *Twice A Year* later in 1942. There he maintained that it was wrong for the masterpieces of the Metropolitan Museum of Art to have been put in safe storage far away from New York just when the people of the city needed great art, more than ever, for their well-being and morale.

PREFACE TO BIBLIOGRAPHY OF THE PUBLISHED WRITINGS OF ALFRED STIEGLITZ

Many years ago when I was a graduate student studying with Beaumont Newhall at the University of New Mexico, he suggested that I collect all of Stieglitz's published writings. The result was my master's thesis, 1976, that compiled and analyzed Stieglitz's published writings. In the intervening years I have found a few additional references that I had previously overlooked, which have been added to this current bibliography.

This bibliography includes all articles written, signed, and published by Stieglitz during his lifetime. Interviews, stories recorded by others, such as those published in *Twice A Year,* or letters published posthumously are not listed. For those periodicals that Stieglitz edited, such as *Camera Notes* and *Camera Work,* all substantial articles signed "editor," "editors," or "publication committee," have been included. Although Stieglitz was also an editor of the *American Amateur Photographer* from 1893 to 1896, these "editorial comments" are not cited because he was only one of several editors under the directorship of the Outing Company, and because many of these comments do not appear to have been written by Stieglitz or express his views.

As the previous selection made by Richard Whelan makes clear, Stieglitz's published writings provide invaluable insights into this complex and influential figure in American photography, art, and culture. From the very beginning of his career, Stieglitz was profoundly concerned with establishing and maintaining his position of prominence; and once he had achieved that station, he worked hard to control and perpetuate his own myth. He employed many means to achieve these goals: the exhibitions he organized, galleries he directed, and periodicals he published proved to be very effective tools for arguing his ideas and affecting his cause. His legendary monologues and his ability to enlist devout followers were other methods he used to garner support. These aspects of his career have justifiably received considerable attention, and they will continue to do so. However his published writings have been somewhat overlooked. Nevertheless, they provide a substantial core of basic chronological facts that enable readers to chart Stieglitz's evolution, evaluate the development of his ideas, and witness his own construction of his myth.

SARAH GREENOUGH

CHRONOLOGICAL BIBLIOGRAPHY OF THE PUBLISHED WRITINGS OF ALFRED STIEGLITZ

COMPILED BY SARAH GREENOUGH

"A Word or Two about Amateur Photography in Germany." *Amateur Photographer* 5 (February 25, 1887): 96–97.

[Letter]. *Der Amateur-Photograph* 1 (March 1887): 48.

"Das Verstärken." *Der Amateur-Photograph* 1 (April 1887): 56–58.

"Neues Negativ-Verfahren mit Eastman Stripping Film." *Photographische Mitheilungen* 24 (Juli 1887): 108–109.

[Letter]. *The Amateur Photographer* 6 (July 22, 1887): 27.

"Ein Wort zu Gunsten des Platindrucks." *Der Amateur Photograph* 1 (August 1887): 122–124.

"Over-Exposed Plates." *Amateur Photographer* 6 (August 5, 1887): 51.

"Zwei neue Verfahren." *Der Amateur-Photograph* 2 (1888): 9–10.

"Das neueste Negativ-Verfahren: der Vergara Film (Haut)." *Photographische Mitheilungen* 24 (Januar 1888): 282–283.

"Zur Herstellung von Duplicat-Negativen." *Der Amateur-Photograph* 2 (1888): 23–24.

"Pizzighelli's New Platinum Process." *Amateur Photographer* 7 (February 10, 1888): 84.

"Ueberbelichtete Platten." *Der Amateur-Photograph* 2 (1888): 46.

"Exhibitions." *Amateur Photographer* 8 (March 2, 1888): 133.

[Untitled]. *Der Amateur-Photograph* 2 (1888): 59–60.

"Neues im Platindruck." *Der Amateur-Photograph* 2 (1888): 73–74.

"Eine einfache Verstärkungsmethode." *Der Amateur-Photograph* 2 (1888): 93.

"Das Trocknen von Gelatine-Negativen." *Photographische Rundschau* 2 (Juli 1888): 227–228.

"Studien und Versuche über Neuerungen in der Praxis. Carbutt's Celluloid Films." *Photographische Rundschau* 3 (Juli 1889): 208–210. Reprinted in *Handbuch der Photographie*. Edited by Josef Maria Eder, 1890, 350–351.

"Photographic Exhibition, Berlin." *Amateur Photographer* 10 (September 6, 1889): 154.

"Eine Kurze unparteiische Übersicht der Amateur—leistungen in der Kunst—Abteilung der Berliner Jubiläums—Ausstellung." *Photographische Rundschau* 3 (Oktober 1889): 332–334.

"Platinum Toning." *Amateur Photographer* 10 (November 1, 1889): 286.

"The Berlin Exhibition." *American Amateur Photographer* 1 (November 1889): 202–204.

"Studien und Versuche über Neuerungen in der Praxis. Temperatur—Einfluss beim Entwickeln." *Photographische Rundschau* 3 (November 1889): 351–352.

"Clark's Platinum Process." *Amateur Photographer* 10 (November 22, 1889): 339.

"Studien und Versuche über Neuerungen in der Praxis. Transferotypiepapier-Willis Neues Platin-Verfahren." *Photographische Rundschau* 3 (Februar 1889): 62–64.

"Studien und Versuche über Neuerungen in der Praxis. Expositionszeit-Entwicklung." *Photographische Rundschau* 3 (Marz 1889): 73–75.

"Studien und Versuche über Neuerungen in der Praxis. Naheres über neue Willis Platinpapier. Kalt-Entwicklungs-Verfahren." *Photographische Rundschau* 3 (April 1889): 111–114. Reprinted in *Jahrbuck für Photographie und Reproductionstechnik für das Jahr 1891.* Edited by Dr. Josef Maria Eder, 337–338.

"Platinum Toning Bath." *Amateur Photographer* 9 (April 26, 1889): 269.

"A Day in Chioggia." *Amateur Photographer*, Prize Tour Number (June 1889): 7–9.

"Tonen von Aristobildern mit Kaliumplatinchlorur." *Photographische Rundschau* 3 (Juni 1889): 192–193. Reprinted in *Handbuch der Photographie.* Edited by Dr. Josef Maria Eder, 1890, 426.

"Toning Aristo Prints with Platinum." *American Annual of Photography and Photographic Times Almanac for 1890,* 120–121.

"Das Chlorsilber-Gelatine-Papier (Aristo und Obernetter) mit Platin getont." *Jarhbuch für Photographie und Reproductionstechnik für das Jahr 1890.* Edited by Dr. Joseph Maria Eder, 110–112.

"Blanchard's Platin-Ton-Papier." *Photographische Rundschau* 4 (Januar 1890): 22–23.

"Ein neues Tonbad für Aristopapier zur raschen Erlangung schwärzlicher Töne." *Photographische Rundschau* 4 (Januar 1890): 23.

"Studien und Versuche über Neuerungen in der Praxis. Das Verstärken von Gelatine-Negativen mittelst Quecksilberchlorid und Ammoniak." *Photographische Rundschau* 4 (Mai 1890): 153–155.

"Studien und Versuche über Neuerungen in der Praxis. Die Beschleunigung des Trocknens der Gelatine–Negative mittelst Alkohols." *Photographische Rundschau* 4 (September 1890): 290–292.

[Untitled]. *Photographische Rundschau* 4 (1890): 305–306.

"Tints of Prints Made on Direct Printing Platinotype Paper." *American Annual of Photography and Photographic Times Almanac for 1891,* 249. Reprinted in *Photographische Correspondenz* 28 (1891): 329, and *Jahrbuch für Photographie und Reproductionstechnik für das Jahr 1892.* Edited by Dr. Josef Maria Eder, 448.

"Studien und Versuche über Neuerungen in der Praxis." *Photographische Rundschau* 5 (Marz 1891): 114–116. Reprinted in *Anthony's Photographic Bulletin* 22 (1891): 238, as "The Origin of Yellow Spots upon Negatives."

"A Correction." *The Photographic Times* 23 (June 19, 1891): 298.

"The Vienna Exhibition." *The Photographic Times* 23 (June 26, 1891): 313.

"A Simplified Kallitype Printing Process." *American Annual of Photography and Photographic Times Almanac for 1892*, 31–32.

"A Plea for Art Photography in America." *Photographic Mosaics* 28 (1892): 135–137.

"Experience with Slide Plates." *American Amateur Photographer* 4 (1892): 61–63.

"Toning Slides with Uranium Salts and a Few Additional Remarks on the Color of Slides in General." *Photographic Times* 21 (January 22, 1892): 42–43. Reprinted in *Amateur Photographer* 13 (April 22, 1892): 329; *American Amateur Photographer* 4 (January 1892): 28–29; *American Journal of Photography* 13 (March 1892): 115–116; *Anthony's Photographic Bulletin* 23 (January 1892): 47–49; *Photographische Mitteilungen* 29 (April 1892): 24–25; *Photographische Rundschau* 6 (1892): 403; and *St. Louis and Canadian Photographer* 10 (May 1892): 203.

"The Platinotype Process and the New York Amateur." *American Amateur Photographer* 4 (April 1892): 153–155.

"The Platinotype Process with Cold Development." *American Amateur Photographer* 4 (1892): 391–392.

"The Platinotype up to Date." *American Amateur Photographer* 4 (1892): 493–497.

"Cortina and Sterzing." From *Sun Pictures from Many Lands*. London: *Amateur Photographer*, 1892, 60–61.

"A Simple Method of Backing Plates." *American Annual of Photography and Photographic Times Almanac for 1893*, 164.

"The Joint Exhibition at Philadelphia." *American Amateur Photographer* 5 (May 1893): 201–208.

"Points On Developing Cold Bath Platinotypes." *American Amateur Photographer* 5 (1893): 209.

"Uranium Toning of Platinotypes." *American Amateur Photographer* 5 (1893): 210.

"The Joint Exhibition at Philadelphia." *American Amateur Photographer* 5 (June 1893): 249–254.

"The Joint Exhibition at New York." *American Amateur Photographer* 6 (April 1894): 153–156.

"Photographic Times Competition." With R. M. Shurtleff and Chas. Ehrmann. *The Photographic Times* 24 (April 20, 1894): 242–243.

"The Seventh Annual Joint Exhibition." *American Amateur Photographer* 6 (1894): 209–219.

[Untitled]. *American Amateur Photographer* 6 (1894): 273–274.

"Photographic Section of the Milan International United Exhibitions." *American Amateur Photographer* 6 (1894): 377–378.

[Untitled]. *American Amateur Photographer* 6 (1894): 431–432.

"A Plea for a Photographic Art Exhibition." *American Annual of Photography and Photographic Times Almanac for 1895*, 27–28.

"Two Artists' Haunts." With Louis H. Schubart. *Photographic Times* 26 (1895): 9–12.

"Pictorial Photography in the United States, 1895." *Photograms of the Year 1895*, 81.

"The American Photographic Salon." *American Annual of Photography and Photographic Times Almanac for 1896*, 194–196.

"Awards in the Third Annual American Amateur Photographer Competition." *American Amateur Photographer* 8 (January 1896): 72.

[Untitled]. *Amateur Photographer* 23 (1896): 149.

"The Reproduction of Pictorial Photographs by Half-Tone Methods." *The Practical Process Worker and Photo-Mechanical Printer* 1 (June 1896): 33–34.

"Pictorial Photography in the United States; 1896." *Photograms of the Year 1896*, 43–44.

"The Hand Camera—Its Present Importance." *American Annual of Photography and Photographic Times Almanac for 1897*, 19–27. Reprinted in *Sunlight and Shadow*. Edited by W. I. I. Adams. New York: Baker and Taylor Co., 1897, 69–78.

"Half–Tone Blocks with Woodcut Finish" *American Annual of Photography and Photographic Times Almanac for 1897*, 221.

[Letter]. *Journal of the Camera Club* 1 (January and February 1897): 35.

[Letter]. *American Amateur Photographer* 9 (1897): 238.

The Publication Committee. [Untitled]. *Camera Notes* 1 (July 1897): 3.

"Some Remarks on Lantern Slides. A Method of Developing: Partial and Local Toning." *Camera Notes* 1 (October 1897), 32–39. Reprinted in *Amateur Photographer* 24 (September 10, 1897): 203–204; *The Photographic News* 3 (October 1, 1897): 645–647; *American Amateur Photographer* 9 (October 1897): 445–456; *Photographic Times* 29 (October 1897): 483–485; and *Photographische Mitteilungen* 34 (November 1897): 242–243.

"Photographic Salon Portfolios (London)." *Camera Notes* 1 (October 1897): 54.

[Letter]. *Wilson's Photographic Magazine* 34 (1897): 238.

"The Photographic Year in the United States." *Photograms of the Year 1897*, 29–30.

"Night Photography with the Introduction of Life." *American Annual of Photography and Photographic Times Almanac for 1898*, 204–207.

"A Natural Background for Out-of-Doors Portraiture." *American Annual of Photography and Photographic Times Almanac for 1898*, 210–211.

"The Chassagne-Dansac Natural Color Photography." *Camera Notes* 1 (January 1898): 70.

"Nach der Natur." *Camera Notes* 1 (January 1898): 85.

"Bromide Enlargements and How to Make Them." *Camera Notes* 1 (January 1898): 86.

"The Test Room." *Camera Notes* 1 (January 1898): 88.

The Publication Committee. "A Greeting to Our Friends." *Camera Notes* 1 (April 1898): 96.

"The F. A. Engle Exhibition." *Camera Notes* 1 (April 1898): 120.

[Untitled]. *Camera Notes* 2 (July 1898): 5. Reprinted in *Photo-Miniature* 1 (August 1899): opposite page 252.

Publication Committee. [Note on "The Other Side—A Communication."] *Camera Notes* 2 (October 1989): 46.

"Notes." *Camera Notes* 2 (October 1898): 53–54.

"Platinum Printing." From *Picture Taking and Picture Making*. Rochester, New York: Eastman Kodak Co., 1898. Reprinted in *The Modern Way of Picture Making*. Rochester, New York: Eastman Kodak Co., 1905, 122–128.

"The Progress of Pictorial Photography in the United States." *American Annual of Photography and Photographic Times Almanac for 1899*, 158–159.

"The Fixing Bath." *The International Annual of Anthony's Photographic Bulletin* 11 (1899): 12–13.

"In Re-Compensating Cover Glass." *Camera Notes* 2 (January 1899): 90–91.

Publication Committee. "A 'Tusch' on Our Own Horn." *Camera Notes* 2 (January 1899): 107.

Editors. [Editors' Note on the Philadelphia Salon]. *Camera Notes* 2 (January 1899): 132.

[Letter]. With W. M. Murray. *American Amateur Photographer* 11 (1899): 106.

"My Favorite Picture." *Photographic Life* 1 (1899): 11–12.

Publication Committee. "Free Speech." *Camera Notes* 3 (July 1899): 23.

"Our Illustrations." *Camera Notes* 3 (July 1899): 24.

"Exhibition of Prints by Mrs. Isabel Churchill Taylor." *Camera Notes* 3 (July 1899): 42.

"The First Orthochromatic Photographs." *Photography* 11 (1899): 538.

"The Members' Exhibition of Prints." *Camera Notes* 3 (October 1899): 78.

"Reviews and Exchanges." *Camera Notes* 3 (October 1899): 88.

"Own Work Throughout." *Amateur Photographer* 30 (October 27, 1899): 325.

"Pictorial Photography." *Scribner's* 26 (1899): 528–537.

"A Few Common Fallacies." *American Annual of Photography and Photographic Times Almanac for 1900*, 19–22. Reprinted in *Photography* 12 (January 4, 1900): 15; and *Photographische Mitteilungen* 37 (1900): 51–52.

"Camera Club Competitions. Lantern Slide Championship Cup." *Camera Notes* 3 (January 1900): 126.

[Note on "The Salon. Its Purpose, Character and Lesson"]. *Camera Notes* 3 (January 1900): 170.

"Camera Club Competitions. The Fin-de-Siècle Lantern Slide Competition." With W. M. Murray and Charles Berg. *Camera Notes* 4 (July 1900): 48.

[Untitled]. *Camera Notes* 4 (July 1900): 55.

"Why American Pictorial Work Is Absent from the Paris Exhibition." *Amateur Photographer* 32 (July 20, 1900): 44.

[Letter]. *Amateur Photographer* 32 (September 1900): 222.

"The Members' Third Annual Exhibition of Prints." *Camera Notes* 4 (October 1900): 109–111.

"Books Received." *Camera Notes* 4 (October 1900): 127–128.

[Untitled]. *Amateur Photographer* 32 (November 16, 1900): 383.

"Pinholes and Fog—A Warning." *The International Annual of Anthony's Photographic Bulletin* 13 (1901): 147.

"Books Received. *Photograms of the Year 1900*, and *A Handbook of Photography in Colors*." *Camera Notes* 4 (January 1901): 229.

[Untitled]. *Camera Notes* 4 (January 1901): "To the Editor of the *American Amateur Photographer*." *American Amateur Photographer* 13 (1901): 41–42.

"To the Editor of the *American Amateur Photographer*." *American Amateur Photographer* 13 (February 1901): 141–142.

"The American Pictorial Photographs for the International Art Exhibition at Glasgow." *Camera Notes* 4 (April 1901): 273–275.

"American Pictorial Photography, Series II." *Camera Notes* 4 (April 1901): 286.

Editor. [Note on "The American New School of Photography in Paris"]. *Camera Notes* 5 (July 1901): 33.

"Camera Notes Report." *Camera Notes* 5 (July 1901): 73–74.

"The Philadelphia Salon." *Camera Notes* 5 (October 1901): 121–122.

"Sloppiness in the Platinum Process and Its Effect." *American Annual of Photography and Photographic Times Almanac for 1902*. 28–30. Reprinted in *Camera Notes* 5 (January 1902): 192–195.

"A Use for Spoiled Platinum Paper." *The International Annual of Anthony's Photographic Bulletin* 14 (1902): 101–102. Reprinted in *Camera Notes* 5 (January 1902): 191.

"Numbering Frames at Exhibitions." *Camera Notes* 5 (January 1902): 124.

"Apropos of Mr. Edmund Stirling's Resignation." *Camera Notes* 5 (January 1902): 124.

Editor. [Note on "The Philadelphia Photographic Salon, 1901"]. *Camera Notes* 5 (January 1902): 207.

"Interesting Statistics of the Philadelphia Salon." *Camera Notes* 5 (January 1902): 216.

"Irreconcilable Positions—A Letter and the Reply." *Camera Notes* 5 (January 1902): 217–218.

"Books Received. *Photograms of the Year 1901*." *Camera Notes* 5 (January 1902): 222.

Editor. [Note on "A Photographic Enquête."] *Camera Notes* 5 (April 1902): 233.

Editor. [Note on "Cave!"]. *Camera Notes* 5 (April 1902): 243.

Editor. [Note on "The Art in Photography"]. *Camera Notes* 5 (April 1902): 247.

Editor. [Note on "Mr. Osborne I. Yellott on 'The Issue'"]. *Camera Notes* 5 (April 1902): 272.

"The History of Philadelphia." *Camera Notes* 5 (April 1902).

Editor. [Note on "The Salon Committee of 1900 Makes a Statement"]. *Camera Notes* 5 (April 1902): 300.

[Letter]. With Joseph T. Keiley, Dallett Fuguet, John Francis Strauss. *The Photo-Miniature* 4 (April 1902): 54. Reprinted in *American Amateur Photographer* 14 (July 1902): 334.

"Extract from Letter from Alfred Stieglitz, West 29th Street, New York, to F. Dundas Todd." *British Journal of Photography* 49 (1902): 459.

"Valedictory." With Joseph Keiley, Dallett Fuguet, John Strauss, and Juan C. Abel. *Camera Notes* 6 (July 1902): 3–5. Reprinted in *Photographic Times Bulletin* 32 (July 1902): 324–325.

"To William M. Murray—An Appreciative Acknowledgement." *Camera Notes* 6 (July 1902): 5.

Editor. [Note on "Eduard J. Steichen, Painter-Photographer"]. *Camera Notes* 6 (July 1902): 15.

"Painters on Photographic Juries." *Camera Notes* 6 (July 1902): 27–30. Reprinted in *American Amateur Photographer* 14 (July 1902): 311–314; *Photo Era* 8 (June 1902): 443–448; and *Photographic Times Bulletin* 34 (July 1902): 318–321.

"The 'Champs de Mars' Salon and Photography." *Camera Notes* 6 (July 1902): 50.

Editor. "Postscript—May 10th." *Camera Notes* 6 (July 1902): inserted between pages 50 and 51.

Editor. [Note on "The Washington Salon of 1896—A Bit of History"]. *Camera Notes* 6 (July 1902): 63.

"The Annual Members' Exhibition." With Joseph Keiley and E. Lee Ferguson. *Camera Notes* 6 (July 1902): 80–81.

"Testimonial," *Trade Circular* (Eastman Kodak Company) 3 (August 1902).

[Untitled]. With Joseph Keiley, Dallett Fuguet, and John Strauss. *Photo Era* 8 (1902): 489–490. Reprinted in *Amateur Photographer* 34 (June 5, 1902): 461; *American Amateur Photographer* 14 (July 1902): 334; and *British Journal of Photography* 49 (June 6, 1902): 459.

"Modern Pictorial Photography." *Century Magazine* 44 (1902): 822–825.

"Mr. Steichen's Photographs." *American Amateur Photographer* 14 (1902): 382.

Camera Work. New York: Privately Published, August 25, 1902.

[Untitled]. *American Amateur Photographer* 14 (1902): 575.

"An Authority." *Photographic Review* 8 (1902): 3.

"Enlarging Negatives—A Practical Hint." *Down-Town Topics* 1 (December 1902): 1–3.

"The Photo-Secession at the National Arts Club, New York." *Photograms of the Year 1902.* 17–20.

"An Apology." With Joseph Keiley, Dallett Fuguet, and John F. Strauss. *Camera Work* 1 (January 1903): 15–16.

Editors. "America at the London Salon." *Camera Work* 1 (January 1903): 26–29.

Editor. "Pictorial Photography: The St. Louis Exposition." *Camera Work* 1 (January 1903): 37.

Editors. "Photography at Important Art Exhibitions." *Camera Work* 1 (January 1903): 60–61.

Editors. "Pictures in this Number." *Camera Work* 1 (January 1903): 63.

Editors. "The Kodak Developing Machine." *Camera Work* 1 (January 1903): 64.

Editors. "Announcement." *Camera Work* 1 (January 1903): 66.

[Letter]. *Photographic Times-Bulletin* 35 (1903): 30.

Editors. "Juries and Judges." *Camera Work* 2 (April 1903): 48.

Editors. "Exhibition Notes—Photo-Secession Notes, and Re: St. Louis." *Camera Work* 2 (April 1903): 50–51.

Editors. "Our Pictures." *Camera Work* 2 (April 1903): 54.

Editors. "Encouragement." *Camera Work* 2 (April 1903): 54.

[Letter]. *Photographic Times-Bulletin* 35 (1903): 236–237

"The Photo-Secession." *Bausch and Lomb Lens Souvenir*. Rochester, New York: Bausch and Lomb Optical Company, 1903, 3.

[Unsigned]. "The Photo-Secession." *Camera Work* 3 (July 1903).

"The Photo-Secession—Its Objectives." *Camera Craft* 8 (1903): 81–83.

Editors. "To Camera-Workers." *Camera Work* 4 (October 1903): 62.

"Renewal of Subscription—New Subscription Price." *Camera Work* 4 (October 1903).

"Sammler und Vorzugsdrucke." *Camerakunst*. Berlin: Gustav Schmidt, 1903, 55–60.

"The Photo-Secession." *The American Annual of Photography and Photographic Times Almanac for 1904*. 41–44.

Editors. "Our Illustrations." *Camera Work* 5 (January 1904): 51.

[Letter]. *Photographic Times* 36 (January 1904): 47.

[Untitled]. *Camera Work* 6 (April 1904).

"The Photo-Secession and the St. Louis Exposition." *Amateur Photographer* 39 (April 14, 1904): 287–288.

[Letter]. *The Photographer* 1 (April 30, 1904): 16.

"The Photographic Salon, 1904." *The Photographer* 1 (June 18, 1904): 128. Reprinted in *Down-Town Topics* 2 (June 1904): 3; *Western Camera Notes* 5 (July 1904): 195; *Photographic Times* 36 (July 1904): 327.

"An Appeal to our Subscribers. Temporary Change of Address." *Camera Work* 7 (July 1904).

[Untitled]. *Amateur Photographer* 40 (July 28, 1904): 61. Reprinted in *American Amateur Photographer* 16 (1904): 383; *The Photographer* 1 (August 6, 1904): 226; *Photographic Times* 36 (September 1904): 419–420; and *Photography* 18 (July 30, 1904): 92.

[Letter]. *American Amateur Photographer* 16 (August 1904): 358.

"The Fiasco at St. Louis." *British Journal of Photography* 51 (August 1904). 739.

"The Fiasco at St. Louis." *The Photographer* 1 (August 20, 1904): 258–259. Reprinted in *The British Journal of Photography* 51 (September 2, 1904): 772–773.

"Some Impressions of Foreign Exhibitions." *Camera Work* 8 (October 1904): 34–37.

"Camera Work." *Photography* 18 (October 15, 1904): 327.

[Untitled]. *American Amateur Photographer* 16 (November 1904): 484.

[Untitled]. New York: Privately Printed, 1904

Editors. "To Our Subscribers." *Camera Work* 9 (January 1905): 47.

"The First American Salon at New York." *Camera Work* 9 (January 1905): 50–52.

"A Note from the Director." *The Photo-Secession* 6 (February 1905).

Editors. [Editors' note on "Eduard Steichen: Painter and Photographer"]. *Camera Work* 10 (April 1905): 42.

"Alfred Stieglitz's Good Wishes." *The Photographer* 3 (May 2, 1905): 2.

"Camera Work, 1906." *Camera Work* 11 (July 1905).

"A Tip." *Down-Town Topics* 4 (July 1905): 1–2.

[Letter]. *Photo-Era* 15 (October 1905): 147.

"Simplicity in Composition." *The Modern Way in Picture Making*. Rochester, New York: Eastman Kodak Co., 1905, 161–164.

"Editorial." *Camera Work* 14 (April 1906): 17.

"Photo Secession Exhibitions". *Camera Craft* 13 (September 1906): 356.

Editor. [Editor's Note on "My Experience of the Rawlins Oil Process"]. *Camera Notes* 16 (October 1906): 17.

[Letter]. *Camera Work* 16 (October 1906). Reprinted in *Camera Work* 17 (January 1907); *Camera Work* 18 (April 1907); *Camera Work* 19 (July 1907).

"Some of the Reasons." *The Complete Photographer*. Edited by R. Child Bayley. New York: McClure Phillips and Co., 1906. Revised 1923 Edition, 360–362. Reprinted in *Camera Work* 18 (April 1907): 25–27.

[Editors]. "Our Articles." *Camera Work* 17 (January 1907): 41.

[Editors]. "The Editors' Page." *Camera Work* 18 (April 1907): 37–38.

"The Colour Problem for Practical Work Solved." *Photography* 24 (August 13, 1907): 136. Reprinted in *Camera Work* 20 (October 1907): 21–22.

"Mr. Stieglitz on the Personal Factor in Autochrome." *Photography* 24 (September 10, 1907): 223. Reprinted in *Camera Work* 20 (October 1907): 23–24; and *The Photographer* 7 (September 17, 1907): 324.

"The New Color Photography—A Bit of History." *Camera Work* 20 (October 1907): 20–25.

"Publisher's Notice." *Camera Work* 20 (October 1907).

"Our Color Number." *Camera Work* 21 (January 1908): 48.

"Frilling and Autochromes." *Camera Work* 23 (July 1908): 49–50. Reprinted in *Amateur Photographer* 47 (June 23, 1908): 636.

"The White Book." *Camera Work* 25 (January 1909).

"Twelve Random Don'ts." *Photographic Topics* 7 (January 1909): 1. Reprinted in *Photography* 27 (March 1909): 179.

Editors. [Editors' Note on "Photography, A Medium of Expression"]. *Camera Work* 26 (April 1909): 33.

"To the Readers of *American Photography*." *American Photography* 4 (January 1910): 57.

Editors. "A Daniel Come to Judgment." *Camera Work* 31 (July 1910): 52–54.

Photo-Secessionism and Its Opponents: Five Letters. New York: Privately Published, August 25, 1910.

Editors. [Editors' Note on "Photography as a Means of Artistic Expression"]. *Camera Work* 32 (October 1910): 21.

Editors. "Our Illustrations." *Camera Work* 32 (October 1910): 47.

"Information Wanted." *Photography* 30 (October 4, 1910): 287–288.

Photo-Secessionism and Its Opponents: Another Letter—The Sixth. New York: Privately Printed, October 20, 1910.

"The 'London Salon.'" *Photography* 30 (November 29, 1910): 457.

"The Exhibition of Pictorial Photography at the Albright Art Gallery." *Academy Notes* 6 (1911): 11–13.

Editors. "Our Illustrations." *Camera Work* 34–35 (April–July 1911): 69–70.

[Letter]. *Wilson's Photographic Magazine* 48 (October 1911): 437. Final paragraph reprinted in *Photographic Journal of America* 55 (July 1918): 302.

[Letter to the Editors]. *The Evening Sun*, December 18, 1911, editorial page.

"His Idea and Ideal." *New York Sun*, March 6, 1912, 8.

"Editorial." *Camera Work* Special Number (August 1912).

"To the Editors." *The British Journal of Photography* 59 (September 27, 1912): 757.

Editors. "The Evolution of Form—Introduction." *Camera Work* 44 (January 1913): 44.

"The First Great 'Clinic to Revitalize Art.'" *New York American*, January 26, 1913, 5-CE.

[Untitled]. *Photo Miniature* 124 (March 1913): 220–221.

[Untitled]. *Camera Work* 47 (July 1914).

"One Hour's Sleep—Three Dreams." *291* 1 (March 1915). Reprinted in *Manuscripts* 2 (March 1922): 8.

"Judges' Report of the Ansco Competition." *Photographic Journal* 52 (May, 1915): 258–259.

[Letter]. *The Conservator* 26 (January 1916): 167.

"Foreword." *Eleventh Annual Exhibition of Photographs.* Philadelphia: John Wanamaker, March 1–17, 1916.

"Foreword." *The Forum Exhibition of Modern American Painters.* New York: The Anderson Galleries, March 13 to March 25, 1916. Reprinted in *Twice A Year* 1 (Fall–Winter 1938): 92–93.

"Photographs by Paul Strand." *Camera Work* 48 (October 1916): 11–12.

[Letter]. *Bruno's Weekly* 4 (January 1917): 8.

"A Bit of Advice from Alfred Stieglitz." *Photographic Journal of America* 54 (October 1917): 432.

[Letter]. *Blind Man* 2 (1917): 15.

"A Message." *Photographic Journal of America* 55 (July 1918): 302.

"Forward." *Fourteenth Annual Exhibition of Photographs.* Philadelphia: Wanamaker, March 1 to 13, 1920.

[Letter]. *New York Herald* March 21, 1920, section 4, 4.

"A Statement." *Exhibition of Stieglitz Photographs.* New York: Anderson Galleries, 1921. Reprinted in *The Dial* 70 (April 1921); *The Philadelphia Museum Bulletin* 40 (May 1945).

"Regarding the Modern French Masters Exhibition." *Brooklyn Museum Quarterly* 8 (July 1921): 107–113. Reprinted in *Twice A Year* 1 (Fall–Winter 1938): 104–107.

[Letter]. *The Arts* 2 (August–September 1921): 61.

"A Note by Alfred Stieglitz." *75 Pictures by James N. Rosenberg and 117 Pictures by Marsden Hartley*. New York: Anderson Galleries, 1921. 11–12.

"My Dear Mr. Field." *The Arts* 2 (January 1922): 254.

"Portrait—1918." *Manuscripts* 2 (March 1922): 9.

"Portrait—1918." *Manuscripts* 2 (March 1922): 10.

"Portrait: 1910–1920." *Manuscripts* 2 (March 1922): 10.

"Is Photography a Failure?" *The Sun*, March 14, 1922, 20.

"My Dear Mr. McBride." *New York Herald*, November 5, 1922, 7.

[Untitled]. *Second Exhibition of Photography by Alfred Stieglitz*. New York: Anderson Galleries, 1923.

"How I Came to Photograph Clouds." *Amateur Photographer and Photography* 56 (1923): 255.

"Chapter III." *Third Exhibition of Photography by Alfred Stieglitz*. New York: Anderson Galleries, 1924.

"Dear McBride." *New York Herald*, February 10, 1924, section 7, 13.

"Sky-Songs." *The Nation* 118 (May 14, 1924): 561–562.

[Untitled]. *Alfred Stieglitz Presents Seven Americans*. New York: Anderson Galleries, 1925, 2.

"Mr. Stieglitz and Mr. Pach." *The Nation* 124 (1927): 40.

[Untitled]. *Marin Exhibition*. New York: Intimate Galleries at the Anderson Galleries, 1927.

"Stieglitz." *Art Digest* 1 (March 1927): 20.

[*Here Is the Marin Story*]. New York: Privately Published, April 17, 1927.

"O'Keefe [sic] and the Lilies." *Art News* 26 (April 21, 1928): 10.

"To the Art Editor." *The New York Times*, February 28, 1932, section 8, 11.

[Untitled]. *America as Americans See It*. Edited by Fred J. Ringle. New York: Harcourt, Brace and Co., 1932, 257.

"Echoes of '291.'" *Creative Art* 12 (February 1933): 152.

"Not a Dealer." *American Magazine of Art* 27 (1934): 4.

[Untitled]. *Alfred Stieglitz: An Exhibition of Photographs*. New York: An American Place, December 11, 1934 to January 17, 1935.

[Untitled]. *Eliot Porter—Exhibition of Photographs*. New York: An American Place, December 29, 1938 to January 18, 1939.

[Letter]. In Robert Taft, *Photography and the American Scene*. New York: Dover, 1938, 1964, 497.

"To the Art Editor." *The New York Times*, December 24, 1939, section 9, 9.

[Letter]. In Hutchins Hapgood's *A Victorian in the Modern World*. New York: Harcourt, Brace and Company, 1939, 417.

[Letter]. In Hutchins Hapgood's *A Victorian in the Modern World*. New York: Harcourt, Brace and Company, 1939, 441.

[Letter]. *Twice A Year* 8–9 (1942): 174.
[Letter]. *Twice A Year* 8–9 (1942): 174–175.
[Letter]. *Twice A Year* 8–9 (1942): 175–178.
[Letter]. *Minicam* 7 (September 1943): 7.
[Letter]. *Minicam* 7 (October 1943): 7.

GENERAL BIBLIOGRAPHY

In the first four works listed here may be found further information about most of the people mentioned in Stieglitz's writings. A general bibliography of Stieglitz and his circle follows.

Naef, Weston J. *The Collection of Alfred Stieglitz: Fifty Pioneers of Modern Photography*. New York: Viking/Studio, for the Metropolitan Museum of Art, 1978.

Includes a very extensive Stieglitz bibliography as well as chronologies and bibliographies for the following photographers, who were represented by prints in Stieglitz's collection, now in the Metropolitan Museum of Art, New York: Ansel Adams; J. Craig Annan; Malcolm Arbuthnot; Zaida Ben-Yusuf; Alice Boughton; Anne W. Brigman; John G. Bullock; Will Cadby; Eustace G. Calland; Julia Margaret Cameron; Sidney Carter; Rose Clark & Elizabeth Flint Wade; Alvin Langdon Coburn; Archibald Cochrane; George Davison; F. Holland Day; Robert Demachy; Baron de Meyer; Mary Devens; William B. Dyer; Rudolf Eickemeyer, Jr.; Frank Eugene; Frederick H. Evans; Herbert G. French; Arnold Genthe; Paul Haviland; Hugo Henneberg; David Octavius Hill & Robert Adamson; A. Horsley Hinton; Theodor & Oskar Hofmeister; Gertrude Käsebier; Joseph Keiley; Heinrich Kuehn; Céline Laguarde; René LeBègue; Eliot Porter; William B. Post; Constant Puyo; Frank H. Read; Harry C. Rubincam; Morton L. Schamberg; Sarah C. Sears; George H. Seeley; George Bernard Shaw; Charles Sheeler; Edward Steichen; Paul Strand; Eva Watson-Schütze; Hans Watzek; and Clarence H. White.

Newhall, Beaumont. *The History of Photography, from 1839 to the Present*. Revised edition. New York: The Museum of Modern Art/New York Graphic Society/Little, Brown, 1982.

Rosenblum, Naomi. *A World History of Photography*. New York: Abbeville Press, 1984.

Whelan, Richard. *Alfred Stieglitz: A Biography*. Boston: Little, Brown, 1995. New York: Da Capo, 1997.

Abrahams, Edward. *The Lyrical Left: Randolph Bourne and Alfred Stieglitz*. Charlottesville: University of Virginia Press, 1986.

Adams, Ansel. *Ansel Adams: An Autobiography*. Boston: New York Graphic Society/ Little, Brown, 1985.

Adams, Ansel. *Ansel Adams: Letters and Images, 1916–1984*. Boston: New York Graphic Society/Little, Brown, 1988.

Adams, Henry. *Thomas Hart Benton: An American Original*. New York: Alfred A. Knopf, 1989.

Baldwin, Neil. *Man Ray: American Artist*. New York: Clarkson N. Potter, 1988.

Beck, Tom. *An American Vision: John G. Bullock and the Photo-Secession*. New York: Aperture Foundation and University of Maryland Baltimore County, 1989.

Berger, Margaret Liebman. *Aline Meyer Liebman: Pioneer Collector and Artist*. Canandaigua, NY: W. F. Humphrey, 1982.

Bry, Doris. *Alfred Stieglitz: Photographer*. Boston: Museum of Fine Arts, 1965.

Bry, Doris. *An Exhibition of Photographs by Alfred Stieglitz*. Washington, DC: The National Gallery of Art, 1958.

Bunnell, Peter C. *Minor White: The Eye That Shapes*. Boston: Bulfinch/Little, Brown, 1989.

Bunnell, Peter C., ed. *A Photographic Vision: Pictorial Photography, 1889-1923*. Salt Lake City: Peregrine Smith, 1980.

Caffin, Charles H. *Photography as a Fine Art*. New York: Doubleday, Page and Co., 1901. Reprint Hastings-on-Hudson, NY: Morgan and Morgan, 1972.

Camfield, William A. *Francis Picabia: His Life, Art, and Times*. Princeton, NJ: Princeton University Press, 1979.

Camfield, William A. *Marcel Duchamp: Fountain*. Houston, TX: The Menil Collection & Houston Fine Art Press, 1989.

Coburn, Alvin Langdon. *Alvin Langdon Coburn: Photographer. An Autobiography*. Edited by Helmut and Alison Gernsheim. New York: Frederick A. Praeger, 1966. Reprint New York: Dover, 1978.

Cowart, Jack, Juan Hamilton, and Sarah Greenough, eds. *Georgia O'Keeffe: Art and Letters*. Boston: Bulfinch/Little, Brown (in association with the National Gallery of Art, Washington, DC), 1987.

Crawford, William. *The Keepers of Light*. Dobbs Ferry, NY: Morgan & Morgan, 1979.

Crump, James. *F. Holland Day: Suffering The Ideal*. Santa Fe: Twin Palms, 1995.

Daniel, Pete, and Raymond Smock. *A Talent for Detail: The Photographs of Miss Frances Benjamin Johnston, 1889–1910*. New York: Harmony Books, 1974.

Dijkstra, Bram. *The Hieroglyphics of a New Speech: Cubism, Stieglitz, and the Early Poetry of William Carlos Williams*. Princeton, NJ: Princeton University Press, 1969.

Doty, Robert. *Photo-Secession: Stieglitz and the Fine-Art Movement in Photography*. New York: Dover, 1978.

Ehrenkranz, Anne. *A Singular Elegance: The Photographs of Baron Adolph de Meyer*. New York: International Center of Photography and Chronicle Books, 1994.

Emerson, Peter Henry. *Naturalistic Photography*. London: Sampson Low, Marston, Searle and Rivington, 1889. New York: Scovill and Adams Company, 1889.

Enyeart, James, ed. *Decade by Decade: Twentieth-Century American Photography from the Center for Creative Photography*. Boston: Bulfinch/Little, Brown, 1989.

Enyeart, James. *Bruguière: His Photographs and His Life*. New York: Alfred A. Knopf, 1977.

Fine, Ruth E. *John Marin*. Washington, DC: The National Gallery of Art (with Abbeville Press), 1990.

Ford, Colin, ed. *An Early Victorian Album: The Photographic Masterpieces (1843–1847) of David Octavius Hill and Robert Adamson*. New York: Alfred A. Knopf, 1976.

Frank, Waldo, Lewis Mumford, Dorothy Nornman, Paul Rosenfeld, and Harold Rugg, eds. *America and Alfred Stieglitz: A Collective Portrait*. New York: Literary Guild, 1934.

Gernsheim, Helmut and Alison. *The History of Photography from the Camera Obscura to the Beginnings of the Modern Era, 1685–1914*. New York: McGraw-Hill, 1969.

Goldberg, Vicki, ed. *Photography in Print: Writings from 1816 to the Present*. New York: Simon & Schuster, 1981.

Goldschmidt, Lucien, and Weston J. Naef. *The Truthful Lens: A Survey of the Photographically Printed Book, 1844–1914*. New York: The Grolier Club, 1980.

Green, Jonathan. Camera Work: *A Critical Anthology*. Millerton, NY: Aperture, 1973.

Greenough, Sarah. *The Published Writings of Alfred Stieglitz*. Unpublished master's thesis. Albuquerque: University of New Mexico, 1976. [With an appendix of photocopies of all of Stieglitz's published writings.]

Greenough, Sarah. *Alfred Stieglitz's Photographs of Clouds*. Unpublished doctoral dissertation. Albuquerque: University of New Mexico, 1984.

Greenough, Sarah, and Juan Hamilton, eds. *Alfred Stieglitz: Photographs & Writings*. Washington, DC: The National Gallery of Art/Callaway Editions, 1983. Reprint Boston: Bulfinch/Little, Brown (in association with the National Gallery of Art, Washington, DC), 1999.

Greenough, Sarah, et al. *On the Art of Fixing a Shadow*. Boston: Bulfinch/Little, Brown (in association with the National Gallery of Art, Washington, DC; and the Art Institute of Chicago), 1989.

Greenough, Sarah. *Paul Strand: An American Vision*. Millerton, NY: Aperture (in association with the National Gallery of Art, Washington, DC), 1990.

Hambourg, Maria Morris. *Paul Strand: Circa 1916*. New York: Metropolitan Museum of Art and Harry N. Abrams, 1998.

Harker, Margaret. *The Linked Ring: The Secession Movement in Photography in Britain, 1892–1910*. London: Heinemann/Royal Photographic Society, 1979.

Hartmann, Sadakichi. *The Valiant Knights of Daguerre: Selected Critical Essays on Photography and Profiles of Photographic Pioneers*. Edited by Harry W. Lawton and George Knox. Berkeley: University of California Press, 1978.

Haworth-Booth, Mark, ed. *The Golden Age of British Photography*. Millerton, NY: Aperture, 1984.

Hill, Paul, and Thomas Cooper. *Dialogue with Photography*. New York: Farrar, Straus and Giroux, 1979.

Homer, William Innes. *Alfred Stieglitz and the American Avant-Garde*. Boston: New York Graphic Society/Little, Brown, 1977.

Homer, William Innes. *Alfred Stieglitz and the Photo-Secession*. Boston: New York Graphic Society/Little, Brown, 1983.

Homer, William Innes. *A Pictorial Heritage: The Photographs of Gertrude Käsebier*. Wilmington: Delaware Art Museum, 1979.

Ivins, William M., Jr. *Prints and Visual Communication*. Cambridge, MA: M.I.T. Press, 1953.

Jullian, Philippe. *De Meyer*. New York: Alfred A. Knopf, 1976.

Jussim, Estelle. *Slave to Beauty: The Eccentric Life and Controversial Career of F. Holland Day*. Boston: David R. Godine, 1981.

Kahmen, Volker. *Art History of Photography*. New York: Viking, 1974.

Lisle, Laurie. *Portrait of an Artist: A Biography of Georgia O'Keeffe*. New York: Seaview, 1980.

Longwell, Dennis. *Steichen: The Master Prints, 1895–1914, The Symbolist Period*. New York: The Museum of Modern Art, 1978.

Lowe, Sue Davidson. *Stieglitz: A Memoir/Biography*. New York: Farrar, Straus and Giroux, 1983.

Lynes, Barbara Buhler. *O'Keeffe, Stieglitz and the Critics, 1916–1929*. Ann Arbor, MI: UMI Research Press, 1989.

Lyons, Nathan, ed. *Photographers on Photography, A Critical Anthology*. Englewood Cliffs, NJ: Prentice Hall, 1966.

McCandless, Barbara, Bonnie Yochelson, and Richard Koszarski. *New York to Hollywood: The Photography of Karl Struss*. Fort Worth, TX: Amon Carter Museum and University of New Mexico Press, 1995.

Margolis, Marianne Fulton, ed. Camera Work: *A Pictorial Guide*. New York: Dover, 1978.

Mellquist, Jerome. *The Emergence of an American Art*. New York: Scribner's, 1942.

Michaels, Barbara L. *Gertrude Käsebier: The Photographer and her Photographs*. New York: Harry N. Abrams, 1992.

Naef, Weston J., et al. *Alfred Stieglitz: In Focus. Photographs from the J. Paul Getty Museum*. Malibu, California: J. Paul Getty Museum, 1995.

Newhall, Beaumont. *Frederick H. Evans*. Rochester, NY: George Eastman House, 1964. Reprint Millerton, NY: Aperture, 1973.

Newhall, Beaumont. *Photography: Essays & Images*. New York: The Museum of Modern Art/New York Graphic Society/Little, Brown, 1980.

Newhall, Nancy. *From Adams to Stieglitz: Pioneers of Modern Photography*. Millerton, NY: Aperture, 1989.

Newhall, Nancy. *P. H. Emerson*. Millerton, NY: Aperture, 1975.

Newhall, Nancy. *Paul Strand: Photographs 1915–1945*. New York: The Museum of Modern Art, 1945.

Niven, Penelope. *Steichen: A Biography*. New York: Clarkson Potter, 1997.

Norman, Dorothy. *Alfred Stieglitz*. Millerton, NY: Aperture, 1976.

Norman, Dorothy. *Alfred Stieglitz: An American Seer*. New York: Random House, 1973.

Norman, Dorothy. *Alfred Stieglitz: Introduction to an American Seer*. New York: Duell, Sloane & Pierce, 1960.

O'Keeffe, Georgia. *Georgia O'Keeffe: A Portrait by Alfred Stieglitz*. New York: Metropolitan Museum of Art, 1978.

Parsons, Melinda Boyd. *To All Believers: The Art of Pamela Colman Smith*. Wilmington: University of Delaware Press, 1975.

Peters, Sarah Whitaker. *Becoming O'Keeffe: The Early Years*. New York: Abbeville, 1991.

Petersen, Christian, ed. *Alfred Stieglitz's Camera Notes*. Minneapolis, MN: Minneapolis Institute of Art, 1993.

Petruck, Peninah R., ed. *The Camera Viewed*. vol. 1: *Photography Before World War II*. New York: E. P. Dutton, 1979.

Pohlmann, Ulrich. *Frank Eugene: The Dream of Beauty*. Munich: Nazraeli Press, 1996.

Porter, Eliot. *Eliot Porter*. Boston: New York Graphic Society/Little, Brown, 1987.

Pultz, John, and Catherine B. Scallen. *Cubism and American Photography*. Williamstown, MA: Sterling and Francine Clark Art Institute, 1981.

Rathbone, Belinda, et al. *Georgia O'Keeffe and Alfred Stieglitz: Two Lives; A Conversation in Paintings and Photographs*. New York: HarperCollins/Callaway Editions, 1992.

Robinson, Roxana. *Georgia O'Keeffe: A Life*. New York: Harper & Row, 1989.

Rosenfeld, Paul. *Port of New York: Essays on Fourteen Moderns*. New York, Harcourt, Brace, 1924. Reprint Urbana: University of Illinois Press, 1961.

Sandburg, Carl. *Steichen the Photographer*. New York: Harcourt, Brace, 1929.

Sandweiss, Martha A., ed. *Photography in Nineteenth-Century America*. New York: Harry N. Abrams (for Amon Carter Museum, Fort Worth, TX), 1991.

Scharf, Aaron. *Pioneers of Photography*. New York: Harry N. Abrams, 1976.

Seligmann, Herbert J. *Alfred Stieglitz Talking 1925–1931*. New Haven, CT: Yale University Library, 1966.

Stebbins, Theodore E., Jr., and Norman Keyes, Jr. *Charles Sheeler: The Photographs*. Boston: New York Graphic Society/Little, Brown, 1987.

Steichen, Edward. *A Life in Photography*. Garden City, NY: Doubleday, 1963.

Stieglitz, Alfred. *Alfred Stieglitz: Camera Work. The Complete Illustrations, 1903–1917*. Cologne: Benedikt Taschen Verlag, 1997.

Strand, Paul. *Paul Strand: A Retrospective Monograph: The Years 1915–1968*. Millerton, NY: Aperture, 1971.

Strand, Paul. *Paul Strand: Sixty Years of Photographs*. Millerton, NY: Aperture, 1976.

Szarkowski, John. *Looking at Photographs*. New York: The Museum of Modern Art, 1973.

Taft, Robert. *Photography and the American Scene: A Social History, 1838-1889*. New York: Macmillan, 1938. Reprint New York: Dover, 1964.

Thomas, F. Richard. *Literary Admirers of Alfred Stieglitz*. Carbondale, IL: Southern Illinois University Press, 1983.

Thornton, Gene. *Masters of the Camera: Stieglitz, Steichen and Their Successors*. New York: Holt, Rinehart and Winston, 1976.

Travis, David. *Photography Rediscovered: American Photographs, 1900-1930*. New York: The Whitney Museum of American Art, 1979.

Vogel, Hermann. *Handbook of the Practice and Art of Photography*. Second edition. Philadelphia: Benerman & Wilson, 1875.

Watson, Steven. *Strange Bedfellows: The First American Avant-Garde*. New York: Abbeville, 1991.

Weaver, Mike. *Alvin Langdon Coburn: Symbolist Photographer, 1882-1966*. Millerton, NY: Aperture, 1986.

Weegee (Arthur Fellig). *Naked City*. New York: Duell, Sloan & Pearce, 1945. Reprint New York: Da Capo, n.d.

Welling, William. *Photography in America: The Formative Years, 1839-1900*. New York: Thomas Y. Crowell, 1978.

ACKNOWLEDGEMENTS

This book would simply not have been possible without the scholarship and the generosity of Sarah Greenough, Curator of Photographs at the National Gallery of Art, in Washington, D.C. When I was beginning to do the research for my biography of Alfred Stieglitz, Dr. Greenough very kindly gave me a copy of her master's thesis, "The Published Writings of Alfred Stieglitz," the appendix of which consists of many hundreds of pages of photocopies of the original publications. Although she had long hoped to publish an extensive selection of those texts herself, her curatorial work made such heavy demands upon her time that she never got around to doing so. (A small selection of the texts was included in *Alfred Stieglitz: Photographs and Writings*, on which Ms. Greenough collaborated with Juan Hamilton, and which draws more heavily upon Stieglitz's correspondence.)

I also wish to acknowledge my enormous debt of gratitude to my editor at Aperture, Lesley Martin, who meets all of my criteria for an ideal editor.

The publisher extends grateful acknowledgement to the following photographers, estates, collections, and museums for providing the images reproduced in this book. All photographs copyright the artist unless otherwise noted.

Frontispiece, pp. xxi, xxiv, 22, 40, 112, 182, 236 courtesy Philadelphia Museum of Art. Gift of Carl Zigrosser.

pp. xx (top) courtesy Richard Whelan.

pp. xvii, xix, 4, 28, 59, 60 (top), 70, 78, 109, 118, 121, 146, 180, 181, 218, courtesy George Eastman House.

pp. xviii, xxiii, 35 courtesy Miriam and Ira D. Wallach Division of Art, Prints & Photographs, The New York Public Library.

pp. xx (bottom), 69 courtesy Gilman Paper Company Collection.

p. xxii courtesy The Metropolitian Museum of Art, New York, The Alfred Stieglitz Collection, 1955 (55.635.19). Reprinted with permission of Joanna T. Steichen.

p. 13 courtesy Peter Hastings Falk. Published originally in *Frank S. Herrmann 1866–1942: A Separate Reality*. Madison, CT: Sound View Press, 1988.

p. 233 courtesy The Metropolitan Museum of Art, New York, bequest of Benjamin Altman, 1913 (14.40.626).

p. 239 copyright © 1976, Aperture Foundation, Inc., Paul Strand Archive.

p. 244 courtesy The Metropolitan Museum of Art, New York. Gift of Mrs. Alma Wertheim, 1928 (28.130.2).

SELECTED INDEX

(Numerals in italic indicate pages bearing illustrations)